CHASING THE MUSE: CANADA

A HISTORIOGRAPHY

LLOYD WALTON

 FriesenPress

Suite 300 - 990 Fort St
Victoria, BC, V8V 3K2
Canada

www.friesenpress.com

ISBN
978-1-5255-4591-7 (Hardcover)
978-1-5255-4592-4 (Paperback)
978-1-5255-4593-1 (eBook)

1. ART, FILM & VIDEO

Distributed to the trade by The Ingram Book Company

This book is dedicated to the memory of Fred Wheatley

Mahn Kiki
1913-1990

PART ONE: The Code of the Trail

There are moments in childhood when a door opens and lets in the future. The first half of the story proves that by staying true to even your wildest dreams of youth, they can actually happen. When dreams do come true, each resulting experience brings a lesson to prepare Lloyd for the larger tests of life ahead.

PART TWO: Into The Stone

Into the Stone demonstrates how those early teachings guided and protected Lloyd in seeking an answer to a mystery regarding ancient knowledge, which according to leading academics at the time was, unknowable. His quest becomes an journey of life threatening, humbling, humorous, and supernatural encounters and adventures. The stories unfold to reveal a grand answer from the past and beyond.

CONTENTS

INTRODUCTION: LIKE A ROLLING STONE 1

PART ONE: THE CODE OF THE TRAIL 3

5 THE SPELL OF HIAWATHA
10 THE COWBOY CODE
13 IMPERMANENCE
16 TO FLY
19 LIFE LESSONS IN HOCKEY
23 A TASTE OF THE NORTH

29 SITUATIONAL AWARENESS
31 A TALENT UNCOVERED
36 GREY CUP FEVER
42 DANCE, WHITE BOY
47 LEARNING A CRAFT
48 PROPAGANDA MESSENGER

PART TWO: INTO THE STONE 57

59 THE STAR APPEARS
62 A PORTAL OPENS
73 THE LAND OF THE CREE
84 CHANCE MEETING
87 WHEN THE STUDENT IS READY
99 A JOB IN THE GREAT NORTHWEST
108 ARCHAEOLOGICAL DIVERSIONS
112 DEEP INTO THE RING OF FIRE
118 SURF CITY, HERE I COME
122 SHE GO BEE (BLACK SPRUCE)
128 CRICKETS MAKE ME NERVOUS
133 A COUPLE OF GREAT SAVES LATE IN THE THIRD PERIOD
139 THE THUNDERBIRD
145 KISSED BY A MOOSE
148 BEYOND THE POLAR BEAR EXPRESS
153 THE ROCKS THAT TEACH

159 THE MIGRATION WEST
161 HITTING THE BULL'S EYE
165 WE MEET ON THE ROCK
170 THE SONG OF HIAWATHA
172 THE FINISHING TOUCHES
175 UNEXPECTED CONSEQUENCES
177 THE VISION QUEST
183 THE TURNING OF THE TIDE
187 WERE YOU LOOKING FOR FOREST FIRES?
193 THEY CALLED ME BACK
195 PLACES OUT OF TIME REVISITED
198 GRINNING DOWN A BEAR
202 THE LAST TIME
206 DEEP INSIDE THE TEEPEE
208 ACROSS THE SKY

BIBLIOGRAPHY 211

INTRODUCTION
LIKE A ROLLING STONE

I've often wondered why I was given the privilege of passing through the gates of extraordinary natural, cultural, and deliberately hidden realms. I have learned that if your heart and mind are in the right place, a "No Trespassing" sign can be meaningless. My soul and spirit have always felt unencumbered by society's directives. The earliest motivation I can recollect for this feeling came from a passage my father read to me from "A Rolling Stone" by Yukon poet Robert Service.

> *To see it all, the wide world-way,*
> *From the fig-leaf belt to the Pole;*
> *With never a one to say me nay,*
> *And none to cramp my soul.*
> *In belly-pinch I will pay the price,*
> *But God! let me be free;*
> *For once I know in the long ago,*
> *They made a slave of me.*

(Robert Service, "A Rolling Stone," Stanza seven)

From a very young age, I practiced living the life of a rolling stone, with a freedom of spirit nurtured by the naiveté of youth. Learning the code of the trail was an essential requisite to walk in that special way. Through a process of remarkable influences and challenges, I fell into a career that paid me to indulge my search for wonder, beauty, magic, and truth. I've lived a life of adventure, danger, and intrigue. Looking back on it all, I tried to write about it but kept hitting walls. Were certain things off limits, or taboo to talk about? How could I write it down? I weighed those thoughts for years.

Then one summer, while visiting the tiny village of Killarney on the northeast coast of Georgian Bay, I saw a man walking down the middle of the road towards me; he looked familiar. You can walk down the middle of the road in Killarney, it being so quiet. I stopped him and said, "You remind me of a highly revered Ojibway elder that I used to know. He passed away a few years ago."

He asked, "What was his name?"

"Art Solomon."

He replied, "Pleased to meet you. Art Solomon was my dad and my name is Gene."

As we shook hands, I said, "Hold on, Gene. I have to tell you a story." He gave me a big smile.

"Your dad once asked me to help him. A film crew from Germany wanted to make a movie about his relationship with nature by filming him and a group of Ojibway out in the wilds of northern Ontario. Art had some concerns about dealing with those strangers from afar, so he asked me to be an intermediary.

"Art told me, 'Paddle out to the mouth of Chickenashing Creek. You will find me and my camp out on an island on Georgian Bay.'

"Paddling out to the mouth of the creek was easy. But Georgian Bay has 30,000 islands. Looking out toward an array of islands on that big water, I had a strong feeling inside that he and his group were east and out to my left. But it was a beautiful day, and I had time to kill, so I headed west instead to explore the outer islands to my right. The water sparkled and I paddled on, surrounded by shiny smooth pink-coloured rock formations, some of which looked eerily erotic. Just when I thought that it was time to turn around to head back to find your dad, a family of ducks appeared.

"For a lark, I started to follow them, zigzagging around jutting rocks and shoals. Always keeping ahead of me, the string of singing, quacking mallards led me down into a long, winding narrow bay. They disappeared around a corner, and I sped up. When I caught up to them, I looked up to see your father, Art, in front of me, arms outstretched, beaming, with his Ojibway greeting, 'Bozho (Hello), Lloyd.'

He had sent the ducks out to get me."

"That would be dad," laughed Gene. "Go get Lloyd."

I went on to tell Gene of the dilemma I faced of trying to write my story, but not being sure what could be told or should not be told.

His reply lifted me. "If you are an artist, you will find a way to tell it."

When I set out to become an artist, in the process I was also becoming a craftsman, magician, and conjurer.

"The deepest art is in contact with eternal wisdom." (James Joyce) Entering the terrain of eternal wisdom requires perseverance, situational awareness, and a retentive mind. On encountering walls, one can walk around them, climb over them, or when the magic is with you, walk right through them. But when the spirit appears, there will be no cameras. My story is true.

PART ONE
THE CODE OF THE TRAIL

There is always a moment in childhood when a door opens and lets in the future.

—Graham Green

THE SPELL OF HIAWATHA

Growing up on North Street in Sault Ste. Marie must have somehow magnetized me with a built-in compass—I can always find north. North Street ran due north up to the top of the hill and ended abruptly at the bush. Following that line, my imagination soared beyond the trees at the top of the hill, up the rugged coast of Lake Superior, across CPR and CNR lines, over tall pines, logging camps, ghost towns, moose pastures, giant rivers, Ojibway and Cree villages, caribou herds, tundra, polar bears, walrus, the ice sea, and the people of the seal. I dreamed of magic to be found in untouched wilderness, up there, up the street, over the hill, and beyond.

On Saturdays, I ventured into the woods, looking for some sort of magic portal. I forged my own routes, plodding deeper and deeper each week through the tangled brush, always hoping to come across an abandoned cabin, a secret lake, a hill with a vista, or a village on the edge of time.

Friends and I rode our bikes to Hiawatha Park, north of town. The park, a landscape of rugged rock and white-pine-forested beauty, had the aura of a holy place. Nature became my religion. We stashed our bikes in the bush, then followed a streamside trail to Minnehaha Falls. Minnehaha was Hiawatha's wife.

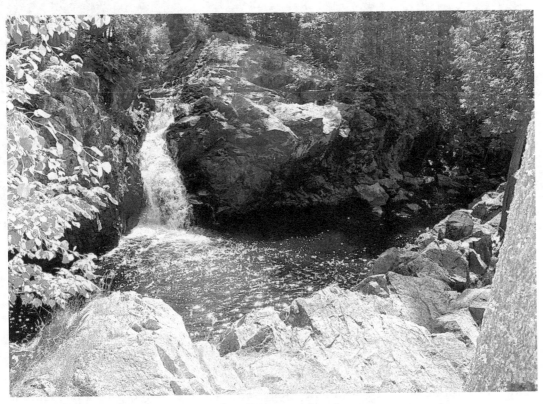

Hiawatha's personal pool

Minnehaha in Ojibway means "laughing water." Drinking out of the falls was said to make you giggle. Coming out of a long deep gash in Precambrian rock, the frothy water tumbled into a calm and secluded grotto ringed by tall fragrant pine trees. Pedestals, naturally notched on the surrounding cliff face, provided platforms of different heights for high dives into the dark pool below. Hiding under the falls, the shattering cascade muffled the giddy echoing laughter of carefree youth. We were sure that Hiawatha himself actually swam there. Hiawatha was a messenger from the Great Spirit, sent down in the character of a wise man and prophet who could perform miraculous deeds.

I still associate the name Hiawatha with that bubbly feeling of freedom, unconfined joy, and eternal youth. It's a feeling you want to seal in a jar, and open when needed. It's a feeling you want to carry till the day you die.

My father, too, had an adventuresome spirit. Alex Walton, according to his friend Norman Green, "had amazing perseverance, strength, and endurance. He was observant, and he had a retentive mind."

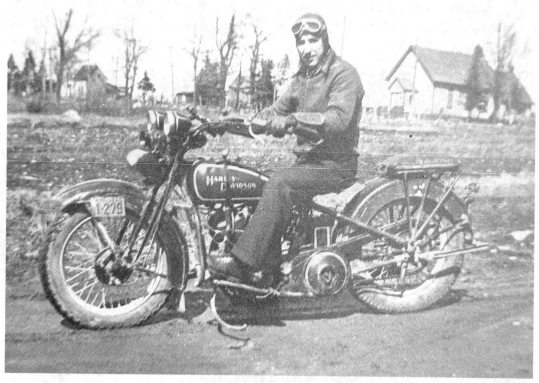

Alex Walton on his 1930 Harley

In 1935, at age twenty-two, Alex rode his 1930 Harley Davidson motorcycle from Sault Ste. Marie to Vancouver and back, with only a rolled-up blanket to sleep on and a pup tent for cover. The tent was held up by a rope, tied on one end to a tree and the other to his handlebars. The whole trip cost him $125. Gas was twenty-five cents a gallon, and a full meal and pie cost twenty cents. There was an unwritten code that you could get a bed for the night above a

Chinese restaurant for a quarter. Twice, where bridges were being built between Fort William and Kenora, he had to drive twenty feet above the water on a single plank. Only local maps, covering small parts of each province, were available. The roads were gravel, mud, or in many cases, just two ruts in the prairie grass. The only paved road in the west was forty miles between Regina and Moose Jaw. Sometimes he had to drive across bald prairie to come to the next road.

As my dad recounted, "I was told that I could take a short-cut to Rosetown and Kindersley to get back on an east/west road. After an hour or so the track just petered out and there was nothing to be seen up to the horizon. It was almost like a sea. There was little vegetation. Sometime later I saw someone on horseback. I rode over to him, and he assured me that I was going in the right direction. Later, at about four o'clock in the afternoon, it clouded over and started to get dark. A wind came up and, just as I got back to the so-called road, a dust storm started. It was just like a snowstorm, only black instead of white. I was very uncomfortable. There was no protection of any kind. I hadn't seen a tree of any kind all day and, since there was no sun to be seen, I had no real sense of direction. I rode on and stopped at the first farm I saw to get directions. I will never forget the look of abject despair and depression on that farmer's face."

Times were tough

Out on the lone prairie

It was the time of the Great Depression, the dust bowl. In Saskatchewan, he saw many families with all of their worldly belongings piled on hay wagons with children driving the cows, pigs, and chickens behind. They were leaving the southern part of the province and heading north.

He saw Indians on the move, their horses pulling travois, long poles extending back from the stirrups, and attached at the back with stretched skins supporting their belongings.

The dirt roads gouged into the steep slopes of the Rockies were often strewn with fallen rock. Leaning into a tight mountain curve, he suddenly came upon a group of about sixteen Indians mounted bareback on horses. Instinctively, he slammed on the brakes, and weaved to a skidding stop. As the dust settled, he first noticed the startled, stomping, black and white spotted pintos. Looking down on him, bare back, bobbing, bare-chested riders wearing only breechcloths were pulling back on their reins. Time stopped.

It occurred to him that some of those older mounted riders had likely participated in the buffalo hunts back in the 1800s. Actually, in 1935 there were Sioux and Cheyenne still alive who had defeated U.S. Army Colonel George Custer and all of his cavalry at Little Bighorn, due south across the Medicine Line (the Canada-US border) in Montana. Perhaps spooked from watching western movies of the time, Dad kicked it in gear, popped the clutch, and thundered away on his trusty iron horse.

My dad's stories gave me the urge to roam. "I'll never forget the huge western sky filled with stars," he said, "nor the overwhelming scent of grain at harvest time. In some places, you could still see evidence of the movement of the huge herds of buffalo that had mysteriously disappeared a generation before."

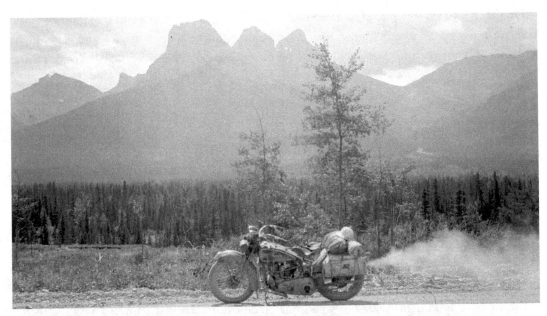

Alex's trusty Iron Horse

Where the buffalo once roamed

On that rocky mountain road, my father had actually wandered into a portal of long-ago time and space. My young imagination was fired, wondering if those pockets of time and place might still exist. My inner compass and clock was set to seek out places of magic, places out of time.

THE COWBOY CODE

Cody Public School sat at the top of Mofley Hill, overlooking the city to the west and the Canadian Shield to the north. Its high ceilings and large windows encouraged lofty thoughts. Framed prints of Group of Seven paintings of northern scenes adorned every classroom. Our art teachers told us that those paintings were done just north of where we were sitting. Those exotic landscapes encouraged me to draw, and my work took on the wobbly lines of ragged pine and Precambrian mountain ranges.

I must have been eight years old when our grade three class first trundled upstairs to the darkened Nurse's Room to see a film. The room had rows of stacking chairs that faced a large, white pull-down screen. A rattling Bell and Howell movie projector at the back of the room illuminated Canadian stories, landscapes, and peoples to an attentive audience.

The logo letters NFB (National Film Board of Canada) alerted my sense of patriotism, and the films stirred my sense of wanderlust. In rich black and white, wet and wily fishermen with weather-worn faces from Bonavista, Newfoundland, were being tossed about in their tiny dories, knee-deep in harvests of cod. The Netsilik Eskimos series showed the life of an Inuit family living among the caribou herds, stalking seal, and surviving the cruel winters in real igloos, and in the summer, in skin tents on the barren ground. For our class of wide-eyed kids, these films opened up our country for us. I wanted to discover this place called Canada.

The National Film Board movies felt real. Of course, we also loved the Hollywood movies at the Princess theatre on Saturday afternoons. There on the big screen, in Vista Vision, Panavision, and Technicolor, we swooned to the majesty of the landscapes, the stirring soundtracks, and the heroism of the cowboy. It was the age of the great cowboy movies, and my hero was Roy Rogers, King of the Cowboys. Roy was a brave and earnest man. He preached the Cowboy Way.

A good cowboy always followed The Code. Some called it The Code of the West or The Cowboy Code. I called it The Code of the Trail, resolving to always try to abide by my own take on the rules. A man's word was his word. A handshake and a look in the eye meant a firm deal. If a cowboy said that he was going to do something, no matter how onerous the task, he went out and did it, and he did it quietly and better than he said he would. After the job was finished, he kissed the girl, mounted his horse, and rode off into the sunset. He likely went back to herding cattle. That's what we figured he would do, anyway.

I wore the cowboy hat, the shirt, the boots, the chaps, the guns, and the spurs. A cowboy's life was the life I was destined to lead. In grade one, I learned how to do-si-do in a square

dance. On Parents Night, the ker-clanking of my loose spurs disrupted the beat for the rest of the dancers, causing confusion, collisions, and laughter from the crowd. My dad laughed the loudest. He had a great laugh. His laugh was so loud that my mother was too embarrassed to go to a movie with him.

To my disappointment, there would be no future job for me chasing little doggies, or drinking camp coffee by the chuck wagon out on the lone prairie where the coyotes howl. Whenever I got near a cow, I could not breathe. Whenever I touched a horse, my eyes swelled shut. Allergies.

The Indians in our imaginations and on the big movie screen seldom looked as real as the Cree and Ojibway kids living down the river at the Shingwauk Residential School. On Saturday afternoons, we often saw the Shingwauk kids getting out of a downtown movie theatre and straggling along in groups walking back to the residential school to be locked up for another week. We just looked at one another with childhood curiosity. The girls seemed very shy, often looking away. Some older boys looked me straight in the eye. But when their dark eyes looked back at me, I felt there was some kind of connection of spirit that was different from what I felt with my other friends. They weren't allowed to stop and talk. Their minders kept them moving.

The old and new Shingwauk residential schools.)

Whenever that school was mentioned by grownups, it was in hushed tones. Perhaps even then, there was a quiet collective guilt about what was happening to those poor children, who were literally kidnapped from their homes and families. I was too young to know about the horrors they were going through, living hundreds of miles from their homes, lakes, forests, seasons, friends, moms, dads, uncles, aunts, toys, and their beautiful and poetically descriptive musical languages.

My friends and I still played Cowboys and Indians, also influenced by shows from the new television station that had began broadcasting five hours a day—shows like the Lone Ranger and

Tonto. Roy Rogers reinforced the cause for justice and cowboy wisdom on the frontier. Davy Crockett, a bushman, also knew the code of the trail. He could "Grin a bar." That is, he could look a bear in the eye and confound it. We were being introduced to wonders and possibilities that our adult lives could provide far off in the future.

The first time I was seriously asked what I wanted to be when I grew up was on a local television show, called *Kiddies on Camera*. All you had to do was write them a letter and you could get on TV. It was television at its most basic, and live to air, so anything could happen. On this weekly program, about fifteen kids would sit in a semi-circle while a host squatted down, microphone in hand, and waddled at eye level from child to child asking questions on significant topics such as, "How old are you?" and "What do you want to be when you grow up?"

Once a kid told the host, local DJ Don Ramsey, "I have a secret."

"Well, tell us for the folks at home, Mary," Don encouraged.

"When Daddy is at work, Uncle comes over and sleeps with Mommy."

On my day for the show, I was impressed with another local hero. It was Bert Luciani, the cameraman. Bert was kind and friendly to this nine year old His job looked interesting. He held me up to the massive television camera and let me look through the eyepiece. I saw things in a whole new light, in black and white. I could see into people's faces. When the host finally lay the big question on me, "What would you like to be when you grow up, Lloyd?" I looked straight into the lens and said, "I am going to be a cameraman."

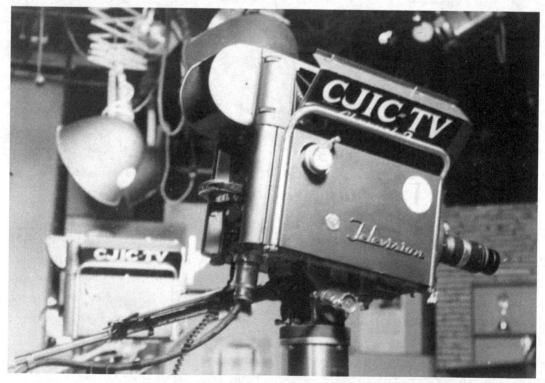

The majestic black and white television CJIC camera

CHASING THE MUSE: CANADA

A job in television made perfect sense to me at the time. I could naturally see my future and feel it. Who would have thought that I was speaking truth to all of those people watching?

I could never forget that cowboy code, though. I would come to have little tolerance for a person who looked me in the eye, said he was going to do something then backed out, especially after a handshake, and from time to time I still wear a cowboy shirt, belt, and boots. My travels have taken me up and down many twisted trails. The higher-heeled boots were practical for hiking and grabbing rugged ground. Wearing them, I felt more comfortable in the company of roughnecks, renegades, and even men in expensive suits. In later years, when addressing an audience while wearing a cowboy shirt under my sports jacket, or in the high-heeled boots associated with those heroes of old, my word had to be true. I would get the job done.

Who could have known that my first influences from such a young age—the Indians on the Rocky Mountain roadside, the spirit of Hiawatha, the Group of Seven paintings, the cowboy, the Shingwauk kids, The National Film Board, and the television station interview—would all resonate again and again in my life over the years?

Stay true to your dreams of youth.

—Alfred Adler

IMPERMANENCE

Upriver from the St. Mary's Rapids was my uncle's cottage at Moore's Point. Moore's Point was an anomaly—a cozy cottage community on the water, minutes from the city. The short commute through the steel plant to get there was an adventure in itself. Quiet tree-lined streets gradually morphed into the mountains and canyons of strange gigantic structures and sky scraping smoke stacks of Algoma Steel. To me, a wide-eyed child, the mills looked, sounded, and smelled like a strange hellish-grey foreign country. Men with blackened faces, hard hats, and dirty coveralls were in constant motion. Little trains dragging tall, toppling, tombstone-molds filled with sizzling molten ingots wound through and around odd-shaped buildings that spewed steam, smoke, and fire. Past the fuming coke ovens, out through Number Four Gate at Goulais Avenue, lake freighters were lined up, unloading cargoes of coal, limestone, iron ore, and pig iron. Further along the Base Line Road was the Dow Chemical plant with its signature pungent odors. That's where we turned left to climb the winding road across a desolate grey desert of slag.

We often stopped to watch the trains hauling the hot slag pots, their searing heat almost melting the windows of the car. Further ahead was a signpost on the barren horizon that directed us to our access road. At the bottom of the steep grade of the bleak mountain, we entered a tight-knit community nestled in a fragrant green forest. Welcome to Moore's Point.

Summer days of soda, pretzels, and beer

Moore's Point was an idyllic section of the Upper St. Mary's River coastline—beautiful, rocky, white pine-rimmed bays, and cozy cottages and camps. For kids, it was a place to roam free. For our parents and relatives, it was a place to party.

For me, the Nat King Cole song, "Roll Out Those Lazy Hazy Crazy Days of Summer," is the anthem of that time and place in the fifties and early sixties, and brings back so many memories. On Sunday afternoons, I could steal a sip of my grandfather's beer as he sat looking out at the ships passing by. Beside him, coming from the radio, the voice of Tiger Baseball, Ernie Harwell, would call, "A swing and a miss!" Between Ernie's colourful comments, were long intervals of stadium-crowd noises. I was transported into the ball park, downriver in Detroit.

My grandfather once turned down an offer to play for the Detroit Tigers. Surrounded by a young family, he told the Tiger scout that ventured up from Detroit that a job as a railway engineer would provide more security.

With fearful trepidation, we kids hiked along the woodland trail to Smuggler's Cove, a log-strewn sandy beach rimmed by dense wilderness. During prohibition it was used as a loading area for the night runs of booze boats delivering contraband across the river to the United States. Somewhere just off the trail lived a powerful old witch that people called the Swamp Angel. One of the big kids had seen her cabin and lived to tell about it.

Future boat captain

Commanding my own rowboat, I could be a lake freighter captain or a pilot edging a floatplane into dock. When the Abitibi tug passed by towing a massive log boom down from the mighty Lake Superior, we swam out in crystal clear water to ride the stray logs into shore. They later became free firewood for our marshmallow roasts.

We knew all of the ships by their smoke stacks and distinctive haunting whistles: The *Sykes*, the *Republic*, the *Keewatin*, and the *Assiniboia*. Their deep resonant musical bursts, day and night, provided rhythm to those carefree times. The whistle of the twice-weekly passenger ships signalled an armada of boats from the bays, roaring out to wave to the passengers and ride the huge rolling swells in the ship's wake. Or we motored downstream to the ore docks to see the freighters up close, avoiding the steady stream of orange and grey gooey water gushing from the humming steel mills into the St. Mary's River. To a nine-year-old's eyes, this was confusing. How could smart people do this?

On foggy nights, the air seemed to ignite, creating an eerie orange glow. My Uncle Chum explained to his credulous nieces and nephews that the Swamp Angel's house was on fire. It was really the atmospheric effect of the molten lava like rivulets rolling down the ever-encroaching grey mountain of slag.

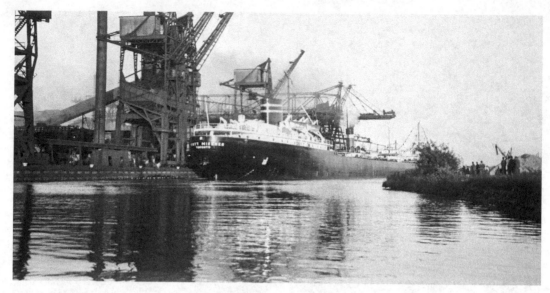

The Algoma Steel ore docks

Alas, the steel plant had enormous economic influence, and it eventually arranged to expropriate all of the cottagers from the area. The Moore's Point community was smothered under a barren plateau of dead, grey, powdered rock and chemicals, immediately beside the city's drinking water intake.

For me, it was an early lesson in injustice and impermanence. There was little or no protest back in those days. I didn't understand why people just accepted their fate. Losing that paradise to the smoke and fire-spewing giant didn't make sense to me. I felt terribly helpless. Were giant killers found only in story books? What kind of a cowboy would it take to ride in and halt the moving mountain and save the day? I hoped to one day be that kind of cowboy.

And what became of the mysterious Swamp Angel?

TO FLY

The mile-wide St. Mary's River held keys to the past, the present, and my future. Before the first white Jesuits and traders canoed into town, the 4,000 Ojibway inhabitants on both sides of the river called the place Bawating, the place of rapids. It was renowned throughout what we now call North America for the abundance of whitefish. Bawating was talked about in places as distant as the mouth of the Mississippi and the headwaters of the Athabasca. The whitefish were so plentiful when spawning, it was said that one could walk across the rapids on their backs.

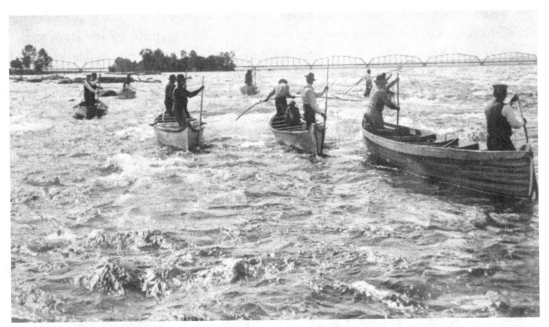

Indians navigating the mile-wide rapids (Public Archives of Canada)

Before the rapids were dammed, my grandfather told me that you could predict the weather by the sound of their roar, which could be heard ten miles away under certain atmospheric conditions. On foggy summer nights, the lake freighters' whistle blasts would hooooot and moan, echoing off the distant hills.

Down by the river

I often biked down to the river to watch the lake freighters slowly chugging upriver, inching into the American and Canadian locks, en route to Duluth, Port Arthur, and Fort William. On their downriver passages they passed more briskly in the strong current. They fed my burning urge to roam to places with exotic names like Toronto, Detroit, and Montreal.

The waterfront was also a hive of aviation activity. The Department of Lands and Forests main air base was on St. Mary's River. Up to fifty float planes were serviced there over the winter. Right in front of me over the water, the Lands and Forests flight engineers were developing the very first water-bombing aircraft to be used for fighting forest fires. To me, their throaty engines sounded like music when they took off.

In public school, the silence of the classroom was often shattered by the overhead roar of the thumping pistons of the Forestry float planes as they climbed with their heavy loads to service ranger bases all across the north. Our school was perched on a hill directly under their flight path. From my desk, I could watch the yellow bush planes disappear into the vast horizon of the distant hills. Flying represented to me the ultimate freedom. I sketched myself, hands on the controls, looking down on winding streams, watching confused moose, floating through the puffy clouds, into the deep blue northern skies.

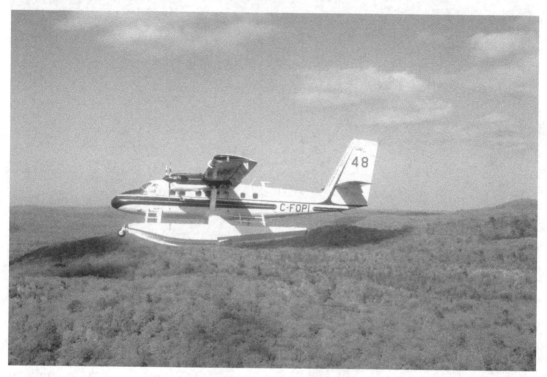

Department of Lands and Forests' Twin Otter

I imagined myself being on high-alert in my RCAF flight suit at a remote Royal Canadian Air Force fighter base on Hudson Bay. This was during the Cold War, and I sat poised for an invasion of Russian bombers. Red lights flashed, the siren wailed, and the scramble was on. While still climbing into the cockpit, my Avro Arrow was firing up and automatically moving along a track to its launch position. By the time I was strapped in, helmet secured, and canopy locked, I was unhooked at the end of the runway and released to go. Two minutes later, with the snowy night 60,000 feet far below, I was heading for the stars in my Arrow, accelerating to three times the speed of sound.

The mighty Avro Arrow

When my grade eight teacher asked me what my ambition was, I told him I wanted to fly with the Royal Canadian Air Force aerobatic team. At that time, they were called the Golden Hawks. He folded his arms, leaned back, and looked up at the ceiling so all I could see was the whites at the bottoms of his eyes. He then bent down over me and said, "You of all people should learn to never set your sights too high. A pilot has to have excellent skills in arithmetic. You would really have to pull up your socks in that department."

My heart sank, but inside I just knew that he was wrong. I have always hated to be underestimated. Inside, I just knew I would fly with the Golden Hawks, after becoming a bush pilot first. I would show him someday. I was a stubborn kid, aided by a strong will, and a strong belief in my dreams.

LIFE LESSONS IN HOCKEY

Behind our house was the North Street outdoor rink. On cold winter days, we heard the cracking sound of ricocheting pucks echoing off the boards, and the sharp hiss and schussing of skates cutting into the ice during Saturday morning shinny. Shinny was generally a very democratic sport. Hockey sticks were thrown into a pile in the middle of the rink and the smallest kid dealt them like cards to each side of the imaginary centre ice red line. Every boy there, including me, dreamed of being in the NHL. Unknown to us all, we were learning valuable lessons to carry on into life.

I will never forget one sunny frosty Saturday morning at the North Street rink. I was the smallest kid on the ice, and still unsteady on skates. The big guys put me in goal. That day, there was a master skater and puck handler on the other team. He was from the west end, the

Italian part of town. This true wizard of puck control was visiting a cousin, and was new to our rink. All of the players on both teams were in awe of him. He was a joy to watch. They called him, "Philly."

Early in the game, on a breakaway, Philly whistled in on me, stick-handled left right, left right, left right, sending me sprawling in one direction, and my stick in the other. He stopped and tapped the puck against my toe and said, "Nice save, kid."

That gesture gave me the confidence to actually make some real saves later in the game. Philly was a hero to me, and to all of the other players.

Every night, the North Street rink scheduled hockey from five till seven, skating till nine, hockey till ten, then lights out. On weekends I skated with friends, then played hockey and, then, after everyone left, I would dipsy-doodle from end to end alone in the dark, stick-handling the black puck on the white ice. Lying down on the ice and looking at the stars in the crystal night air, I listened to the Algoma Central Railway diesel engines far in the distance as they strained and pulled the long line of empty ore cars up over the height of land and into the rolling hills en route to Hawk Junction, Wawa, and Michipicoten Harbour. Around midnight, I walked home in my skates, squeaking sounds amplified in the minus-twenty temperatures. One day I dreamed I would wear the red, white, and blue Canadiens sweater worn by the likes of Jacques Plante, Maurice Richard, and Boom Boom Geoffrion.

Future NHLer

I played left wing for the Cody Public School hockey team. We had to walk across the city to all of our after-school games with our duffel bags, skates, and hockey sticks slung over our shoulders. The games were all played on outdoor rinks. After the games, I walked home. Upon arrival home, I was greeted by a list of irate callers, angry at not having received their *Sault Daily Star*. After a quick bite, I had to walk eight blocks to pick up my papers, then walk another fifteen to finish my route.

On Saturdays, when I did my route collecting, I was often invited into my customers' living rooms to wait as they rooted around the house for loose change to pay me. Standing in doorways and hallways I learned a lot about people's behaviour and circumstance.

One family on my route, the Coghills, did not have a television. A silver-painted pot-bellied stove stood against the wall in their living room. The family of nine would be seated in a semi-circle around the stove at suppertime. Open cans of creamed corn or beans sat heating on top of the stove. A baby, who resembled Popeye's Sweet Pea, crawled on the floor holding a rubber nipple in her teeth--which was stuck on the top of a 7UP soft drink bottle. The milk in the bottle took on a green hue. Food from the hot cans would be spooned sparsely onto waiting plates.

There was often an older woman visiting the family at suppertime. She was from the nearby First Nation reserve at Garden River, just east of the Sault. Her name was Rosie. She had a reputation among older men in town. I didn't like the way big people in town talked about her. With her dark, dark eyes, Rosie didn't just look at me, Rosie looked into me, but with dignity and curiosity. Rosie, a tiny woman, had a large beak-like nose, only a few teeth, and eyebrows that met in a deep dark V. I hadn't heard of the word aura at the time, but she had it. An electric current seemed to radiate from her. Her eyes said one thing but her face said another. (Could she be the Swamp Angel?)

Whenever I went to collect *Sault Star* money, Mr. Coghill, a poor but gracious man, always gave me a tip. The people down the street, who had a jumbo 23-inch television set, seldom tipped.

I switched from left wing to minding net for the Crusaders in the Soo Midget Hockey League. The Crusaders wore the Montreal Canadiens sweater with the C on the front. I was on my way to the NHL.

In our opening game of the season, three musical sounds kept me in the game. First, the sharp, echoing PING of the puck bouncing off the goal post. Next was the TOOF of the puck ricocheting off the toe of my outstretched leg. The best was the ringing RAP of the puck hitting the skinny end of my stick, which I had thrust toward a shot from a streaking forward on a breakaway. Late in the third period, the puck flipped over my head and dropped down behind me. Frustrated, I skated out and said "Sorry, guys," to the defensemen, who were smiling at me. "No goal," said the ref, as he picked the puck out of the ridge of the kidney pad protecting my back. I think the puck was actually caught on the horseshoe coming out of my ass.

Sault Star sportswriter Tom Keenan wrote of me, "A fine net minder who shows all indications of becoming one of the better goaltenders in the league." I had trouble pulling my sweater over my head after that.

"Success has ruined many a man," said Thomas Edison. Friends and family all came to watch the new superstar's next game. I let in eight goals. In those days, there were no such things as goalie coaches. A goaltender learned by his mistakes, and that night I learned eight great lessons.

The Crusaders were a good team. We made it to the final game of a hockey tournament in Sault, Michigan. Late in the third period of that big game, I heard a whistle and, thinking the play was over, I stood and watched someone skate in and score. It was an easy stop, but I was sure I heard a whistle. We lost by one goal.

Game over, I had my head in my hands, sitting in the dressing room, mentally replaying that stupid mistake. In walked Scotty Bowman. Scotty Bowman, coach of the Montreal Junior Canadiens, and scout for the Montreal Canadiens. Scotty Bowman...future multiple-Stanley-cup winner, Les Canadiens! My team! Mon équipe! I pulled myself together and sat upright.

Mr. Bowman walked straight towards me, reached into his wallet, and pulled out his card. The beloved red CH image flashed as it went right under my nose. Michel Paquin, our secret import from Quebec, sitting on the bench beside me, gratefully accepted it. Scotty said to him, "I would like to meet your parents."

Maybe I gave up too early, but sadly, a light went on in my head. I wasn't going to be a professional hockey star. I can justifiably say, though, that I really did sniff the big time. The big CH passed right under my nose.

Fast-forward twenty-eight years, I was boarding an Air Canada flight out of Sault Ste. Marie and, to my surprise, I sat down beside the fast forward, Boston Bruins superstar Phil Esposito; "Philly," as we called him as kids. Philly scored a record 76 goals in one NHL season. After we were airborne, I looked at him and said, "Hey, I've played against you."

He looked at me. I could see him wracking his brain through thousands of professional games. I grinned, "The North Street outdoor rink." I reminded Phil about the time he tapped the puck against the toe of my skate.

He laughed, shook his head, and said, "You know, playing shinny in the Sault was the most fun I ever had playing hockey."

In the resonance of his reply, my secret remorse for not making the NHL completely evaporated. The youthful freedom of playing shinny outdoors is as good as it gets.

I told that same story about my hockey ambition to my friend Dennis Hull, a Chicago Blackhawk, brother of Bobby Hull, and member of Team Canada in the 1972 Russia series. Dennis, in his wisdom, added that maybe I didn't make the NHL because he and his brothers played on the outdoor rink till two in the morning, not midnight. "You quit too early," he laughed.

Hockey gave me many more skills I needed to live the code of the trail. A goalie has to be a mind reader, to analyze his opponent's plan of attack. What is his plan to get that puck past me? A goalie has to be vigilant, fearless and withstand pain. A netminder has to be a dancer, dancing to the shifting rhythms of the game. A goaltender has to be an acrobat, springing and flinging arms and legs in every direction with lightning reflexes. In the future, those reflexes would help keep a canoe upright at the top of a rogue wave on big water on a black night, catch an expensive camera lens rolling off a cliff edge, and even snatch me from the jaws of death.

Another important lesson? Don't let what they say about you in the press go to your head. And thank you, Dennis, for "Don't quit too soon." And, for the record, I really did sniff the big time.

One more thing. Grownups often referred to the thousands of Italians that lived in the west end, the poorer part of town, as wops, DPs, and other derogatory names. But to us kids, they were our friends. They were fun to play with, good at baseball and hockey, and they kept my game up. From a very young age, joyfully playing together, we kids ignored the cultural condemnation happening in the older generation. I knew it was wrong. What could I do about it? What would I do about it? Then there was Rosie from Garden River First Nation. Her eyes weren't a plea but a command.

A TASTE OF THE NORTH

From my desk in high school, I had an even better view of the Lands and Forests airbase. Beaver and Otter aircraft were constantly taking off and landing down below, out on the river. Every spring, the whole fleet emerged from the hangar to go through their control checks, while dodging ice pans, running up their engines, checking the left and right dual ignition, turning into the wind, throttling up, and lifting off the river, up, up overhead, then soaring into the faraway hills. Just as at public school, the classroom windows and desks reverberated as the planes climbed cloudwards, especially in May and June, the heavy fire season. They were flying to freedom and adventure, and so was my mind. And my pencil flew, too, sketching on the blank parts of the pages of my notebook.

A genuine taste of the real North came with my first summer job at Montreal River, 139 kilometres north of the Sault. I was fifteen years old. One Sunday in late June, my dad drove me up the highway and dropped me off at a construction camp deep in the Algoma hills. I signed in for my lunch pail and blankets. A French-Canadian camp foreman led me to my bunk and showed me where to eat and wash up.

Before the wakeup siren whined, a line of sleepy workers stood in the dark morning mist, waiting to enter a long, log lean-to structure. Inside, in the dim light, ten coughing and grunting men sat side by side hunched over a rough-hewn log, with their pants pooled around their ankles. Trembling nicotine-stained fingers clutched packs of cigarettes or a chewing tobacco stick in one hand, and in the other, a roll of toilet paper.

The breakfast siren went off at five o'clock. We had thirty minutes to eat, then a bouncy half-hour diesel-fumed ride in the back of a two-ton truck to the construction site. I sat squeezed on a wooden bench, rocking back and forth in a sleepy daze among heavy-smoking labourers from the Gaspé region of Quebec. "Dey were happy gars."

Arriving at the construction site, the squeal of the brakes woke me. Clutching my lunch pail under my arm, I jumped to the ground and my hard hat went flying. I chased it, wrangled

it, then slapped it on, trying to look cool. The new dam loomed up, way up, high overhead. Steel construction rods shot out of the concrete back wall of the new structure like it had been attacked with arrows. Ten-foot-long planks were laid across the rods in a pattern to make a zigzag trail up to the top. With tenuous steps, focusing on the bouncy boarded footpath, clutching my lunch pail and trying not to faint, I advanced, terrified of stepping off into the abyss. On my first morning, not one minute after I arrived at the top, still gasping for breath from my fear of heights, a concrete dumping bucket dropped off its crane and bounced over the edge. It fell, snapping and smashing the planks that I had just climbed. A few men were scooped up at the bottom and rushed away in the truck. My French was not good enough at the time to hear what happened to them. I was afraid to find out, anyway.

To my ears, Quebec Gaspésian French was a different language than the Parisian French we were taught in high school. As an example, the word "jamais," meaning "never," was pronounced "jaw miss." So the foreman and I had a communication problem. He was asking me to do things I had *never* done before. I was transferred to the blacksmith shop back near the camp.

The low-slung tarpaper blacksmith shack sat in the most majestic of landscapes. Looking out the front door, the Montreal River came around a bend in front of a pine-crested, twelve-hundred-foot-high granite cliff. Right there in front of me was the very spot where J.E.H. MacDonald of the Group of Seven sat and painted his sketches for the iconic *The Solemn Land*. And there it was, facing me. Looking to my right was where he painted his sketch for the equally famous *Montreal River*.

Back in school, those same scenes had inspired my endless doodling in sketchbooks and notebooks. Was my being here the result of conjurings from the end of my pencil? I was too young to acknowledge this notion at the time. But I have changed since then.

The blacksmith shop was a social hub for the construction site, hosting a cast of colourful characters drifting in and out through the ten-hour work day, six days a week. One of these was Big Jack Ansley, who in his white five-gallon Stetson would regularly duck in to hide from the camp foreman. Unlike the other workers, he was always impeccably dressed. His fancy cowboy boots always had a shine, his pants neatly pressed. Big Jack had the John Wayne stature and swagger. I'm not sure what his job description was. He always seemed to be on the move. His eyes shifted from door to window and back, as though he was being hunted by someone or something.

But he sure was an entertainer. With one bloodshot eye to the window, and the other to stuffing his Copenhagen snuff between his teeth and lower lip, you could see his mind winding up to begin his daily address. Dramatic pauses with lurching tobacco spits gave cadence to his tales of gamblers and horse thieves, bank heists and chicanery. Jack was a man from a bygone era. I found out later that Jack, who was an ex-cop, died while hitchhiking. He was standing too close to the highway and a fast-moving truck mirror clipped him hard.

My boss, blacksmith Wes Carrol, spent his life as a millwright in bush camps all across the North. He was moody if provoked, as I soon found out.

Many times every day, Wes Carrol took the red hot metal out of the fire and rotated it on the anvil in front of me. My job was to hammer it into form. In swinging the twelve-pound

sledgehammer, the arc had to have power and accuracy. If I missed the red-hot piece he held in his gloved hand and hit the anvil instead, the heavy hammer head bounced straight up with a loud PING, just missing his face. "Christ!" he screamed, and I shivered. I didn't blame him for being cranky, or shaky. His nerves were shot. Eventually I got it down to only a few missed pings a day. He was also prone to the shakes, but he had a good heart.

After a few weeks, Wes started to tell me about his life. He worked once as a millwright for the CPR in Schreiber, on the north shore of Lake Superior. One night in the 1930s, a bad storm caused a washout, sending a steam locomotive into Lake Superior. His job was to recover the body of his best friend, engineer Frank Wheatley. After building a cofferdam and pumping out most of the water, they found Frank's body impaled on the engine throttle. Wes had to crawl down beneath the corpse to guide it out. Just as the throttle eased out of the gaping wound, Frank Wheatley's railway watch fell through the cavity and dangled in front of Wes's face. Wes instinctively pulled on the watch, causing all of his buddy's guts to rain down on him.

The CPR sent Wes to a hotel in Fort William with a case of rye whisky, and gave him a week to get over it. Wes drank himself to the DTs, a frantic delirium similar to withdrawal from heroin. For the rest of his life, he fought the bottle and the DTs. Old Wes was giving the kid a good lesson on the ineffectiveness of alcohol to soothe anguish, and to forget. To this day, whenever I am tempted to use alcohol as a crutch to ease anger or sorrow, I think of old Wes.

In the evenings I hitchhiked down the mountain to the shore of Lake Superior to watch the sunsets. Looking across 350 miles to the farthest shore, Superior had the feel of an ocean. It is in fact, an inland sea.

Lake Superior

Devil's Warehouse Island, Lake Superior

The northeast coast of Superior has been called "The Haunted Shore". Graced with that inauspicious name, its islands and bays have been charged with tales of the supernatural since long ago. Off to my right in the distance, a long blue peninsula pointed out to the horizon.

Looking north from Montreal River)

On that peninsula, about twelve years previous, archaeologist Selwyn Dewdney came across ancient rock paintings, and the story made quite a splash in the local paper. The discovery was heralded as a mysterious ancient place of power. Sitting there on the cobble beach, the distant rock face smouldering in the evening light had a magnetic effect on my imagination. A subliminal compass locked in.

The surf music craze was hitting big that summer with the sounds of the Beach Boys and Jan and Dean. Songs of California Girls, sunny beaches, Malibu surf, cool cars, and endless summers blasted from car radios. The waves pounded, and I dreamed. Oh, to live in California. Lake Superior became my Pacific Ocean. Watching the big waves roll in, I imagined myself out there catching a wave, getting up on my board.

I was only fifteen, turning sixteen, but I had been accepted into some unusual circles of characters—some renegades to be sure. That felt good. But when a bush plane swooped down, taxied to the dock in front of the blacksmith's shop, boarded some bigwigs from the power company in the Sault, and then took off over the hills, I was ecstatic.

The Beaver, workhorse of the north

There I was, at fifteen years old, living in the north-woods dream-world that I had conjured in my mind when I was at school, drawing while the teacher droned on about English grammar and usage.

The cookhouse, clerk's shed, blacksmith shop, garages, and sleeping quarters are all gone now. Today a thick forest of jack pine and alders hides the imprint of a once-thriving community of five hundred men. Off in the distance, the real *Solemn Land* from J.E.H. MacDonald's iconic painting still reigns.

All along the rugged coastline of Lake Superior, the cold waves lap and pound relentlessly. Alone by the shore, I whiled away those long twilight evenings skipping flat-bottomed, round-topped stones off the tops of waves, out toward my Pacific Ocean dreams. Around the cove to my left was the cabin that Group of Seven artist A.Y. Jackson used while painting his famed Algoma masterpieces. And to my right, that long westward-pointing peninsula, holding its mysterious images of red ochre bonded into the stone. There is energy in a mystery, and eternity in art. That energy began to smolder deep inside me.

mysterious images

SITUATIONAL AWARENESS

Through diligence, dedication, and good teachers, I won a flying scholarship from the Sault Air Cadet Squadron. At age seventeen, I boarded a train for Windsor, Ontario where I would learn to fly. At ground school and in the cockpit, I learned that the freedom of flight comes with a great deal of preparation, planning, concentration, and practice. Two weeks after my arrival in Windsor, on a hot July evening, I got the nod for my first solo.

"OK, Lloyd, you're ready. Take her up yourself." These few words led to immense exhilaration.

As the wheels left the ground, I kept glancing at the empty seat beside me. If only my grade eight teacher could see me now, scoring the winning goal, winning the lottery, drinking the laughing water, falling in love, flying a plane. I practiced a few steep turns, looking straight down over my left shoulder at the lake freighters heading up Lake St. Clair, then turned toward Detroit and radioed the Windsor tower that I was coming in.

To enter the landing zone, my first instruction from Windsor Air Traffic Control was to begin my descent to 1,000 feet. Next, I was assigned the number-seven spot in the landing pattern. (Wow, I had to find six airplanes in the sky!) I began searching the sky, counting aircraft, to

slip in line behind number six, a twin-engine Piper. This was on-the-spot learning of another very valuable life skill: situational awareness. Off my right wingtip appeared a Canadian Pacific DC-8 airliner in a wider circuit, inbound from Mexico City. When he radioed, acknowledging my presence, I blushed.

Pilot at last

A year later, at home at the flying club on the river, I obtained a float endorsement for flying seaplanes. One windy autumn day, I took my little sister Brenda for her first airplane ride in a rented underpowered Aeronca Champ on floats. It was the kind of airplane that you had to start by hand. To start the engine, you stand on the float and flip the propeller by hand. I hated doing that—it scared me out of my wits. This particular time, after Brenda and I were strapped in, a dockhand flipped the prop to fire up the engine for us. We pulled away from the dock, headed upstream and, after control and engine checks, lifted off. I took her up and around the city, circling our house a few times, then turned back down river towards base. A strong tailwind brought us back to base very quickly.

The landing spot where the river narrows by the air base was very short, and due to a strong cross wind, I decided to try a test landing on a larger open body of water, descending in front of the Garden River First Nation Reserve. The Aeronca hit the white caps, clipping wave tops with a bang, bang, bang on the pontoons before settling down in a heaving, rowdy, rocking motion.

When I re-applied throttle, the engine sputtered and stalled. For the dreaded restart, I to go out into the wind and walk along the wave-washed floats to flip the propeller. When I opened the door, a blast of cold spray filled the cabin. Moving forward, hand over hand, heaving up and down, and carefully gripping all of the handholds, I made it to the solid handle on the engine cowling and braced my feet. With my free arm, I gave the prop my best shot, and the engine fired up. The wind from the prop wash sped my way back. Just as I buckled in, the engine stalled with a clack, clack, clack, and hiss. Alarmingly, we were being blown closer to the looming rocky shore.

I reset the throttle to high so it wouldn't stall out and quickly climbed back out into the wind and the rocking. I grabbed the prop and flung. The engine fired up with a full throttled furious, whaaaaaa! The sudden violent prop-wash blew me out backwards over the water, arms up over my head.

In an airborne zeptosecond, the first thing I saw was a flash of white sky. I watched sister Brenda taking off in a plane with no pilot while I hurtled into the abyss.

Wham! My outreached hands caught the oncoming wing strut as though it was a trapeze swinging up from behind to meet me. Instinctively my body continued the movement using the rotational momentum like an acrobat to fling me through the open side door and into my seat. I turned into the wind, took off, circled the base, and slid a picture-perfect landing on a small patch of calm water. While I was tying the pontoon to the dock, a stranger came down and said, "Nice landing."

To this day I wonder why and how I was snatched from oblivion. Was it the lightning reflexes practiced from snapping ninety-mile-an-hour pucks out of the air? The acrobatics from performing a toe save at the top corner of the net? A life-and-death lesson from hockey? Was there an angel guiding me to a greater purpose?

That purpose would not be with the Royal Canadian Air Force. In applying for a military career, my mathematics scores were too low for supersonic flight school. I was stunned for about a week.

Inside, it was still satisfying to know that I had done it. I can still say, "I'm a pilot." Re-evaluating my future career, I would learn to adapt the skills of preparation, planning, concentration, practice, and situational awareness to another field—art.

A TALENT UNCOVERED

Art was always my best subject in public and high schools. When I learned that I couldn't join the Royal Canadian Air Force, I fell back on the notion of being a great artist like Andrew Wyeth. Wyeth painted haunting solitary objects and landscapes that compelled me to look deeply into the mystery and think. When the painting is done right, trying to solve that mystery engages

an interesting form of energy in the viewer. Good art will do that, whether poetry, writing, film, music, or painting. And when I saw painter Edward Hopper's work, it made me think something was just about to happen. Hopper was the artist who said, "If you could say it in words, there's no reason to paint it."

After walking home from Air Cadets wearing a kilt on a sub-zero February night, I thawed out watching a black and white program, "Quest," on CBC Television. The set was a makeshift northern bunk house. Men with rugged weathered faces, just like those on the men I had worked with in Montreal River, sat on their bunks and smoked. A few played cards in the corner. A rough-looking young man in work clothes was walking around singing and playing guitar. This minstrel was delivering messages in a poetic rhythmic language as though he had been touched a powerful spirit. He was singing songs and stories using words and phrases I couldn't fully understand, but I felt they rang true deep inside me.

His words and music cut through me like few poems had never done. In the tender, longing love song, "Girl from the North Country," he sang, "Where the winds hit heavy on the borderline."

I knew those winds. I lived on that borderline.

Another song was about how we felt when we were young, "We thought we could sit forever in fun." It carried me back to those carefree days under Minehaha Falls at Hiawatha Park.

"At last," I thought, "Someone from around these hills has connected to a new truthful musical vision." Most music that talked about our area didn't mention the dark side. Hearing lines like "Pellets of poison flooding their waters," reminded me of what happened when the slag-dump crept over and smothered our beautiful Moore's Point paradise.

By his sound, and his look, I guessed that he must have grown up just north of the Sault. He definitely had the north in him. He had to be a local. In a way I suppose he was. He grew up just a half a degree in latitude north of me, but on the other side of Lake Superior. His hometown was Hibbing, Minnesota, and his name was Bob Dylan.

Times were a-changin'. Bob Dylan's bold and defiant attitude and ideas, projected through the poetry of his songs and revised ancient folk melodies, awakened and bolstered my own feelings of confidence and self-reliance. If he could do it, I could do it.

I wanted to make great art, and I was ready for a great teacher. It would be Marilyn Guerriero at Sault Ste. Marie Collegiate Institute. She opened up the world of classical and modern art to astonished students from a steel town. We learned that true art could be subversive, beautiful, graceful, profound, inspiring, or all of these at the same time. It was the subversive idea that grabbed me. Spanish master, Goya, turned me on to that concept in his portraits commissioned by royalty. Painting the aristocracy, his patrons, with shortened foreheads and elongated jaws—his subjects had no idea that they were being laughed at.

Hearing Bob Dylan's song "Like A Rolling Stone" for the first time was like opening a jar and having a genie pop out. The crack of Bobby Gregg's first snare drum beat, hitting like a rifle shot, followed by a blazingly delirious fanfare and Dylan's explosive sneering pronouncements in defiant tumbling, taunting riddles, was transformative. It sounded important, and it was

beautiful. Played loudly, the immersive experience of that song's elusive meanings opened my mind to the meaning and power of art. "Like A Rolling Stone" bursts with the exhilaration and glory of youth I felt in that pool of laughing water in Hiawatha Park. I was transported back to the teenager I was, looking backward, forward, sideways, up, and down.

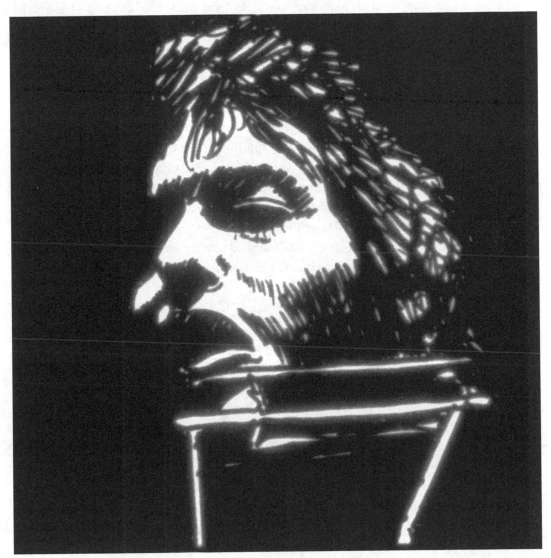

My sketch of fellow northerner Bob Dylan

How does it feel?
To be on your own
Like a rolling stone

(Dylan, "Like a Rolling Stone")

The spirit in the song "Like a Rolling Stone" gave my mind, will, and spirit permission to keep dreaming big. The expression of freedom in Robert Service's poem "A Rolling Stone" came calling again, and this time, as a promise.

When I was eight years old, our family took a summer vacation to the Canadian National Exhibition in Toronto. Down the road from the CNE, I was captivated by the lighted, wooden carnival roller-coasters and the classic merry-go-round atmosphere at the Sunnyside Amusement Park on the shore of Lake Ontario. From the back seat of my dad's '53 Chevrolet, I pointed to a building across the road from Sunnyside Park and announced, "That's where I am going to live someday."

Thirteen years later my parents drove me to Toronto to start life as a student at the Ontario College of Art. My new address—a boarding house—was 46 The Queensway, the very building I had pointed to so many years before, directly across the road from the Sunnyside Amusement Park. It made me wonder, at the time, about whether dreams exist only in your head. My mother thought that Art College would teach me to make those signs we used to see at Kresge and Woolworth Stores announcing "Thanksgiving Sale" or "Dishes 1/2 off."

I enrolled in the four-year Advertising course. Advertising was going through a creative revolution. Nothing works better than a great idea. It seemed terribly exciting to learn a science and trade that rewarded art directors for overturning the last forty years of advertising techniques. Consumers were not all seduced by showiness.

Volkswagen's great advertising campaign, for example, had everyone talking and taking notice. Before Volkswagen's ad for the Beetle, nobody had ever sold a car by saying, "Think small" or by referring to their product as "ugly". Volkswagen's ad agency got people talking about, and taking notice, of the Beetle.

Surrounded by highly talented artists at OCA, I honed my skills doing homework four hours a night, six nights a week, just to keep up. Being from out of town, I was in some ways a foreign student. Most of my classmates were from Toronto and had their own lives, so I was undistracted.

The first essay I wrote was about the 15,000-year-old cave paintings found near Lascaux, France. To me it was a eureka moment, learning that those hunters and gatherers used their pictographs to conjure successful hunts. I could see a future in experimenting with the art of conjuring.

Projects at the Ontario College of Art were handed out with a long list of strict rules. Over time, I learned that my best marks came when I broke the rules creatively. As a cowboy would say, "Do what they ask, but do it better than you said you would."

I would also add, "And do it 'more differently' than they could ever imagine."

All-night radio was becoming an art form in Toronto. Perfect for drifting into other realms while hunched over a drawing board, CHUM's all-night disc jockey, David Pritchard, rewrote the book on radio programing. His hypnotic progression of ideas, music, words, and sound starting at midnight, opened up the night to sonic dreams and adventures. The possibilities of sound design fired my imagination.

At about the same time, in theatres all across Canada and around the world, a new documentary appeared. It was called *A Place to Stand*, directed by Christopher Chapman. This highly creative multi-image film was Ontario Pavilion's premier feature at Expo 67 in Montreal. It amazed me that an image, combined with the right sound, could produce either chills or tears of joy. There wasn't a real story, but I was sobbing as I watched his combination of interesting pictures, stirring music, and the timing and use of well-recorded sound effects. I returned from the magical Montreal World's Fair, burning to learn how to make beautiful movies with great soundtracks. Christopher Chapman won the Academy Award that year for *A Place to Stand*. I had found my calling.

My high-school art teacher recommended me for a fill-in summer job doing television graphics for CJIC Television in the Sault. After a job interview, followed by a month of study and practice of hand-lettering, I began a job where I raced to work in the morning, grinning all the way, and kept grinning and laughing for the rest of the day. After work, I drank draft beer in the local watering hole, The Vic, and watched the bar TV to see if anyone reacted to my latest creation. Seeing my artwork out there in the public was pretty cool—and provided instant audience feedback. As a future filmmaker, I couldn't have asked for a better experience.

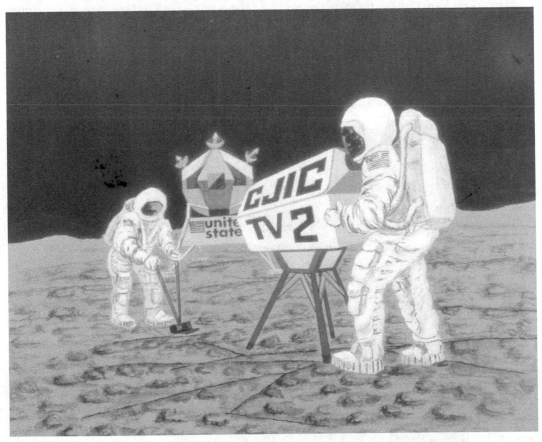

A station identification I painted to be televised the night Neil Armstrong first walked on the moon

Surrounded by talented people in radio and television production, it felt like an idyllic job, joking around all day at the drawing board. But most of all, it was the trust and respect given to me, a young artist. Everyone at the station encouraged and nurtured my creative confidence. People looked at my work and responded. I was learning how to conjure an original idea, and then deliver it.

GREY CUP FEVER

By guile not strength.

—Royal Marines Special Forces Branch

The art school world of the late sixties basked in a swirl of optimism propelled by the British music invasion and the psychedelic hippie movement, and drugs were everywhere. Although it was tempting to try mind-expanding drugs to find the magic, I kept my nose poised over a hot drawing board, hoping for the magic to come from the end of my brush or pencil. As it was still in my nature to roam, I took a few side roads and detours to find inspiration away from class. Life is in the detours.

I tracked down an old girlfriend whose family moved away from North Street when we were both nine years old. Elizabeth and I had exchanged a few letters over the years, but had no other contact. I knew that she still lived in a town somewhere north of Toronto. A few phone calls got us connected. Her soft voice fired feelings I had long forgotten.

"Oh, Lloydie, Lloydie, how lovely to hear your voice. Please come up for Sunday dinner with my family. I'd also like you to meet a good friend of mine. We will pick you up at the north end of the subway line."

I burst through the turnstile and looked up. At the top of the subway stairs stood Elizabeth, her blonde hair backlit in the October noonday sun. As my eyes adjusted to the light, it was thrilling to see how she had matured into a slender hazel-eyed beauty. As I moved towards her, arms outstretched, she tensed and stepped back, demurely holding out her hand for me to shake.

"Oh, Lloyd, I would recognize you anywhere."

From out of nowhere, a weaselly person with short greasy black hair edged directly between us, offering a limp handshake. I thought at first that he was just a passerby.

"Lloyd, I would like you to meet my fiancé, Frank." Naturally, I was speechless.

Frank was slickly dressed in a three-piece suit right out of the Eaton's catalogue. I was a bell-bottomed, turtle-necked, Beatle-booted, longish-haired, mop top.

My instincts shouted, "Get back on the subway." But I couldn't just leave her without…. "Without what?" I wondered.

"We'll go for a drive this afternoon, and then have dinner with my parents this evening. They are really looking forward to seeing you again," she said.

Squeezing into the back seat of Frank's black and white two-door Chevy Bel-Air coupe, I felt like a kid being taken to the dentist by both Mom and Dad.

"Our plan for the afternoon," he said, "is to cruise Richmond Hill, looking for a house for Liz and me to raise a family."

And so, for what seemed like hours, listening to 1940s big band music on the radio, that's what we did.

With one hand on the wheel and the other around Elizabeth, Frank commandeered the conversation, boasting about big business deals, and about one day taking over his father's used car business, where he now worked. Frank let me know that he didn't think much of "artistes," as he called them. Being a sports fan, he boasted about how he was setting up a bleacher in his backyard, and renting a large-screen TV to watch next weekend's Grey Cup game with all of his friends, and Elizabeth, of course.

Whenever I brought up old reminiscences, as I tried to do all afternoon, Frank changed the subject back to wedding plans or next weekend's big game. He was obsessed with planning his celebration of the football final.

Liz said, "You should come."

"Fat effen chance," I thought.

We stopped to get ice cream. It was too difficult for me to get out of the back seat, so Elizabeth said that she would stay and keep me company. Alone at last. She turned slowly and looked deep into my eyes. After a nervous silence, a burst of longing and forgotten feelings filled the Bel Air. Frank was back in a flash.

"Here, grab this. It's melting," he barked, shoving an ice cream cone up to my face.

At last, we pulled up to her house, Her father and mother warmly greeted me from the front porch. I made it through the Sunday dinner with her parents and Frank, who kept suggesting new names to add to the guest list for next week's Grey Cup party. Elizabeth was very quiet.

It was a tense drive back to the top of the subway line. I tripped getting out of the car, and hit my face on a "No Parking" sign post. My nose hurt and my eyes were watering. I kissed her hand, and said, "Nice to see you again, Liz. Enjoy the big game, Frank."

He gave me a look that said, "Now get lost, buddy!"

His tires "chirped" as he sped away. I slinked down the subway stairs and fumed the whole long, cold, lonely Toronto Transit Commission ride home.

All week at school my head swirled, thinking of that moment in the car when we were alone together. I had the fever. I couldn't just walk away. Then there was Frank. I had to get back at that son of a bitch. I just had to show him. How would a cowboy do it? I had to conjure up something.

The boarding house where I was staying didn't have a shower. It had a bathtub. But it was no ordinary bathtub. It was also where the boarders had to wash their dishes because the tiny kitchen had no sink. In the dim bathroom light, I prepared a deep, hot nurturing soak and stepped into the tub. Peas and carrots from someone's dirty dishes popped up and swirled on

the soapy, soupy surface like flotsam. Reluctant to drain the tub and start over, I lay back and pressed on, thinking of how to send a message to them both. A good way to conjure is to let things go. Don't think too hard, just lie there in the soup.

Pow…it came to me. I would appear at centre field for the opening of the Grey Cup and they would see me on their big rented TV. All I needed to pull it off was planning, talent, and nerve.

Dried off and back at my desk, I made a press pass by gluing a fifty-cent photo booth portrait next to a CJIC Television logo cut from stationery from my summer job. Beside it, I lettered PRESS. On the way to the big game, I had it laminated in a coin machine in the basement of Union train station.

Approaching the Canadian National Exhibition stadium, I slung my camera over my chest and added every filter I could to make the lens look bigger and more professional. I flashed my fake press pass at a surprised and confused ticket taker, and she waved me through.

Whisked along with the crowd, entering the brightness and the roar of the stadium brought back a memory of entering the same stadium leading the Warriors Day Parade, playing my bagpipes with the Sault Air Cadet pipe band. The Sault Star newspaper said at the time that we had played in front of 22,000 people. My father told me not to look up at the crowd. He said that that CNE stadium was so big, "It even made Bob Hope nervous."

As I made my way down to field level, the football fans were standing, cheering the kickoff teams as they moved into position, A Toronto Police constable stopped me as I was climbing over a fence. He checked my concocted credentials and waved his hand, pointing.

"That's the way to centre field. You'd better hurry."

Roughriders in pre-game jitters

CHASING THE MUSE: CANADA

Walking between the massive kickoff teams of the Calgary Stampeders and the Ottawa Roughriders on either side of me was like walking through a deep canyon. The players, in pre-game jitters, looked as nervous as I felt. To keep up my ruse, I began snapping pictures. And there behind me, bursting with dynamism, was that packed, gigantic CNE grandstand.

Suddenly, around me was a flurry of activity and a huge roar of applause. I looked over my shoulder to find myself walking right in front of Miss Grey Cup, the Premier of Ontario, John Robarts, and the Prime Minister of Canada, Pierre Trudeau.

There he was, the gushingly charismatic French-Canadian Prime Minister with his handsome grin, savouring the raucous adulation in the heart of English Canada, not to mention the millions viewing "Canada's Super Bowl" on television. It was a time of innocence, with no obvious burly bodyguards talking into their wrists. I solemnly took my place beside Premier Robarts for the singing of "O Canada." There we were, the three of us, shoulder to shoulder, Walton, Robarts, and Trudeau.

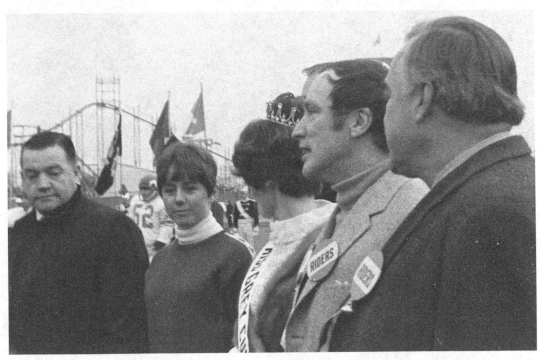

L-R: CFL Commissioner Jake Gaudaur, Olympic skier Nancy Greene, Miss Grey Cup, Prime Minister Pierre Trudeau, Ontario Premier John Robarts)

Looking up to the cameras, I fixed my gaze directly on a group of football fans hunched together on a rented back-yard bleacher somewhere north of Toronto. "O Canada..."

"Look! Look! Is that Lloyd?!"

"Can't be."

"It sure looks like him."

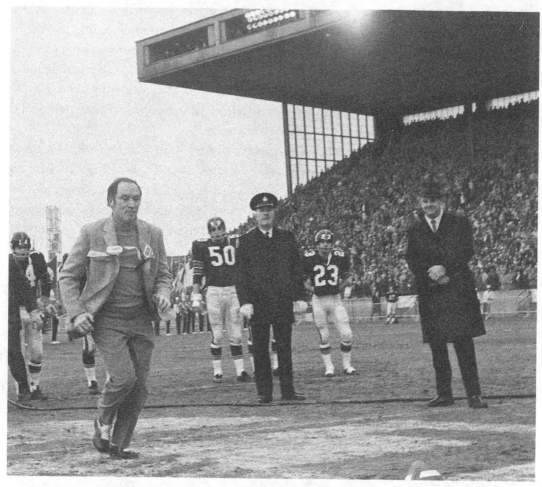

Pierre Trudeau wearing football cleats for the ceremonial kickoff

National anthem over—back to work. I joined the real press photographers to shoot the prime minister performing the ceremonial kickoff. Pierre had obviously been practicing. He even wore football cleats. He had a bravado and guile about him, with something to prove in front of sports fans across the nation. He made a good kick. I sauntered off the field smiling up to the cameras and the hopefully confused couple on the little back-yard bleacher out by the garage. I felt like a cowboy riding off into the sunset.

At the game's-end celebrations, I found myself rubbing shoulders with winning Ottawa Rough Rider quarterback, Russ Jackson. As he held the coveted Grey Cup, I reached over and touched it. I felt like I, too, had won it.

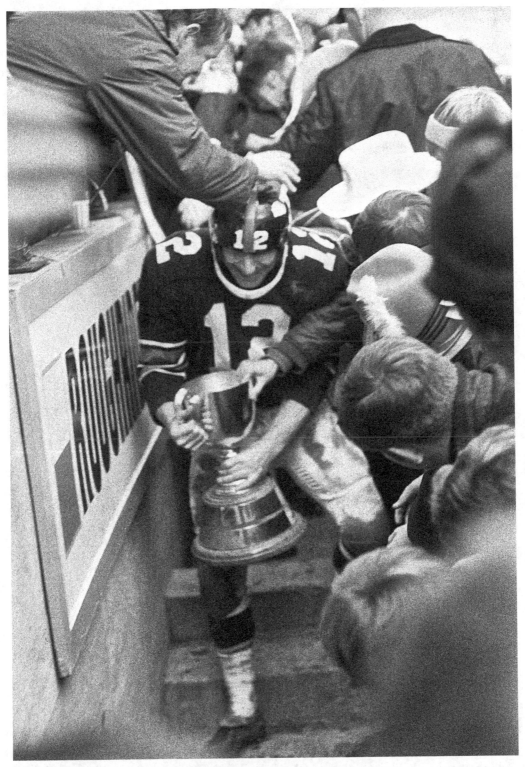

Russ Jackson, winning quarterback

THE CODE OF THE TRAIL

A month later I received a Christmas card from Liz. She asked me to call her after the holidays. I wasn't sure if she wanted another fun day as a threesome, so I declined to follow up.

This caper taught me that ideas can come, not when the mind is busy, but when it is at peace. It came while quietly soaking with the flotsam soup of the boarding house bathtub. It was also a strong lesson in the power of a simple, well-crafted visual image to persuade. Like the cave painters fifteen thousand years ago, I was using an image to forge fortune. In this case it was small enough to hold in my hand. It was shorthand for "Let him in." I also discovered a wellspring of guile I didn't know I had, to go for centre field.

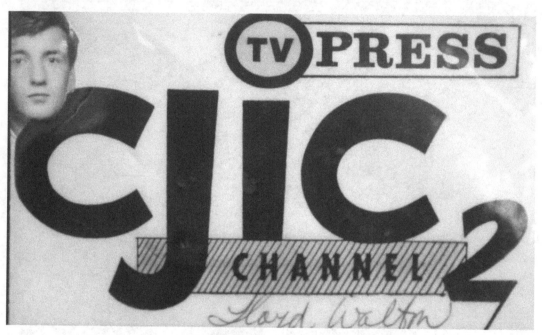

Shorthand for "let him in"

DANCE, WHITE BOY

Creativity won't invite what wasn't there to begin with.

—Bob Dylan

I was absorbing a lot of skills at school that I would need to survive as a visual artist. Finding myself in a jam, I was once forced to paint a picture, without paint or canvas; in other words, by telling a story. Highly important to the disciplines of both painting and storytelling was being observant and attentive to detail, and having a retentive mind.

Synonymous with the sixties in Toronto was Yorkville Avenue, the notorious hippy hangout. Yorkville crawled with freaks and straights perusing each other, and exchanging awkward glances up and down the boulevard, night after night. A string of poster and gift shops were mixed with "happening" coffee houses and nightclubs. From venues like The Purple Onion, The Riverboat, and The Mynah Bird, music flooded out into the night. The Riverboat audiences at that time witnessed the early careers of Gordon Lightfoot, Joni Mitchell, and Neil Young, to name just a few.

Sonny Terry

The Riverboat also presented many long-time respected greats in the business, like Sonny Terry and Brownie McGhee, two old black blues-musicians from the American Deep South. One was blind, and one was crippled. They hung on to each other, and hobbled back to their dressing room after each set. I had seen them in Yorkville when I was in high school, and now as an art student, I was invited to meet them backstage by a waiter friend who worked at The Riverboat.

Approaching the dressing room door, I wondered what a young white boy like me could say to interest these two living legends who had been through it all. To make things even more awkward, I was aware that even though they had played together exquisitely as a duo for thirty-nine years, they did not get along personally.

I shuffled into the dressing room and introduced myself. Sonny farted when I shook his hand. Taking this as a sign that he might be comfortable in my presence, I sat down on an old couch and looked around at the drab green walls. This was the room where, legend had it, Joni Mitchell wrote the song "The Circle Game." (It was one of the most perfect songs ever written. It still makes me break down every time I hear it or think of it.)

After an awkward silence, to make conversation, I stupidly asked Sonny if he sucked or blew on his harmonica.

"Well, son, I done suck and blow," he gruffly replied.

I felt like an idiot.

Brownie spoke up. "What's on yo mind, boy?" Brownie was a tough man. I sensed he didn't want no kid wasting his time. I broke into a sweat. Time to dance.

"Well, sir, I would like to know if a white boy could have the blues."

"Wach you mean by dat, boy?"

"I'll have to tell you a story."

"Sho, boy, you go ahead. You tell dat story."

"Well, Brownie, I come from the snowy north, and three of my high-school friends and I spent the winter fixing up a 1956 Chevy to drive to Toronto for March break to see the Yonge Street strip, hear the music, and meet some of the fine big-city women we'd been hearing about. We finished sanding the bodywork on our dream machine on a Sunday night, and took it to a paint shop on Monday. It was painted metallic blue. On the Tuesday we sat on a porch watching the paint dry as it sat parked beside a snow bank. 'What a bomb,' we thought. 'Wait till the chicks on Young Street in Toronto see this!'

"On Wednesday, we rented a canoe from Pete's Canoes. Pete asked, 'Will it be used in rivers?', worried about it being gashed in rushing spring-runoff waters of the rocky Canadian Shield.

"'No sir, only lakes, down south.'

"All of the lakes at home were still frozen. We lashed it to the roof racks and sped out of chilly Sault Ste. Marie, our hometown. We were heading to a canoe race on the Credit River, just west of Toronto.

"Every 125 miles we switched drivers, and my turn came at a place called MacTier. I speed-shifted toward the road, spinning out of gravel with a chirp of the tires when they hit pavement. It was happy motoring, until climbing a railway overpass. A white wall of sleet whacked the windshield. Someone in the back seat yelled, 'Let up on the gas!'

"Against my better judgment, I did. Because of the bald tires, the car went into a spin, dougnuting 360 degrees. The first bang against the guardrails crunched our shiny chrome grille and headlights, and popped the hood. Still spinning, we whipped around, crunching the back bumper, and then came to rest with a guard post dug into the driver door. It got quiet inside. 'Anybody hurt?'

'56 Chevy in a spin

"As we emerged, shaken, the trunk lid sprang open. The canoe was still lashed to the roof, and no one was hurt. We were thankful we hadn't hit an oncoming car. After the police investigation—'Yessir, we will pay for the guard rails'—we were towed to a dingy nearby garage.

"With one hour left to closing time, we did a quick assessment. Front and rear bumpers were badly bent but still attached to the frame. The radiator needed a new fan and belts. The sprung hood and trunk lids could be wired down. The bent driver's door had to be welded shut, and silver duct tape would hold two new headlights into place.

"There was a canoe race to win and a city to conquer, so we all pitched in to help the mechanic. Our broken dream waddled back on the highway at closing time, its grille a grin of broken teeth. At midnight, somber and shaky, we arrived at Halton Hills, the home of the Credit River Canoe Race.

"Well, wouldn't you know it, in the canoe race, a rock in the rapids ripped open a gash the length of the canoe. We had to turn our motel room into a makeshift canoe repair shed. While unscrewing the outer doors off their hinges to fit the canoe into the room, the desk clerk became suspicious, and called the owner. In a shouting match over spilled plastic resin on the dresser and rug, we were evicted.

"Late Saturday afternoon, licking our wounds in a coffee shop, a group decision was reached. Hard times were over. It was time to let the good times roll! We stashed the canoe, found a new motel, shined our shoes, and put on our best spring ensembles—sport jackets, white shirts, and ties. Back on the road, our mantra was 'Look out, all you Toronto women. The Soo boys are coming to town!'

"A golden sun was setting behind us as we chirped out onto a winding country road. An oncoming transport truck in a hurry roared past us, leaving a windy wake of dust and stones. As debris rattled around us, the hood of the car ripped off of its hinges, lifted off over our heads, whoomphed a deep bowl in the roof, bouncing up as if in slow motion, floating like a big blue leaf, then banged down onto the road behind us in a trail of sparks.

"Although we were flustered, we were pumped by the nearness of TORONTO and set to work. We found a large boulder to bang the hood back to its original shape, using the pavement as an anvil. With our shiny shoes sucking in the muddy ditch, we wiggled sections of a rusty farm fence-wire free to tie the hood back in place on the car. To fix the deep dent in the roof, we lay on the seats and kicked it back into shape with our feet. Back on the road, once again, we remained focused. 'Toronto, here we come.' Darkness fell and a heavy wet snowfall blanketed the night.

"Of course, we were too embarrassed to even try cruising glittering Yonge Street. Slush deepened to the tops of our slippery, sopping, leather summer shoes. To our sad surprise, all of the chicks on Yonge Street seemed to be taken, or sitting in warm bars waiting to be taken? The drinking age was twenty-one, but the oldest person in our group was eighteen. In spite of our snappy appearances, Yonge Street became a blur of bouncers turning us out into the cold, damp night.

Dreary Yonge Street on Saturday night

"Humiliated, wet, freezing, and desperately looking for shelter, fate delivered us to a coffee house in the Yorkville district—The Purple Onion. Performing that night were two elderly, black blues-musicians, Sonny Terry and Brownie McGhee."

I looked at them both sitting there and opened my arms.

"Other than on late-night Detroit radio, it was the first time I heard the blues up close, all around, and through and through. You two played gospel, delta, big city, small town, lost love, bein' in jail, highway, and heart-breaking blues. Then you whooped and howled and sang songs of joy. You two had seen real trouble, but you moved on. It was humbling, it was healing, hearing 'Walk on, walk on, got to keep on walking, to make my way back home.'

"Thank you, men. Thank you."

There was a loud rap on the door. "Time to go back on, sirs."

As they struggled to their feet, Brownie put his hand on my shoulder and I helped him up. He shook his head, looked at me, and said, "Yea. You boys sure done had da blues."

The feeling of inclusiveness in that room was a fine thing. It was also good to know that white boys, too, sure can have da blues. Sometimes, when the light points to you, you've got to just get up and dance. But you have to have the steps and the moves.

LEARNING A CRAFT

Success is the ability to go from one failure to another with no loss of enthusiasm.

—Winston Churchill

My plan after graduation was to go back north to work in television. To learn more about filmmaking, I took extra classes in animation.

Everyone needs a teacher who influences their life in a meaningful way, and I have had many. My animation teacher, Hans Kohlund at the Ontario College of Art, began his work in television in Adolf Hitler Square in Berlin during the Second World War. Now he was a Canadian citizen, and as a talented lute player, he even accompanied the great pianist, Glenn Gould, in concert.

He lectured us while delicately holding his cigarette on the tips of three fingers, Marlene Dietrich style. As ash grew longer and longer, we couldn't take our eyes off the drama of the drooping ash-worm. To hammer home a point, Hans would fall to the floor, roll over in a somersault, kick his legs in the air, then spring back to his feet, continuing the lecture with his cigarette now perched on his lips, dangling a gravity-defying two-inch ash. A magician always uses diversion. Our eyes were focused on the diversion while our minds absorbed his message.

Hans Kohlund encouraged me immensely with my first animated film, *Peace and Quiet*. It was done in the old hand-drawn style, frame by frame, twenty-four frames to the second. It

was a subversive little story about a little man who sabotages an annoying machine that was destroying his peace and quiet. It was a movie about peace. The final mark for my film was A++.

The week after I graduated from OCA, I sold *Peace and Quiet* to the CBC. I also met a fast-talking film distributor, a young Ivan Reitman who, in his Yorkville office, with feet on his desk, offered to take *Peace and Quiet* for theatrical distribution. I delivered a print to him. I never heard from him again. Ivan went off to Hollywood to become a successful director of blockbuster movies like *Stripes* and *Ghostbusters*. I wonder if he still has my film? A review in the University of Toronto's *Varsity* magazine called *Peace and Quiet* "simple, controlled, and very funny." I was on my way. I was an animator.

Animation, I sadly found out, was out of vogue in the advertising industry. I went from studio to studio throughout the city looking for a job, only to find empty animation tables. One studio director, a dignified man named Vladimir, told me I needed two more years of training before I would be any use to him. Shocked at first, I knew in my heart he was right. I knocked on a lot of doors and was told to go home and practise a whole lot more.

The big city of Toronto made me homesick. Mercifully, in retrospect, the folks at CJIC Television told me that no job was available. The radio and television station had begun to decline, and was moved to Sudbury a few years later. One hundred and fifteen jobs working out of the CJIC building was eventually reduced to six.

Guile kept me on the street searching for that job. "Don't give up too soon." Back at the art college, a note was posted on the bulletin board advertising a two-month contract job for a "producer, photographer with Ontario Provincial Parks." I interviewed for the job on a Friday afternoon and started work the following Monday. I thought I had finished my learning. Now it was time to put it into practice.

PROPAGANDA MESSENGER

The secret to a successful career is to find something you love to do and get someone to pay you to do it. Ontario Provincial Parks was expanding in size, and the number of visitors was increasing dramatically. I was hired on a two-month contract to produce automated slide shows for the parks, from the historic Whitney Block building at Queen's Park in downtown Toronto. This job would eventually take me across this huge province—up and down side roads, backwaters, and detours to places of majesty, magic, and mystery. I was in for a ride and I knew it; that is, if I could stay longer than two months.

Evening interpretive programs were offered in most parks, and there was a need for audiovisual productions to show in their outdoor theatres. Each amphitheater had a 16-millimetre projector and a Kodak carousel projector that could be programmed to change slides by an inaudible beep on the pre-recorded soundtrack.

Provincial Park outdoor theatre

Park amphitheatre

THE CODE OF THE TRAIL

The Provincial Park organization was mostly made up of young, energetic, and altruistic individuals who felt that, by creating and saving large tracts of wilderness and educating our citizenry about the natural, cultural, and historic heritage of each park, we would be building a healthier society.

There was a government-issued ashtray on every desk, electric fans on tops of metal bookcases, and a wooden tree for hanging your coat and hat in every office. Some of the old-timers were a bit wary about this kid with the longish hair and bell-bottomed trousers making "audiovisuals." The government way of doing things took some getting used to. A person needed three signatures to say it was Thursday.

To introduce myself, on a Friday morning in June in the boardroom over coffee, I showed the staff my animated film from school, *Peace and Quiet*. It was a pleasant surprise when they all laughed at the climax. The next time, I screened Bill Mason's National Film Board (NFB) production, *The Rise and Fall of the Great Lakes*, and the room filled with boisterous laughter.

In Mason's film, glacial rebound, of all subjects, became fun to learn about. He made a clever and hilarious movie about glaciation, which built to a warning about pollution in our Great Lakes. The bar was set. Seeing the effectiveness of Bill Mason's approach gave me permission to be completely creative when explaining an idea or story. He made the film about a stodgy subject differently than anyone could have imagined, as any true artist might have done.

I also screened the animated NFB film, *Propaganda Message* by Barrie Nelson. This film made fun of every contentious Canadian institution and religious and ethnic group, to hilarious effect, by subtly demonstrating the stupidity of prejudice. There was something subversive about it, too. I wanted to meet those two film makers.

These are films that touch our hearts and make us smile; both are lessons in the power of outrageous humour to bind people. I grew even fonder of the bold work of the National Film Board and hoped one day to work there.

With a letter that allowed me into any park in the province to shoot images, I camped in natural wonders, and discovered the history of various parts of Ontario that I didn't know existed. Each provincial park has its own particular magic, and its own story.

Stepping off the Polar Bear Express train in Moosonee on the James Bay frontier for the first time was like entering a foreign country in my own homeland. It had big sky, vast horizons, and a different people, and there was something exhilarating about the air. It was alive.

First impressions of Cree country

THE CODE OF THE TRAIL

Emily Linklater

Russel Cheechoo

I photographed a group of young Cree men at the station, checking out the arriving tourists. One in particular seemed to be looking me over. I suppose that I was looking him over, too. We eventually met (three years later) and we become lifelong friends.

My guide for the trip was Gerry O'Riley from the Cochrane office of the parks department. As we walked down the road in Moosonee to grab a water taxi, Gerry explained the effects of glacial rebound on the James Bay Lowlands. When I looked over at him, he was walking on his hands. I thought, "Now this is an organization I really want to work for."

This was most definitely the Land of the Cree. It had freighter-canoe water taxis, and it had beautiful people from a world outside of mine. I was saddened by the condition of the housing, yet I was stirred by the defiant resilience in the eyes of the Cree people. I observed a divide between some not-so-well-meaning tourists and the local inhabitants.

Flying in the co-pilot's seat in a thumping yellow Department of Lands and Forests Otter on floats, lifting off the Moose River out of Moosonee, we headed north up the coast of James Bay to Fort Albany, to an archaeological dig organized by the Royal Ontario Museum.j Just after we arrived, a young archaeological student found a coin dated 1670, exactly 300 years old. The jubilant ROM's Archaeological Curator, Dr. Walter Kenyon, authorized issuing an extra can of beans for that student's dinner.

Back in Toronto, mixing my photography with good scripts, working in recording studios with actors and announcers, choosing the music and directing the mix, I was experimenting with a

new medium. A lot of it was timing. I learned that I could manipulate the mood of the audience by carefully directing the performance of a narrator, selecting unusual but effective music, and mixing effects in an audio choreography. I could make people laugh, then swell with pride, then come to tears. It was a different type of cinematic language. My contract was extended.

Freelance writers were thrilled when I asked them to have fun with the subject I assigned them. There's nothing like the face of an actor who, when sitting down in the recording studio to do a voice-over project for the government, discovers intelligently crafted words to play with. One of the big names in Toronto, Henry Shannon, was a top personality from the esteemed radio station, CFRB. He joined me to do a voice-over. He had just left the hospital before coming to the studio. It was a painful and delicate operation that resulted in him having to place an inflatable rubber doughnut on his chair. I was slightly intimidated to direct a man of his stature, but his condition caused one of the most sensitive reads I have ever heard.

We were making a show about what had started as a personal project done by Park Superintendent, Charlie Leberge from Samuel de Champlain Provincial Park, near North Bay. Charlie, with the short, squat, muscular body of a French-Canadian voyageur, could roll a cigarette with one hand, in the wind. Following a dream, he and his friend, Andy Greene, built a thirty-nine-foot birch bark voyageur canoe the old way, using hand tools. When I first saw that canoe, I realized that I could fit my Volkswagen van in it; I got goosebumps, and tears came to my eyes.

Amich: the 39-foot bark canoe in Samuel de Champlain Provincial Park

Viewing my resulting production made grown men weep. It won me my second award in the United States, a Gold Camera Award at the U.S. Industrial Film Festival in Chicago.

York University held an "Anti-Logging in Parks" Symposium and I accompanied my manager to support his presentation on behalf of the government with another of my shows. Academy Award winner Christopher Chapman was there to show his film about Quetico Provincial Park. At the end of the proceedings, Chris Chapman told my manager, "Better keep that young man on."

My contract was extended again.

Playing with a dissolve unit for linking two slide projectors, I had another eureka moment. The dissolve unit allowed one slide to fade into the next. I found that by gradually and carefully manipulating the centre of interest on the screen using two synchronized projectors, I could get the motion effect of an animated film as one image subtly changed into another.

The slide shows I made this way became like rolling film, and they were written up in articles like this one in *ASKI* magazine:

WALTON'S WONDERS EXPAND A NEW MEDIUM

The traditional techniques of illustrated talks have been left far behind by the group's advances in timing, jolting images, and dramatic sound. Somehow, their static stills have the effect of rolling film. It's a revelation. The accumulation of international honours seems to support a local view (and some federal opinion, too) that the group has developed slide tape messages to the point where they are, in effect, a new medium of communication.

In my first few years with Ontario Provincial Parks I had won six significant awards from festivals in the United States. My job became permanent.

That was good, but working for the government took great diplomacy. I still had to be careful as an employee and as an artist, while remaining mindful of my credo from Robert Service's poem, "A Rolling Stone." But once I got relatively established in the way things worked in government, I began to develop my own point of view.

PART TWO
INTO THE STONE

The true story of any play is the story of how the birds come home to roost.

—Arthur Miller

THE STAR APPEARS

One hundred and ninety kilometres north of Sault Ste. Marie, in the Algoma hills on the northeast coast of Lake Superior, near the tip of a long peninsula, is a tall vertical rock face that falls into the water. It's called the Agawa Rock, or Pictograph Rock. Aboriginal pictograph images were painted on its surface hundreds, perhaps thousands, of years ago. Their meanings remain a mystery. Also mysterious is how the paint has adhered to the exposed rock face for so many years. In the 1930s, some local fisherman painted the initials KD in black paint over the red ocher images. Twenty years later, the graffiti using modern paint had naturally worn off the rock, leaving the original symbols in near pristine condition.

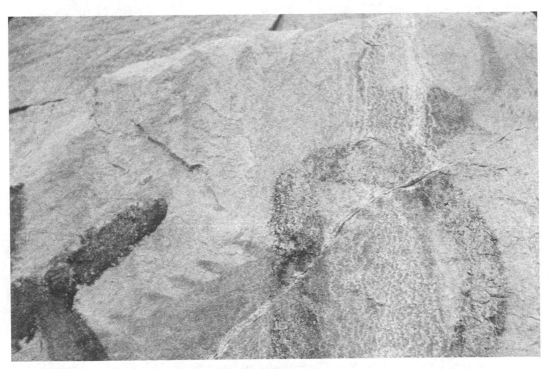

Vandalized pictographs

The Pictograph Rock lies twenty-four kilometres from where I worked as a teen in a northern bush camp construction site. Due south was the pebble beach where I spent long twilight evenings skipping stones into the waves. A park interpretation workshop brought me back to Lake Superior. A visit to the pictographs was part of the itinerary for training park naturalists. It is possible to walk in front of the pictographs on a sloping granite ledge that is often wet from lapping waves. There were about twelve of us that evening, wary of our footing on the inclined rock.

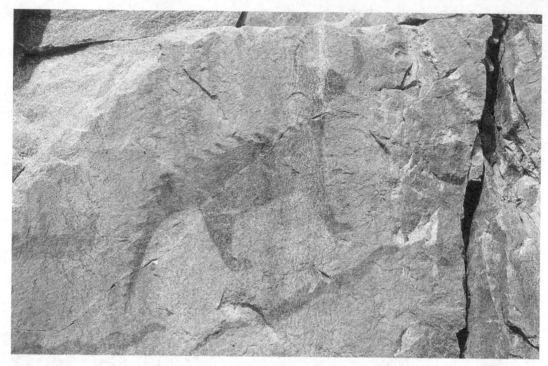

The Meshepezhieu

The glow of the setting sun seemed to lift the red images right off the rock. Meshepezhieu, a horned undersea creature, or perhaps a lynx, is one of the predominant images. *Was it a force for good or evil?* I wondered. Legend said that a swish of its tail could cause stormy seas. It was a force to be reckoned with, or at least, to keep you on your toes. Near the Meshepezhieu, there are also images of serpents, caribou, sturgeon, and a person on a horse. This was history that, as far as I could tell, was not in any book. With the images lasting so long, the writings had to have a connection to eternal wisdom. I held up my hand and asked the resident hosting naturalist, "What do they mean?"

He snapped back, "Nobody knows. All of that knowledge is lost. Those people are all dead. It's gone forever, heh heh." His snippy answer, so confident, so final, so cocksure, shook me.

Beside me, the image of the Meshepezhieu, the horned lynx monster that lives below the surface, stood out in the sunset's glow. Sparkling orange reflections from the water rippled across its surface, producing the appearance of movement.

I looked out towards the lake. The first star, Venus, burned into a deep indigo sky halfway between the horizon and heaven above. I instinctively made a wish. Venus glowed brighter. A soft voice came into my head.

"There is somebody out there that can still read them. The meanings are not lost. Someday you will make a film about what they mean."

I knew that someday I would get to peer into the abyss of knowledge that I was being told was "unknowable."

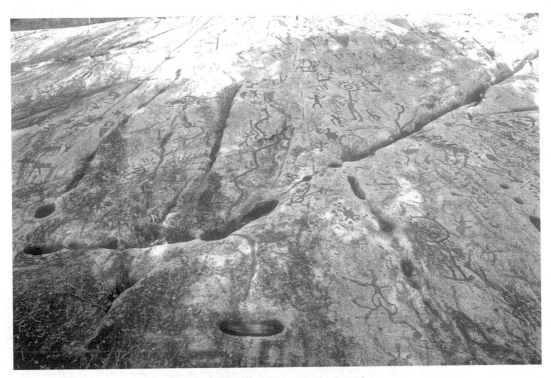

The Peterborough petroglyph rock

Another provincial park holds a similar mystery. The Peterborough Petroglyphs, as they are called, contains the largest single concentration of prehistoric rock images "discovered" in Canada to date. It is a massive white quartz rock, roughly the size of a softball diamond, into which the consciousness of another civilization was carved—not painted—on the rock. Three hundred identifiable, and six hundred vague and undecipherable glyphs, have been recorded. I tried to learn something about it by reading academic writing by leading archaeologists and anthropologists. The figures were measured, dissected, and described, but, for me, the speculative studies didn't go deep enough. The official academic and government position at the time stated, "At some point in the distant past, the carvers ceased coming to the site and their bright white images faded to a dull grey as knowledge of the site faded from mankind's consciousness."

There is a certain energy that comes in the pursuit of a mystery. But how to contain and control that energy? The idea that patience can be its own reward can be a difficult thing for someone who is bursting for answers. My deep inner clock started ticking faster. It did not tick in a conventional concept of time. I would learn to accept that things would happen in what was called, "Indian time," giving time the time to act. I had to hurry up and wait. For the greatest gifts, one has to wait.

I had to keep one eye on the star. It wasn't a "wish upon a star" fantasy. I knew I would have to work to make things happen. Many walls would be thrown up in front of me. I would be sent down box canyons, stonewalled, stalled, and stymied. As my will got stronger, I learned that with walls, you could walk around them, climb over them, or, when the magic is with you, walk right through them.

A PORTAL OPENS

The Mississagi River in earlier times

On the wall of my father's basement workshop was a framed double-wide-angle photograph of a long majestic canyon on the Mississagi River, northeast of Sault Ste. Marie. He took the photo in the 1940s, just before a dam buried this exotic landscape beneath a twenty-five-mile-long lake. That image is among my first memories. I didn't realize its historical significance and its connection to my own future till twenty-five years later. The Mississagi River was, by then, a provincial park. When I think of all the times I stared at that photograph of the river as a child, and then how destiny delivered me back to the Mississagi so many years later, I wonder again about the power of image to forge fortune.

The Mississagi River was pivotal in the transformation of Englishman Archie Belaney from a white man to the world-famous Red Indian writer, Grey Owl. Grey Owl was a genuine Canadian hero of his time. My newly hired historian, Donald Smith, was an expert on the subject of Grey Owl, and was providing research for both a CBC documentary, and a book about Grey Owl's life.

Grey Owl, in full feathered headdress and beaded buckskin clothing, became a famous writer, naturalist, and conservationist. Men, women, and children the world over bought his books and flocked to see his lectures about Canada, the beaver, and the noble Indian. He was often referred to in the press, at the time, as "the modern Hiawatha."

I, of course, felt a certain identification with Grey Owl. The Mississagi River, once his domain, was not far from my hometown. In one of his books, *Tales of an Empty Cabin,* he rhapsodized about life on that river. He, too, had worked for the Forestry Branch, before it became the Department of Lands and Forests. We both loved canoeing. I also became very attracted to the Aboriginal way of thinking about nature. I was learning about biodiversity directly from those living close to the land, long before it came into the lexicon of my colleagues in the Forestry department.

Grey Owl, aka Archie Belaney (Credit: Parks Canada)

His biographer, publisher, and friend, Lovat Dixon, wrote, "I could think of no writer in Canada who had caught so truly the essential boom-note of this huge, rocky, monolithic land. He made pure Canada, the Canada outside the concrete urban enclosures, come alive."

He was a rock star of his time. Paraded through the streets of New York City in full headdress, he was given the keys to the city by Mayor La Guardia.

Grey Owl died on April 13th, 1938, and the world mourned his passing. Hours later the press exposed him as a "fraud, an imposter." It's interesting that so many of his northern friends on the Mississagi, who knew he was a white man for all of those years, never spilled the beans.

It was time, I felt, to reacquaint Canadians with Grey Owl's story and message by producing a slide-film about him, and how the Mississagi River and its people influenced him. Historian Donald Smith and I travelled north to Biscotasing, a town on the Mississagi River, to talk to the locals who had been Archie Belaney's friends, those who were still alive. They were the men of the last frontier. Men who would never spill the beans.

Stepping off the train in Chapleau, a town between Sudbury and Wawa, Donald and I were met by forest ranger and park manager, Tom Linklater. Getting to Bisco was tricky. From Chapleau, we drove for hours in Tom's truck along private logging roads gated off by local timber companies. Many of these roads still used corduroy (horizontally placed) logs over large sections of bogs. Other times we had to get up a good run to drive across riverbeds. A washed-out, half-fallen sign, BISCOTASING, tangled in the undergrowth, indicated the turn-off to an even rougher

rutted trail that tunneled through thick spruce and jack pine branches, whipping and snapping on the windshield. It felt like we were travelling to the centre of the universe. The trail finally opened to exposed fields and a little village on the edge of the frontier.

Welcome to Bisco

Biscotasing, on the rail line between Chapleau and Sudbury, had seen better days. The children had all grown up and gone to a different life. The youngest person in the village at the time we visited was 67. Most of the old folks still fished, trapped, and hunted, and grew a few potatoes, beets, and turnips for sustenance, storing them for the winter in root cellars.

The houses were heated with wood and lit with coal oil lamps. They were to get electricity soon, the folks told us.

Biscotasing or "Bisco" as they called it, was a one-horse town, literally. A horse named Moose walked freely around the village, scrounging potatoes and turnips from people's gardens. The old former bush camp logging horse looked like a moose. Curious about the three visiting strangers, Moose followed us all over the village and waited for us outside while we made our visits to the generous and colourful locals.

A Bisco root cellar

Moose, the town horse

INTO THE STONE

Over tea, Bill Langevin told us of how he once wired together his own radio station, and broadcast Radio Bisco throughout the town. The RCMP came from Sudbury and shut him down. Another couple, Dave and Niza Langevin, recounted the winter the snow smothered their home, covering their doors and windows. Trapped in the house with no phone, they almost starved.

Bill Langevin

Donald interviewed Bud O'Neil. Bud recalled the Klondike gold rush, which was in full flow when he was a kid. Trains passed west with thousands of prospectors: "Klondike or Bust."

Maurice Kingsford was a fire ranger before World War One. He patrolled the region by canoe from spring to fall. He said, "I do remember, as we paddled back toward the forest reserve, we passed groups of Indians living there on islands; they never said anything. When we passed, we waved. They hardly waved; they just looked at us. You would think they hadn't seen anybody for months or years."

Everyone we met talked about Archie (Grey Owl) as though he had been there just yesterday. Half the town thought he was crazy. They'd say, "He called himself "Grey Owl" because the cuckoo bird was extinct."

Dave and Niza Langevin

Madeline Woodworth, the daughter of a Hudson's Bay manager, told me about a momentous morning: when the train came in, the newspapers were thrown down from the baggage car right in front of her. The headline screamed "TITANIC SINKS, 1,500 FEARED DEAD". She looked up to see a tall, handsome Archie Belaney stepping down from the train to begin his residency in Bisco. She had never seen a white man with long hair like that before, and it scared her. As she got to know him she said, "He told me he was born in England. I'm not an Indian, but I'm going to be one when I'm finished."

He must have had some cowboy in him, too. True to the code of the trail, he went out and did it, better than anyone thought he would.

Madeline went on to describe Archie as "always a gentleman around ladies. He would come here to play the piano. He was a wonderful piano player."

As we sat listening to her stories, we were startled at strange noises tapping the window.

"Oh, that's just Moose," she said. "He's curious about you strangers."

Moose pushed his nose, and then one eye, against the window.

Moose again

Harry Kohls with his first beaver of the season

We were invited to dine at the home of Harry and Katie Kohls. Harry, a trapper in his late seventies, had caught his first beaver of the season the day before. Both Harry and Katie were eager to share Katie's freshly made beaver liverwurst. Beaver trapped in early fall and winter is at its tastiest. Savouring the sacrament of beaver in my mouth by the cozy wood stove, the room lit by coal oil lamps, and hearing first-hand stories about life and times with crazy Archie Belaney, I had truly entered a different time and place. It was as though Archie had just arrived on that train yesterday.

As it turned out, he was run out of town over a knife-throwing incident. I think he was caught throwing knives at a moving train.

Archie throwing knives (Credit: Public Archives of Ontario)

Jack Leve, a former Hudson's Bay manager and fur buyer at Bisco, remembers seeing Archie in New York City when Mayor La Guardia gave Grey Owl the keys to the city. He said, "After a couple of drinks, Archie was a bad actor. We went to a movie matinee in New York where the U.S. cavalry were routing out Indians. He had been drinking all morning, and he stood up and shouted, 'God damn son of a bitch white man killing my brothers!'"

Jack laughed, "They threw us out."

Jack also told me Archie's version of meeting the King. On his sold-out speaking tour in his native England, he was asked to give a lecture and show his film to the Royal Family at Buckingham Palace. In the audience, of course was our young Queen Elizabeth. Grey Owl, as the Red Indian, insisted that the King rise when he entered the room, as it was "the custom of

my people." King George VI acquiesced. That was a nervy request from a bloke who had grown up an hour and a half train ride from the Palace.

Back at Madeline's for tea and fresh biscuits, she told us that back in the day, her sister suffered from anxiety and depression. It required her to take the train to Sudbury often to visit doctors for medication.

Madeline continued, "Archie would take her up the lake every afternoon, you know. They'd snowshoe up and find a spot to have a fire and sit and make tea. They'd sit and talk, you know, and after that winter she wasn't depressed anymore."

Archie at his Dominion Day war dance in Bisco (Credit: Public Archives of Ontario)

We got lucky; a roll of 16-mm film that had been stored in a shed in Bisco was turned over to me. It was a recording of Archie's war dance. He got dressed up in buckskin and danced around a fire—very drunk—waving a peace pipe high in the air. There were also scenes of his trip down the Mississagi with his pals from *Rivermen*, a film he made to show people the beauty of the river, before all its tall pine were cut and deep canyons were submerged by dams. Grey Owl Belaney foresaw the threat to the spectacular charms of his beloved Mississagi River.

Everyone in the town, not only Archie Belaney, became characters in my resulting slide-film. I can still hear the stories. "Zed Chretien snuck up behind a moose in his canoe and whacked it on the ass. The moose reared up, put his front legs through the canoe, then bolted into the bush leaving Zed sinking in his canoe."

Six inches of bright snow greeted us on our last day in Bisco. Tom Linklater dropped us off at the station and bravely headed out alone in the truck, back home to Chapleau. Donald Smith and I hung out in the waiting room of the train station recording banter among the locals who popped in and out. It was the kind of banter you'd hear in a coffee shop, if they had had a coffee shop. But always there were the trains, the transcontinentals, whizzing by, two miles long, shaking, rattling, and rumbling the foundation of the old brick centrepiece of the town.

The station

The stationmaster, Margaret Cameron, took pity on us, waiting so long for our train. and she invited us upstairs to her living quarters for tea. Sitting in her living room I noticed that all of the pictures hanging on the wall were totally askew, oddly arranged at wacky angles. With a roar and a rumble, another transcontinental train zoomed by and conversation stopped, as Margaret lit another Black Cat cigarette. When the ripples in our tea cups settled, the pictures had rearranged themselves into new configurations.

We climbed on to the Bud car at dusk. Just as we heard the "All aboard," we heard a clinking and jangling noise coming from the stairwell of the rail car. An old man we hadn't met in town came stumbling onto the train dragging a big burlap sack filled with bottles of moonshine. He was on his way to Sudbury to sell his wares.

My experience in this time warp was profound. Biscotasing was a town on the edge of time. It was the frontier. Electricity and indoor toilets would wait another twelve years to arrive. Its people still lived in harmony with the long-time native inhabitants, "the old Bisco Indians," they called them. In the not too distant past, the old Bisco Indians had shown them, in a true spirit of community, how to survive by living off the land.

Cigarette Annie and Jose Pichnatti, seeing us off at the station)

The mighty Mississagi canyon walls seen in my father's picture are now submerged beneath Rocky Island Lake, as Grey Owl fearfully predicted. But upsteam, Bisco was still alive and kicking. The Bisco experience gave me a deep-in-my-bones taste of the history I knew was still out there. Another of my childhood dreams was coming true.

Donald Smith later became a professor of history at the University of Calgary. He wrote a wonderful biography of Grey Owl, *From the Land of Shadows*, published by Prairie Books in 1990. Donald continues to be a great and prolific Canadian history writer.

The slide-film that resulted from the Bisco adventure, *Biscotasing, Retreat From the Land*, won a slide-film award in Chicago, but it confused my employers. Everyone enjoyed watching it but they wondered what it had to do with Ontario Parks. It wasn't selling the program. I didn't hammer on the fact that it was a place you could still discover when travelling by canoe on a river in the provincial park. The film had an elusive meaning, which I liked. Cubist painter George Braque (1882-1963) once said, "There is only one valuable thing in art. The thing you cannot explain."

However, my sympathetic treatment of the "Bisco Indians" attracted interest among Aboriginal and educational organizations. At the time, it was unusual for government to take such a sympathetic stand. Requests began to trickle in from museums and universities and northern Ontario television stations to show my work. I was gaining strength in my artistic ability by challenging the status quo with patience, persistence, and a high level of creativity. Most importantly, I was still able to do things differently than they expected. For years afterwards, I had sweet dreams about being in the time warp town of Biscotasing.

THE LAND OF THE CREE

From my first visit to the James Bay area barely two months into starting my job, the place and its people had a hold on me. In the early 1970s, up to 20,000 people were taking the Polar Bear Express rail excursion from Cochrane to Moosonee during each summer season. For most tourists, stepping off the train at the southern end of James Bay, marked their first contact with Cree country.

I was involved in the production of a visitor museum in a railway car next to the train station in Cochrane. Painted the length of the car on the outside in Cree syllabics was "The Land of the Cree". Inside, I had to produce a six-projector sound and light show on a screen twenty feet long, and seven feet high.

Through a colleague at work, I heard about a singer-songwriter, Archie Cheechoo from Moose Factory, who had written a song called "The Land of the Cree."

Archie Cheechoo)

I called Archie. He was living in Timmins at the time, and he was in charge of treaty rights and research for the Grand Council Treaty Nine. The Treaty Nine organization represented Aboriginal communities north of Timmins, from the Manitoba border to the Quebec line, and north to Hudson Bay. It comprised a vast area of remote Cree, Ojibway, and Ojicree communities, most with air or water travel as their only link to the outside world.

Archie grew up in Moose Factory and went to high school up in North Bay. (When you live at sea level, everything inland is up.) He told me that when he first got to the city and saw the DON'T WALK sign on the corner, he thought it meant that he should run across the road. Archie sang "The Land of the Cree" to me over the phone and I loved it. It had passion. I offered to pay his travel and expenses to Toronto to record it, and he agreed to a fee for us to purchase the rights. He also told me that he would bring a drummer to the recording session and asked me to find a drum. I convinced the Ethnology Department of the Royal Ontario Museum to loan me a historic artifact, a wooden Nescapi drum stretched with a caribou skin head.

The day before the recording session, we spent the afternoon getting to know each other. I recognized him from a photo I took at the Moosonee train station three years previous. He was the guy looking me over. We were both northerners, and we both loved hockey, the outdoors,

early Elvis, and Bob Dylan. During the run-through, I felt that one particular verse stood out as a mite too harsh for my employers.

We knew someday the freedom would be gone
When the sign of the HBC came
When the sign of the HBC came.

"HBC" referred to the Hudson's Bay Company. I tried to explain that the Ministry of Natural Resources may not want to sign off on that statement because it attacked a company still operating.

Archie reasoned, "But I came to do this song for you because you said that you wanted the truth."

"Yes, I understand, but the optics would not get past my employers."

"Ok," he said, "How about this?"

We knew someday the freedom would be gone
When the sign of the white eyes came
When the sign of the white eyes came."

I replied that "white eyes" might scare the tourists away. "Can I make a suggestion? How about,

We knew someday the freedom would be gone
When the sign of the white sails came
When the sign of the white sails came."

I told him I had a shot of the Nonsuch in full sail, the first recorded sailing vessel that entered into Hudson Bay and James Bay. It would be a great image to enhance the wording. It was historically accurate and still carried the sentiment. We shook hands and called it a night.

The following day, the day of recording, Archie called me at the office at noon and asked for the money up front because he might need it to bail himself out of jail. I reacted with *WTF?!*

This happened to be the very day in 1973 that the FBI had given an ultimatum to the natives occupying Wounded Knee in South Dakota. Government forces were planning to go in with guns a-blazing. A massive protest sympathetic to the Sioux Nation was forming in front of the U.S. Consulate in Toronto.

I headed down University Avenue and found Archie in a crowd of five or six hundred people marching in a circle in front of the U.S. Consulate. Slipping into the group to reason him back to the recording session, I was aware that the RCMP, the OPP, the FBI, and the CIA were photographing me as a suspected rabble-rouser.

As we circled up and down on the sidewalk in front of the Consulate, Archie said, "I cannot sing my song for you when my brothers in Wounded Knee might be murdered later today." I relented and gave him the government cheque because he was indeed broke. I bought a cigar and smoked it on the way home. I don't smoke tobacco—never have—but a cigar seemed to fill a

need that I couldn't quite put my finger on. I thought of Grey Owl's rant when they threw him out of the theatre in New York City, "Goddamn son of a bitch white man killing my brothers."

At six-thirty p.m. I got the call that the FBI siege was off and the recording session back on. I loaded the troops, instruments, and recording gear into my VW van and drove to the Ryerson sound stage to record. My recording engineer kept getting the Ryerson radio station signal in his headsets, so we packed up and moved to an apartment in North Toronto to try again.

Jim Wenjack, the drummer, held the historic Nescapi caribou skin drum under the kitchen tap to wet it, then he waved it over the hot kitchen stove element to dry, tighten, and tune it. We went into the living room, set up the microphones, and got ready to record. As Jim began beating the Nescapi drum, I noticed that the stove element had imprinted burnt black rings into the soft hide of the precious museum piece. Soundwise, the recording session was superb. I later mixed the raw tapes in the same recording studio where Stompin' Tom Connors recorded his iconic "The Good Old Hockey Game."

Esteemed ethnologist Dr. Ed Rogers of the Royal Ontario Museum, had loaned me the Nescapi drum artifact for the recording session. Dr. Rogers had paid his dues in Aboriginal lands, and had an excellent professional reputation in both native and non-native cultures. He was also known as a man who didn't suffer fools gladly. With a lump in my throat, I walked from my office to the Royal Ontario Museum with the drum cradled in a bag under one arm, and my reel-to-reel tape player under the other. A buzzer let me in and a guard directed me down a maze of corridors to Dr. Roger's office. How was I going to present the damaged drum ? . While setting up the tape machine, Doctor Rogers told me that he had already met Archie several times. I mentioned that Archie told me that he wanted to be a shaman. Dr. Rogers shook his head and muttered, "No, no, no, Archie."

I pushed the play button, and the bold introductory drumming rhythm and mood made his eyes light up. When the song was over, I took the drum out of the bag and shyly handed it to him. He pretended he didn't see the burn rings, sliding it up onto a shelf. Dr. Rogers turned and smiled, shook my hand, and said, "Well done."

"The Land of the Cree" was a great tune—it had rhythm, passion, and story. Field staff in Timmins and Cochrane were outraged. They thought that I had been duped and they refused the product. An angry park manager said, "We, the Ministry of Natural Resources, are here to protect our lands and waters, so how can we allow such negativity?"

It was the last verse that made them boiling mad.

> *The environment it would be destroyed*
> *The rivers and streams would someday be dead*
> *But the life of the Cree would go on and on*
> *Someday it will be the white man's turn.*

I tried to explain that the song was based on a Cree legend about a society dependent on an artificial way of life. There comes a time when nature is disrupted to a point where it turns on modern society. Then, people will have lost the memory of how to survive on the land. The song was a plea to preserve knowledge of living on the land. The legend mirrored the biblical prophecy, "The meek shall inherit the earth." That explanation didn't impress them.

Managers also argued that the song gave the feeling that the Indians owned the land, with its multiple refrains, "It's the land of the Cree, It's the land of the Cree."

Devastated, I tried to reason that singing "It's Provincial Crown land, It's Provincial Crown land," just *wouldn't* have the same bite.

Some kind staff members tried to reason with me, but in my gut, I just knew I was right. Disconsolate, I felt like getting in my canoe and paddling straight out into Lake Ontario. This was in February.

In our original recording sessions, Archie also did a slow, talking version of the same song. It had a tinge of anger in it. Archie had never heard that version of the song since he recorded it, but he took it to a radio interview with him on a Saturday morning country and music radio show in Timmins. When he heard himself sneering in spoken word at the end of the song,

"For three hundreds years we have stood the test.
Someday, it will be the white man's turn! "

He told me it even scared him.

But the upbeat version was still a good song. I couldn't deny an honest legend, and I couldn't get the song out of my head. In the past, I had sent out my own press releases about various film awards that I had won, so I had a few contacts in the media. I sent the song to country radio shows in various northern communities, including to my friend Saddle Pal, Don Ramsey, at CJIC in the Sault. Saddle played it and interviewed me on air.

I alerted the CBC, and a broadcast team went to Moose Factory to interview Archie and play his song nationally. This bought us some credibility. The song, mixed with layers of complex stereo effects, was played throughout the summer in the exhibit on the big wide screen in the rail car museum. The Ministry of Natural Resources (MNR), wary of negative reaction, polled the tourists visiting the train car exhibit in Cochrane. The only reaction to the music was, "Where can we buy it?"

Exterior Land of the Cree train museum.

Wide screen interior theatre

Wide screen scene

That summer for my holiday, my wife and I drove north to Cochrane and boarded the Polar Bear Express bound for Moosonee. Across the river in Moose Factory, an archaeological crew from the Royal Ontario Museum was doing a major dig, and hiring and training many local Cree to help out. The dig leader told me that they were looking for Moose Fort.

We then hopped an MNR flight—with our recording gear—to fly to Archie's father's fish camp at Kesagami Lake. Kesagami, meaning "warm water," is a big, big lake. Archie's father, Sinclair Cheechoo, was a well-known fiddler with original song titles like "James Bay Doings" and "Sealskin Moccasin Shuffle."

Using professional stereo recording equipment, I recorded some of Sinclair's authentic Cree fiddle music. He was accompanied on guitar by his son, Vern Cheechoo, who would one day himself be a well-known country recording artist and JUNO winner. Sitting on the floor during that log cabin recording session was little Thelma Cheechoo, who would one day pen and sing one of the most tender and Canadian songs I have ever heard, "Nature's Lullaby" (although she recorded it in L.A). The sound recorded in that log cabin had the tone of a concert hall. I used this music in many films down the road.

Vern Cheechoo)

Archie and his brothers worked as fishing guides to American clients eager for big pike and pickerel. On the guides' day, off we went out with Archie and his brother Arnold to fish, sit by the shore, laugh, sing, and eat one of the ten best meals I have ever had. It was a shore lunch of fresh battered pickerel.

Arnold told us a story about the three fishermen from Buffalo, New York, who he had taken out the week previous. One was a judge, and the other two were prosecutor and defense lawyers for a certain case. Arnold sat at the back of the boat, listening to the three of them plan to rig a trial when they got back to the city, and divide the spoils among them. The three lawmen were unaware that their Cree guide was educated in English. Arnold was getting a first-hand lesson on how the white man's legal system worked.

Earlier in the story, I mentioned the archaeological dig underway in the village of Moose Factory. Both Archie and Arnold said that what the scientists were looking for was nowhere near where they were digging. Moose Fort was down the river on another island, where the community annually held a gathering.

"Why didn't someone tell them?" I asked.

In unison, with big toothy smiles, came their reply: "They never asked."

Arnold Cheechoo

Archie Cheechoo: Guides day off

INTO THE STONE

Kesagami Lake, a wilderness area south of James Bay, had a certain power about it. In my travels through Ontario parks, I had heard stories of "places of power." One such place was called Porte de l'enfer, the Gate of Hell. It was a cave on a rock face on the Mattawa River, a major Canadian east-west canoe route of the First Nations, and later the voyageurs.

Archaeologists speculated that it may have been an ochre mine used by aboriginals of long ago. To the voyageurs, this place had supernatural power. They paddled by it quickly, while looking away. From my canoe on the Mattawa, I looked up at the rock face near the cave and saw a distinct face in the rock. Further down river, I found another. There are many secrets about the Mattawa River that have yet to be discovered.

Voyageur face in the rock)

One day, I took a stroll along a Kasagami beach. Strewn along the sandy shoreline were unusually shaped rocks of all sizes and elements. Some were decorative enough to display on a mantle. Some looked like they came from outer space.

I had a feeling that, although I was alone, I wasn't. I came across the face of an old woman in a boulder lying in the sand. As I walked by, her eyes moved as though she was looking right at me. A chill went up my spine. I froze.

She looked at me and spoke two words, "Be careful."

One of the unusual rocks strewn on the shores of Kesagami Lake)

I ran back to the camp to get my camera. When I came back to the same rock, there was no such face. The surface was almost flat. That old woman had given me a warning, and a teaching. When the spirit appears, there will be no cameras. *Had I entered yet another portal? Was there magic afoot?*

When I began to ask about pictographs and petroglyphs, Archie suggested that I first had a lot to learn about certain teachings regarding a different attitude towards the earth. We talked about shamans. They seemed to be gatekeepers to another kind of knowledge.

I knew only a bit about shamans from the book, *The Teachings of Don Juan* by UCLA anthropologist, Carlos Castaneda. This was a good start for understanding the protocols an apprentice had to follow when learning from a medicine man, a man of knowledge, a sorcerer. I studied sorcerer Don Juan's exercises for dreaming, seeing, and strengthening one's will.

To speed up the learning process for his hapless apprentice, Castaneda, teacher Don Juan had him ingest psychotropic plants. I used marijuana only occasionally, and I skipped the serious drugs part, but I practised his other methods by trying to dream and will myself to California. *Will I ever meet a real shaman?* I wondered.

First, I had much to learn about interacting with nature. That would come in time. I certainly had the right job for it, and as they say, patience is a virtue.

CHANCE MEETING

On the road again

After leaving Kesagami Lake, my wife and I proceeded from the Polar Bear Express at Cochrane, driving southwest across northern Ontario to Wawa, via Hawk Junction. Hawk Junction is a nice place to live, but you wouldn't want to visit there. I had my new canoe strapped to the roof of my VW van. It had taken me three years to find the perfect watercraft for my needs. It was a sixteen-foot cedar strip Northland Ojibway design, made for big water.

South of Wawa, the breathtaking first sight of Lake Superior greeted us at Old Woman Bay, a spectacular sand beach graced on the south end by a giant cliff with the texture of an old woman's face. Three hundred and fifty miles of open water stretched out in front of us. The raised rock beaches around the rocky point to the north are pocked with pukasqua pits, evidence of ancient occupation. At that time, they were referred to as "vision pits" by archaeologists. I learned later that they had other uses in the distant past.

My wife stayed on the beach to read and sun herself while I paddled straight out into the big water. At that time, the ozone layer was still healthy, and the sun felt friendly on my skin. It was a perfect day to put in a jar, to open on a gloomy day in January when my spirits needed raising. About a mile out from shore, I sensed that the canoe was being drawn toward the huge, craggy cliff face. As it loomed closer, I found myself humming the theme song to Bill Mason's

Rise and Fall of the Great Lakes, that crazy comedy about glaciation and isostatic rebound. (This was the most popular movie I purchased for park campground showings)

An intense déjà vu, it hit me. I was in the exact location that was used in Mason's film. Suddenly a red canoe drifted out from behind a large rock. Paddling that red canoe was the man himself, Bill Mason!

Bill and Paul Mason at Old Woman Bay

Bill and his son Paul were in the process of shooting a National Film Board production about canoeing. We greeted each other in great surprise, and Bill invited me to join the film crew and watch the proceedings. I tethered the canoe to a heavy stone and scaled the large rock from where cameraman, Ken Buck, was shooting. I sat down to watch the master direct and star in his own film. After each cut, Bill, down below, referred to the storyboards he had folded in his pockets, before starting the next scene.

Sitting beside me was a pleasant-looking fellow who introduced himself as Barrie Nelson.

"Barrie Nelson?" I thought. Barrie Nelson was the director of that very funny animated film *Propaganda Message.* I told him I was a huge fan, and I described the fantastic reaction to his film in that stuffy boardroom on my first week at work. He, of course, was delighted. Barrie had recently moved to Malibu, California, and had already been nominated for an Academy Award. The word "Malibu" perked up my ears. Hmm. Surf City, here we come!

The extraordinary chance meeting on that rock set off a series of ripples that would echo through incidents in time, and return in astonishing resonances. Barrie, living in California, referred to me for years to come as, "the dot on the horizon, the man who came paddling out of the sun."

Paddling out of the sun

Back at the office, a question remained with my new supervisor. He was due to retire soon, and was wary of a young upstart, full of ideas, taking over. Should taxpayers be paying for an artist to exercise his frivolous and whimsical ideas about juxtaposing sounds and images? What would the public think? The cold hard fact was that I was a civil servant, there to serve. (In my

heart I never called myself a civil servant.) The purpose of art is to serve. I always maintained that there was a way to provide a public service, while stretching myself artistically, but I did have to fight the temptation to cave in, and be a faceless civil servant—and not rock the boat.

A memo came from management, "It appears that a large amount of time is spent by the AV Group in refining selected productions to an excellence far in excess of what is required for good standards within our parks."

Civility costs nothing, and buys everything. I couldn't tell them what I really wanted to do (make movies)—not yet, anyway. But I was determined to keep paddling out of the sun. I posted that stern management memo on the staff bulletin board beside a sketched self-portrait and a review of my work from an evening presentation I gave at Trent University, hosted by the Canadian Studies department. The headline was "MAGNIFICENT!"

> Lloyd Walton's audiovisual presentations were magnificent, both conceptually and technically. I hesitate to call them slide-shows, too mundane a term, but they are not strictly movies. Conceptually, the presentations approached each topic indirectly and left the viewer aware of the setting and significance of the subject rather than the minute details of its form.

I continued to receive inspiration from the music and poetry of fellow northerner Bob Dylan, and fellow Canadian Neil Young, who were strong enough to resist corporate record company pressure, and artistically, never do the same thing twice. I loved the idea of seducing an audience into an awakened dream state, and taking them on a journey, before I popped the message. And after the message, I had to draw them out of their trance, and leave them smiling or thinking. I could unite diverse groups of people because the overriding message was about a love of nature.

That bright planet Venus hanging over the Lake Superior horizon still kept me moving toward to what seemed, at the time, an impossible goal. There had to be someone out there who could still read those ancient symbols to me.

WHEN THE STUDENT IS READY

My assignment for a new project at Wasaga Beach Provincial Park would be a creative challenge. I would have to use my art to bring about political change. In the process, an unexpected new acquaintance would enter my life. He would introduce me to a vast vault of hidden knowledge I had always hoped existed.

Wasaga Beach is the largest freshwater beach near the city of Toronto. Locals say it's the largest freshwater beach in the world. It has been a mecca for beach lovers for centuries. Wasaga Beach is also a provincial park. In 1974, the area on and around the beach became incorporated into a town. With that change came new town-council zoning bylaws that often clashed with the preservation and conservation ethos of our Parks Branch.

The town and provincial park both incorporated a beach, a river, and a large sand dune system. There were conflicts as park management began tearing down shack-like cottages and expanding parking lots, and building washrooms, change rooms, and boardwalks. The motels and restaurants were hurting for business in the winter months, and the new town council, eager to entice shopping malls, industry, and winter tourism revenue, wanted to proclaim the sand dunes behind the town as the "Snowmobile Capital of the World."

From a preservation point of view, snowmobiles are the worst thing for the vegetation necessary to stabilize a sand dune ecosystem. Their treads would rip out the plants holding the parabolic-shaped dunes in place, causing blowouts and a diminished landscape. Earth scientists in our office were bewildered by the fact that plants indigenous to the western Prairie provinces were found in the Wasaga Beach dunes, but nowhere else in Ontario.

My assignment was to do a slide show to emphasize the significance of the rare plants and orchids in the dunes, and how snowmobiling would destroy them. I commissioned a writer, Chris Rutledge, to draft a compelling script. His story was poetic in its description of the geomorphological forces that created the dunes and their vegetation.

I drove to the park for a meeting on a frosty January morning, where I learned that the project had to be ready for early spring.

How could I make a film about a summer place in the winter? I wondered. *Where will I get the images?*

Park Superintendent Bob Reynolds suggested that I attend the local Lions Club dinner meeting that evening to get a "taste" of Wasaga.

When I arrived, there was a charade going on to pry money from the members' pockets to fill the fundraising kitty. The person assigned to grab the cash was called the "Tail Twister." Anyone whose tail was twisted paid into the kitty. It was all in good fun. These men all were stalwarts of the community, pushing fundraising to its limits.

Over a roast beef dinner, I listened to stories across the table, in which members extolled their love for their Wasaga. They talked about their memories of driving along the beach to watch the sunset. Watching the sunsets was one of Wasaga's big features, but driving on the beach was halted when it became a provincial park.

All around the table, everyone wanted their say. "We have the most beautiful sunsets in the world.... It's the largest freshwater beach in Canada—some say the world."

"In 1910, the Dardenella was built. We were packed full there every night. All the big-name bands, then the Silver Slipper, it too was packed."

"Oh, that was the most beautiful dance floor. You could easily get 500 couples in there dancing—they had good bands here then."

"Once or twice a week, they'd have wiener roasts, take the people up the river, and supply the whole shoot-and-ke-bang sing-songs and everything else 'til two or three in the morning. But in the meantime, they rigged it so somebody would come out of the bush, the ghosts of the Indians and white sheets on them. Oh, we used to have a lot of fun."

"Quite a lot of Indian artifacts were turned up there."

"This is fantastic, to think there were people living here 2000 years ago."

It hit me. *Wow, there's my story. The story of Wasaga Beach, as told by the people who have lived it and love it.*

I was chewing a mouthful of after-dinner raisin pie when the Lions president stood up and said, "We have here tonight, as a special guest, a Mr. Lloyd Walton from Provincial Parks Branch in Toronto; he is here to give us a speech."

Nobody alerted me to that. There went my pic out over the table.

Mustering all of my sensibilities and clearing my throat, I summoned every bit of situational awareness, and my evening's observations, to come up with a story. I took the microphone and looked out at my audience of men with twisted tails. Among them were some of the folks I would have to convince to abandon their Snowmobile Wonderland enterprise. I decided not to mention rare orchids. Under my sport jacket, I was wearing a cowboy shirt. My words had to be honest. One more cough cleared my windpipe. *Dance, cowboy!*

I began by talking about history, culture, and community and rambled on about my experiences in Bisco and other places across the province. I reminded them of the richness of the cultural event they were all presently sharing. As I looked out at the faces of these men who were so proud of their community, it hit me. I stopped talking, looked out at their faces, and said, "Oh, man. I will knock your socks off with a film I'm going to make about Wasaga Beach."

I gave my word. A cowboy's word is his word. The job would not be easy. With the help of the park staff, I sat in many living rooms collecting personal photographs and recording interviews on tape. Different eras of music, activities, and events began to unfold into distinct chapters, separated by decades. A lively, rollicking soundtrack evolved from the voices of the people who lived it, and who loved "the Beach." Their unique linguistic cadence gave lustre and rhythm to what became a fun show to watch.

Wasaga Beach

Wasaga

Wasaga

Wasaga

But the famous dunes were still a question mark. My story had to include the effects of snow machines on the fragile dunes. I still didn't think that rare orchids were enough to convince my audience.

Back in the city, my friend, historian Donald Smith, suggested that I might want to talk to his Ojibway teacher, Fred Wheatley. Donald hinted that Fred might have some aboriginal historical knowledge of the area. The three of us met over lunch in Toronto.

Fred Wheatley was, at the time, working at the University of Toronto as a porter in a men's residence. I was immediately struck by his quiet and dignified manner. He was an Ojibway who grew up on Parry Island on Georgian Bay. One of his early jobs was being Lady Eaton's personal guide when she was at her summer residence on Georgian Bay. Lady Eaton was the wife of the famous department store magnate, Timothy Eaton.

After some general conversation, I told him I was looking for some aboriginal history of Wasaga. After determining my general intentions, Fred began by explaining some guidelines that he was taught for retelling the oral history of his ancestors.

Certain young persons would be taken aside and told specific stories while still at a tender age. The young person being taught would be told the story three times before being asked to repeat it. The story had to be repeated in the way it was told.

"In repeating it," he said, "if you use other terms, you lose the conception of what the story is. A non-native person might want to garnish it to make it sound exciting. Some things are not to be excited about. We were being taught truth."

I drew a picture of the parabolic-shaped dunes and showed it to Fred. He studied my sketch, and then gave me a very long, serious look. He said, "I have heard some of the elders from Christian Island talking of certain things that happened there, but the story was not told to me directly, so it is not mine to tell."

"But," he said, "I will help you find a way."

Fred was raised by his grandparents who lived to be 110 and 112. Fred was born in 1913, so when he retold their stories, he was referring to events of the early to mid-1800s.

His grandmother, growing up on Lake Superior, used to go by canoe each spring with a group from present-day Thunder Bay, down through the Great Lakes all the way to Black Rock, near present-day Buffalo, New York. In Black Rock, they stocked up on a year's supply of flint to use for fire, and for use in bartering for other goods. They also traded indigenous goods and medicines from their area with bands all along the way, while getting caught up on news and gossip. After paddling down from Lake Superior, traversing eastward across the north channel of Georgian Bay, and then southward through the 30,000 islands, her group of Ojibway would enter the mouth of the Nottawasaga River at Wasaga Beach.

They paddled up the Nottawasaga River to the Holland Marsh area, put their canoes up on poles, and walked overland to the Humber watershed. As I understand it, there was a universal law at the time; if you came across someone's canoe up on a stand, you would not touch it. Arriving at the headwaters of the Humber River, using rolls of bark, spruce root, and tools that they carried with them, they quickly made canoes to continue their trip down the Humber River to Lake Ontario. Fred talked about his grandmother's wonderful teeth and smile. He felt that perhaps she was taken on the trips because her teeth were good for chewing the spruce root, called *watape*, to soften it for sewing the birch bark. (Now, there's a skill lost to the past!)

Arriving near the mouth of the Humber River, before venturing out on Lake Ontario, they sent a runner overland to a high point of land called Ishpadinah. The runner climbed up one of the very large pines that grew there and looked out onto Lake Ontario for Nau-to-way canoes. The Nau-to-way, as the Ojbway called them, were "snakes," their often enemy, the Iroquois. This high place is the very spot where the present Casa Loma is situated, at the top of Spadina Road in Toronto. The name Spadina comes from the Ojibway word *Ishpadinah*.

If the coast was clear, they would continue to Port Dalhousie, near present-day St. Catharines, then inland and over to Buffalo, New York, following the route now traced by the Welland Canal. After completing their trades, the group hurried to get back to Thunder Bay before mid-July; that's when the winds pick up on Lake Superior, making it dangerous for canoes travelling with heavy loads.

Alas, matches were eventually introduced by the traders, and the annual trip for flint became unnecessary. That overland portage from the Nottawasaga River was renamed the "Humber Carrying Place" or the "Toronto Carrying Place," as explorers and settlers moved in droves.

For this one hundred and fifty year time shift in the film I decided to use images of a birch bark canoe moving up the river, winding into the dunes. As soon as the ice left, I borrowed a bark canoe from a local museum and invited the press to film me shooting the river/dunes sequence for the film. The publicity provided by story in the paper resulted in a crowd of over 300 residents showing up at the Wasaga Stars Arena, including the mayor and council, for the film's premiere.

On a large screen, the show *Share a Memory, The Story of Wasaga Beach,* began with big band sounds from Bert Niosi playing "Blue Skies."

Blue skies
Shining on me
Nothing but blue skies
Do I see.

(Irving Berlin, 1926)

Then Guy Lombardo and the Royal Canadians, playing "Cruising Down the River On a Sunday Afternoon," followed by Artie Shaw's Fee Fi Fo Fum, and Les Brown's orchestra's, Sentimental Journey, then Hank Williams singing "Hey, Good-Lookin'."

Wasaga Scenes from Share a Memory

w

Wasaga

CHASING THE MUSE: CANADA

Wasaga Scenes from Share a Memory

Mixed over the music were the proud Wasaga citizens' voices, their memories spoken with enthusiasm and love:

"It's a pleasure town, more or less."

"It's a beautiful thing to say, 'I'm going to Wasaga Beach to enjoy my holiday'."

It went on with:

"Hot dogs, five cents. Hamburgers, five cents...."

"It would take them twelve hours to drive up from Toronto, and my dad was bald headed, and he got sunburnt."

"We were packed full every night, all the big-name bands."

"Oh, the river, we had regattas."

"And the sunsets, the most beautiful sunsets in Canada. In fact, some say the world."

"And the sand, you see, nobody's got that sand. That's pure white sand, pure as gold."

On the Nottawasaga River

And then silence. On the screen, the nose of a birch-bark canoe threads its way up river in slow six-second dissolves.

Fred's quiet voice spoke.

> "The Nottawasaga River has always been known as a river of plenty for the Indian people when they came into it. Nautowaysaugene is what we called it. Fish were always plentiful in the Nottawasaga river—even winter and summer—and that is why many of them camped in that area. You go up the river and there's a bend in the river where it flooded over, and there's a clearing there. This is where they used to camp."

On the screen we see shadows of children in the distance on the dunes. Then Fred's mellow voice:

> "They always told the children, don't play on that side if we're going to camp. We'll be camped on the opposite side because they didn't want anyone running around certain areas. And we just…the children took it that it might have been a cemetery of some kind. An Indian cemetery. Nobody of my knowledge knew what it was but whatever it was, they had a high regard for it."

Shadows on the dunes

The shadows of the children in the distance faded into the snow. Then, a sunny scene of a snowy crest of a dune with tall, dried bright-yellow prairie grasses appeared abruptly. The dead stalks of this hardy plant species, found nowhere else in Ontario, stood defiant against the winter winds.

tracks appear

A blowout

The prairie grass image slowly dissolved into a close-up of a snowmobile track and crushed and torn-up grasses. Next, a dark gouge of sand appeared, cut deep through the snow. A collective audible gasp and shuffling came from of the audience. The music and mood then moved to rock and roll, cut to snowmobile races on the river, then softly blended into community activities, and the voices of residents.

"You've got to share this with other people. There's a wonderful beach here—it should be made so that everybody can enjoy it."

The show ended with a laughing grandmotherly voice saying, "Once you come here and get sand in your boots, by gum, you'll always come back...tee hee."

After the applause stopped, and the lights came up, the mayor gave a grateful speech and proclaimed, "One thing for sure, there won't be any snowmobiling in the dunes."

Over forty years later, the secrets beneath the graceful parabolic forms are still intact. Fred Wheatley would remain my mentor, teacher, and friend. When the student is ready, a teacher will appear.

A JOB IN THE GREAT NORTHWEST

Back on the superior shore

For summer holidays, my family, friends, and I often camped on distant islands on Georgian Bay, or on remote beaches on the coast of Lake Superior. Because I worked with parks, I learned of many hidden places, long before they were discovered by other canoeists, hikers, or wolf packs of kayakers. It was a busman's holiday. On some of these exotic beaches and islands, the rock formations and vegetation were so pristine, we wouldn't have been surprised to see a unicorn race by.

On many of Superior's remote-boulder beaches, one can find deep pits circled by boulder walls more than a metre high. These so-called "Pukasqua Pits" have been identified and described by archaeologists and anthropologists as "vision pits" for ancient rituals of the First Nations people. Being from the area, and naturally skeptical of outside "experts," the use of the pits was one question I wanted to ask Fred Wheatley about later on, as we got to know each other.

Looking into a pukasqua pit

When I got to ask Fred about the Pukasqua pits, he answered, "In the early spring, the lake trout and whitefish come in close to shore and beat their spore on the rocks for their spawning ritual. This is the easiest time to catch large quantities of fish. But due to the fierceness of the weather and the winds, and the coldness of the lake at that time of year, it is too dangerous to load a canoe with fish to bring it back to the village. The fishermen packed the boulder pits with fish and snow, which would turn to solid ice when the breezes flowed through the spaces in the rocks. In warmer weather, the community would chop out the fish still frozen in the ice pits, heap the bounty into freighter canoes, and paddle back in safer calm waters."

Stray logs, escapees from the huge booms towed in floating islands in an era past, still littered the beaches, and allowed for giant campfires. After everyone else drifted off very late one night, I sat up reading alone by the glow of the campfire's light. I had a startling experience.

Log strewn beach

I was reading *The Wabeno Feast*, a novel by Wayland Drew. It is the story of a married couple escaping a major ecological catastrophe as they canoed and camped on the Superior coast. Each night, they read from a journal written one hundred and fifty years earlier by a Hudson Bay employee guide in a voyageur brigade, on his way to take over a post in the northwest.

The modern man and woman were following his route, and so they were likely camping in the same spots as the Hudson Bay man had when he wrote his journals. Very late one night, the journal writer was awakened by offshore sounds of shrieking and drums. On a nearby island, flames lit up the night. The Hudson Bay man described a chilling native orgiastic ritual of drums, mutilation, and fire on the island, just off his campsite. The ceremony was called "The Feast of the Wabeno".

In my dimming firelight, Wayland Drew's description of their frenzied horrifying ceremony swept over me in a curious, cold, and creepy way. Now I was a camper, reading a book about a couple who were reading a journal account on the same spot, written one hundred and fifty years before, about an eerie event that occurred just out from this Hudson's Bay trader's campsite. I could feel the trader's presence around me.

Apparition of voyageur sharing my campsite

I looked out into the darkness. At the edge of the firelight's glow, the outline of a small offshore island flickered.

There, in the wavering light, had to be the very island where this horrific event took place. It was just as described in Drew's book. Wayland too had obviously camped on this same spot. A strange piercing noise came from out on the water. "Eeeeee rookkk."

I put the book down and crawled into the tent, cowering in my sleeping bag. I lay awake till dawn haunted by the word Wabeno. The image of that island going up in flames—trees exploding around the wild Wabeno people, their bodies mutilated, but still paddling off under the morning star, burned into my brain and psyche. Those Wabeno were bad people.

The concept of different events taking place at different times on the same landscape—places out of time—and reliving them in a new way reinforced the notion of the circularity of life that kept creeping into my life and films.

The next evening, we paddled out to enjoy a glorious sunset behind the Chair of Nanabush, a stunning rock formation. On the map it was named "Devil's Chair." Places held in high spiritual regard by the original aboriginal inhabitants were often renamed with the prefix, "Devil," by the missionaries. The setting sun's rays shone through a hole in the rock. I stood up in the canoe with my arms open—and discovered that when the spirit appears, sometimes you are allowed to use the camera.

Devil's Chair (Chair of Nanabush)

INTO THE STONE

Such was the type of job I had. For my holidays and weekends I would camp in our parks, because they were of course beautiful places, and I enjoyed the lifestyle. It also helped me to understand the needs and interests of the audience who would be watching my productions. But there was a question back at the office whether a job like mine in government was really a necessity. A new supervisor didn't quite know what to do with me. Truth be told, he was due to retire soon, and he had his mind tuned for shutting things down. He looked terrified whenever I came into his office excited about doing something. Full of enthusiasm, I would hit him with an idea. His frequent refrain, "Oh, they might take a dim view of that."

I never asked him who "they" were. To ease my frustration, I filled sketchbooks with *Faces of Civil Servants.*

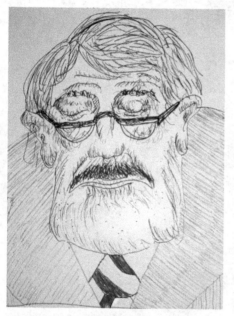

From my civil service sketchbook

Mercifully, I was loaned out to the Ministry of Culture and Recreation to make an introductory film about the fur trade for visitors to the newly constructed Old Fort William tourist attraction in Thunder Bay. It was to be shown in a theatre in an onsite orientation centre. Wearing a voyageur costume as I shot stills and recorded sound, I was in the midst of a cast of several dozen historical re-enactors, living life as it might have been in north Superior country around 1804, and I was a thousand miles and a hundred and seventy years away from Queen's Park.

Off to work, in costume at Old Fort William

The film was called *The Great Rendezvous*. I wanted to give a sense of North America beyond the shorelines that the voyageurs were paddling past on their way from Montreal to Old Fort William and beyond—they would have paddled past hundreds of aboriginal encampments en route to the Great Northwest.

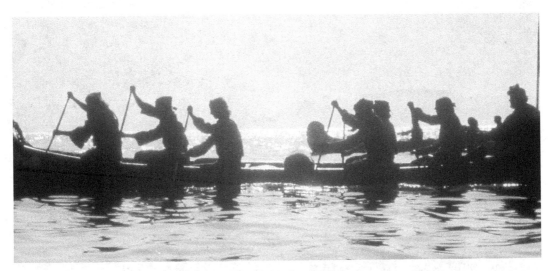

A voyageur brigade

My summer holiday images from Lake Superior gave me a head start in the production. The slide-film won a Silver Screen Award in Chicago in 1976, the year celebrated as USA's Bicentennial, a year of many historical films. At the time, the state of Illinois was discovering that French-Canadian voyageurs were a major part of their history. The singing canoe men left Quebec and crossed the Great Lakes, entering the Illinois River at Chicago. Continuing on to and down the Mississippi, they established a French presence and style of settlement. As a Canadian, I was heralded as a link to Illinois's heralded French-Canadian past.

At a voyageur re-enactment ceremony on the Fox River outside of Chicago I wore buckskin regalia on stage with the local congressman. When I was asked to speak, everyone in the crowd expected me have a French accent. While I tried, I learned that I was a bad actor. I direct.

I was also given a VIP tour of the Field Museum in Chicago, including the locked vaults below in the catacombs. One room held the medicine bags of many great chiefs from the American West, including Crazy Horse and Sitting Bull. My guide announced in a sprightly way that the artifacts had been sprayed with a poison substance to preserve them. I took two steps into the room, made a quick glance at the objects, and was literally blown back out into the hallway. It was as though had I walked behind an aircraft engine throttled up for takeoff. Was it the poison in the air or the power coming out of those medicine bags that threw me out?

What impressed me most about making *The Great Rendezvous*? was a late-night conversation with a Fort William Ojibway Band elder. He said, "I know the history around here going back to around 1200. If you would like to know it, you would have to spend a long time with me."

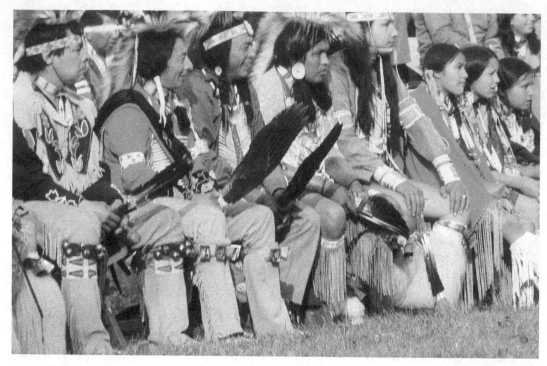

A pow wow at Fort William

This was a confirmation of knowledge that I knew was out there, but I couldn't see myself moving to Thunder Bay to learn it. Gaining more knowledge of oral North American history, pre-1500, would have to wait for my next project.

ARCHAEOLOGICAL DIVERSIONS

Although my job involved many other tasks, I kept looking for a project in which I would be able to probe deeper in time. One such park project was *Imprint On the Land, Ontario's Archaeological Resources.* One theme of the film would be: *It seems that where we like to camp in parks, so did the Indians.*

Archaeologists and anthropologists were, at the time, the only voices speaking publicly about aboriginal history pre-1500s. That knowledge primarily came through scholarly archival records, or by digging in the ground. I did not have my archaeologist or anthropologist credentials, so as an artist, I hoped to inject some of my own theories into the science.

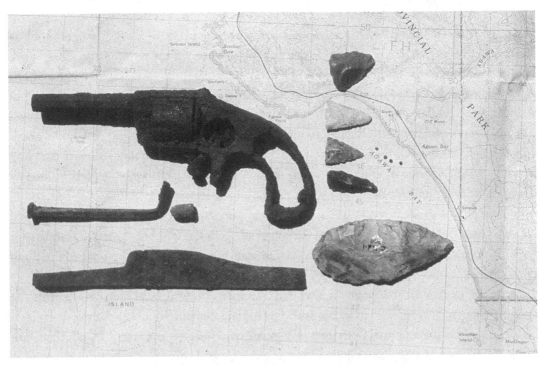

A series of artifacts unearthed from the mouth of the Agawa river, illustrating different years and societies of occupation

I travelled north of Toronto to an archaeological dig at what was then called Methodist Point, on Georgian Bay. It is now called Awenda Provincial Park. Using two microphones, I simultaneously recorded the thoughts of several archaeologists as they were on their knees gently scraping the earth, painstakingly looking for artifacts. As their minds and trowels travelled below the surface of the dirt they were sifting, some talked of hearing things—sometimes music, sometimes voices. Often while immersed in scraping and digging down to the past, they remarked that they had the feeling that they were being watched.

Taking a cue from the brilliant Glenn Gould's contrapuntal piano performances and radio documentaries, I mixed several tracks of the archaeologists speaking all at once to create a musical effect. Another reason I did this, as well as the effect worked, was that when I pointed across the water to Christian Island, a nearby First Nation reserve, and asked them, "Have you talked to any of the elders there, about where the sites you are looking for might be?" they replied, "Of course not. They wouldn't know."

This grated on me, particularly after hearing Fred Wheatley speak so reverently about the Christian Island elders and the history they revered and protected over time with their strict rules of storytelling.

Once again, I called on my dear friend Fred for help. I happened to meet him walking down Wellesley Street in Toronto on the day he was notified about his new job, Professor of Ojibway at Trent University in Peterborough. He was walking two feet off the ground with a huge grin. Fred quietly noted that he spoke, "Oxford Ojibway."

My feeling is that, to go deep into the past of a living culture, understanding the nuances of a language is necessary for the story. The first explorers entered a land that was already named. The place names often described the prominent features of the landscape. I grew up in places with Anglicization of Ojibway names with a story behind them; Batchewana, our favourite beach on Lake Superior, in Ojibway was Baa je wanaag, which describes how it was formed by the effect of prevailing winds on an eddy coming out of a river.

To illustrate the descriptive nature of the Ojibway language, Fred often referred to the word his grandmother used for "coffee". Nibi shaboo bekshibodek getchi boozhagmig. Translated it goes," a beverage which is brewed, which catches your nose and has a sharp taste to the tip of the tongue."

The script for *Imprint on the Land* was written by Robert Sandler; it was sparse but salient. The soundtrack, highly hypnotic, was accompanied by the late Richard Thomas' deep resonant voice.

But it was the voice of Fred Wheatley that took over. I showed the sacred island, the Chair of Nanabush on Lake Superior where the setting sun glowed through a hole in the rock—the place I felt the spirit allowed me to film.

Fred's voice-over was, "When you see an Indian sitting down facing the sun, he is not a sun worshipper. He is worshipping the power that activates the sun."

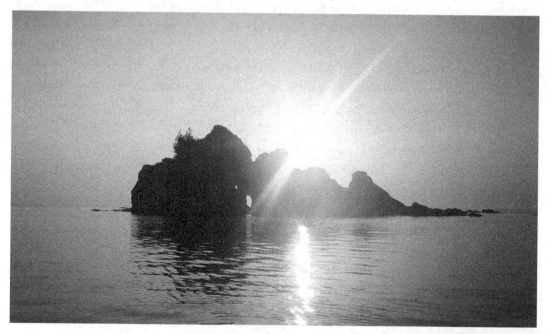

It is the power that activates the sun

Next, with scenes of the Peterborough petroglyphs, Fred revealed it as a place where teaching took place. He introduced the images as,

> "The rocks where they used to teach. There were hills where maybe an elder would take a young person and live with this person and while they were living a way of life this young person was being taught. I have heard by an elder, he tells of the rock where they teach. It wouldn't be in the literal sense of teaching but it would be a place where a child would observe his elder and the signs on the rock and in turn be told by the elder."

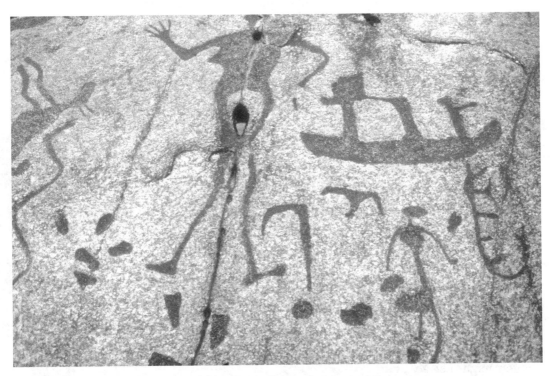

A place to teach a young person

He provided a glimmer of hope that there was more to be learned about these places of mystery than academia was telling us. I enjoyed displaying the contrast between the different levels of perception between the two cultures. It felt good to hear another variation spoken from the heart, from the native viewpoint. It felt real. It was truth. One reviewer in the Trent University newsletter wrote, *"Imprint on the Land* dealt with the Ontario Prehistoric Society in an attempt to question the 'primitive' label attached to it by Europeans."

These productions looked and sounded good when projected with 35-mm slides using cuts, variable speed dissolves, and rich sound. But they required specialized projection systems. The problem was distribution. Someone had to be there to set all of that stuff up. The big question was "How can we put these on 16 mm film to mail out to schools and libraries?"

The next logical step was to put them on film for the abundance of Bell and Howell 16 mm projectors in every provincial park, school, town library, and church basement. This was the era before VCRs became the norm.

I located a company in Los Angeles, called Image Transform, that could take a two-inch video and make a 16 mm negative. Our distribution problems would be solved. With much cajoling, and conjuring, I had a trip to California approved, and was preparing for a departure in ten days. Then I got a call from Archie Cheechoo.

DEEP INTO THE RING OF FIRE

Normally Archie started a conversation with a joke, but this time he sounded serious.

"Lloyd, we need your help. The Reed Paper Company of England has been given permission by MNR (my employer) to clear-cut an area the size of Nova Scotia right in the middle of Treaty Nine Territory, with no discussion among the bands involved." (Today the area is referred to as the Ring of Fire, due to its vast mineral potential.)

Archie went on. "There are no roads in the area but this will result in machines, clear-cutting, alcohol, drugs, and hunters from the south invading our communities. Many people still live off the land. This same company is polluting the Wabigoon River with mercury from their paper mill in Dryden."

"That's terrible, Archie. What can I do?"

"Can you do us a slide show to get our point of view across?"

"Well, sure I suppose I could. When do you need it?"

"We need it real soon. We have a group of supporters that are booking meetings all over the province to show the public what's at stake, and we need you."

"How might I go about it?"

"We would like you to go with two forest biologists from Waterloo University and Harry Achneepineskum from our office on a week-long tour of the territory involved."

"When?"

"You leave Sunday."

This was Thursday. I had to quickly do some packing, and figure out how to tell my wife that our coming week's holiday was off.

I had heard about Harry Achneepineskum from my high-school bush-pilot buddy, Jim McLarty. Jim had flown Harry and a group of reporters through Treaty Nine territory a few years before. They landed at sites where core samples had been drilled for future water-diversion dams. The scheme was planned in the 1940s, and developed by an engineering firm from California along, with the U.S. Corps of Engineers. The plan was to reverse the flow of northern rivers

south to the United States. I had seen a copy of all of the marked sites on the rivers and, to me, it looked rather ominous.

I had heard Harry's voice on the CBC talking about this plan, which was, until this time, locked in secrecy. Jim McLarty, my bush-pilot friend, spoke very highly of Harry. Harry was young, handsome, and educated, and he spoke five languages: English, Cree, Ojicree, Ojibway, and French. He grew up in the north, and was educated in the south.

Harry Achneepineskum

Harry met the professors and me at the airport in Thunder Bay. We took a cab to the seaplane base on Lake Superior and boarded an old twin-engine Beechcraft on floats from the 1940s. It had tar on the wings, presumably to keep water out of the gas tanks. *Will it lift off with all that drag?* I wondered. The cockpit instrument panel shook violently as the plane struggled to get off the water. I was wishing I was back in a clean, efficient yellow Provincial Air Service Beaver or Otter.

We landed at Cat Lake, in remote northwestern Ontario, on a hot afternoon and unloaded our gear onto the dock. The two scientists set out to measure trees. Harry and I sat by the water near some forty-five-gallon gas drums to talk and get acquainted. An Ontario Provincial Police Beaver on floats appeared above us and circled the two of us from a height of 300 metres; then it departed.

Checked out by the police

Harry began telling me of the life in which he was brought up, and what his people might be facing.

"You can boil water in a moose or caribou stomach, eh," he said, "if you do it right. You can't burn a hole in it, if you do it the right way. We make certain medicines from the spruce, some

from the roots and certain branches. The moose eat part of the branches, too, along with aspen and other food. He mixes it with other food."

Cat Lake was quiet. I asked him if people here still lived off the land.

"People come here because services are channeled here, eh? But they still live off the land. Seventy-five percent of the people live on the reserve about twenty-five percent of the year. The other twenty-five percent live on the reserve about eighty percent of the year. They are off hunting, fishing, gathering wild rice… doing lots of things. I wish we had time to live here for a year to see all of the things they do. We could go out to the rice harvesting area. The politicians just don't understand what it means to live off the land. It's not an easy life. One error and you are finished. You have to be a master of your lifestyle. The weather, the habitats of animals, the trees, you have to know it well. It's not an easy life up here. If you want to live off the land, you have to limit the wolves. If there are too many martens, they will kill off the rabbits. You have to balance the numbers."

Black spruce

I mentioned to him that requiring logging companies to replant before leaving each area might ease some of the issues.

"See those trees they are after," he pointed across the lake.

"They call those, she go bee. Black spruce, eh? They take a long time to grow, those. There is no way that a tree artificially planted will grow in a muskeg bog. There is no way. I'm not a scientist but I know.

The moose, they like thick forests. I've never seen a cutting area, but if you take the food source away, it would seem that a lot of the animals would go away. I can't say for sure, but something inside tells me that, but I would have to live with that question for a while. A politician could give you an instant answer. But what we will be doing here will be using science to back up our arguments."

The low sun began creating great lighting for filming. We took a walk. Harry talked to the residents about me, and they went about their chores, letting me photograph them. There was a peace in the air. Cat Lake was a dry reserve. I was particularly struck by an older woman on her knees scraping a stretched moose hide with an axe blade tied to a stick of wood. She graciously posed for what became one of my all-time favourite shots.

Cat Lake kids

CHASING THE MUSE: CANADA

Cat Lake life

Scraping a moose hide

Harry, the two scientists, and I travelled the territory for a week by motorized canoes, bush plane, and rented cars. On the last day, as the scientists went off into the bush north of Red Lake, Harry and I walked along a stream, and then sat down on a rock by a riverbend. A fisherman, or someone trying to look like a fisherman, was lurking about. He seemed to be watching us over his shoulder more than he was concentrating on his line. Eventually a truck door slammed and we looked up to see a game warden's truck pull away. The under-cover cop, playing angler, must have thought we were up to something.

Harry told me about the big trip he was about to undertake at the same time I planned to be on my dream trip to California. In two days, he would be taking journalists and members of the Ontario Royal Commission on Electric Planning on a week-long tour of the north to hear the views of the people that would be affected by the damming and reversing of the Winisk, Albany, and Attawapiskat rivers.

Suddenly we were surrounded by a swarm of about ten dragon flies, causing us to squint and cover our eyes—the spots on top of their wings were like mirrors reflecting the sun. He smiled and said, "The dragonflies are our friends. They eat mosquitos, eh."

We saw each other off at the airport in Sioux Lookout with a hug and a handshake.

"Hollywood, eh?" he smiled. I watched Harry's plane disappear into the deep indigo northern sky.

SURF CITY, HERE I COME

Surfin' Safari

When I was in high school, Malibu, California was Nirvana to me. I subscribed to *Surfing Magazine* and played the Beach Boys records as I read each new issue, dreaming of someday surfing in the California sun. By chance, the animator Barrie Nelson, who I met on the rock when I paddled out of the sun on Lake Superior, still lived in Malibu. Barrie invited me to stay in his guest house overlooking the Pacific Ocean while I worked in Los Angeles transferring my film.

Driving into town on the Pacific Coast Highway, I saw, off to my right, surfers catching waves in the morning sun. With the windows down, and the radio cranked up to the Eagles' "Take It Easy," Malibu, California was indeed Nirvana. I grinned all the way to work, even when it turned to gridlock as I approached Hollywood.

Malibu was pretty much as I dreamed it. Suntanned blondes wore white fox fur coats in open convertibles, or in air-conditioned Mercedes. In the morning I took my outdoor shower, while looking down at the blue Pacific, and off to my left was an onion-shaped dome rising out of the construction of Bob Dylan's new house. Bob was working on a film at the time, *Renaldo and Clara*, with another friend of Barrie's, Howard Alk.

I told Barrie that I had made an animated slide-film of Dylan and the Band's Tour 74 show in Toronto. I called it *Planet Waves,* and I used it as a bonus feature to my Audio Visual Road Show for universities. Barrie asked me if I wanted to meet Bob.

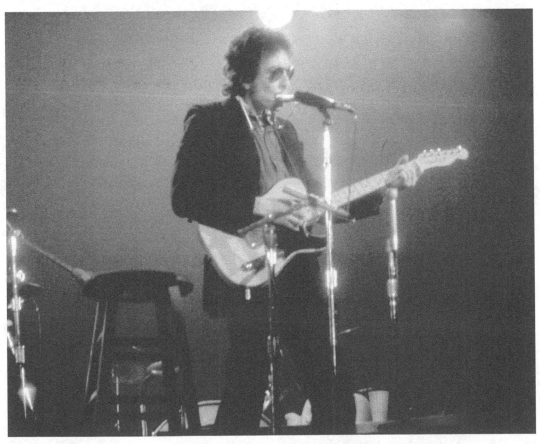

Bob Dylan from my film, Planet Waves

Feeling out of my league and shy, I demurred. I did, however, come across Bob on a back road, skateboarding with a bunch of kids, likely all his. As I slowly drove by, he gave me a look that said, "Keep moving." Can't blame him.

Hanging from the ceiling directly over my bed in Barrie's guest house was a surfboard. It haunted me every night as I tried to fall asleep. On my last day in Malibu, I borrowed Barrie's wetsuit and board, and drove to the closest surfing beach.

Wading out into the waves, I kept getting bashed back to shore, until a lovely bikinied beach bunny took pity on me, and showed me how to roll under the board to punch through the oncoming swells. I eventually reached the outer shoal and sat bobbing up and down shouting, singing every Beach Boys song I knew. I knew them all. I kept returning to my favourite, "Don't Worry Baby."

> *Well, it's been building up inside of me*
> *For oh I don't know how long*
> *I don't know why*
> *But I keep thinking*
> *Something's bound to go wrong.*

(The Beach Boys, "Don't Worry, Baby", stanza 1)

It was time to catch a wave. I never much considered the skill and balance that might be required to paddle up to speed, jump up on board, plant the feet, squat a bit, then nurse the wave to the right angle and ride it in. That lack of forethought hit me like a ton of bricks—literally. I am not a strong swimmer. I can swim the length of a pool, and that's about it.

After a few false starts, an oncoming wave looked good. I paddled quickly, got to the top of the wave, stepped up onto the board, then slipped off and grabbed it tightly…falling, falling. On the way down, I looked up to see the curl coming down hard. I instinctively swung the board between my head and the plummeting crest of wave. A huge mistake. Whack! The board slammed hard into my face, sending me flailing and spinning in a universe of foam like an astronaut on a spacewalk gone horribly wrong. I couldn't tell up from down.

I saw white then a vision came in a flash. From somewhere out of the swirling fury, a story I read as a teen in *Surfing Magazine* flashed through my mind. The writer, in the same situation as mine—knocked off his board—was thrashing around in the foam, not knowing which way was up or down. His hand happened to touch sand above his head. It had to be the sea bottom. Quickly, he inverted his body to allow his feet to hit the solid bottom and kick up to the surface.

I frantically began reaching, then one hand over my head touched sand. I twisted, planted my feet, and kicked up to the surface. Gasping for air, I was hit again with another down-curling wall of water. Hurled again into a furious foam world, I found bottom again and kicked off. With lungs bursting as I surfaced, a full-page cover picture from *Surfing Magazine* flashed into my head. It was a photo of a person body-surfing. Instinctively I assumed the same body-surfing

profile, and found myself quickly propelled towards shore on a wave. It tossed me hard onto the beach.

Wheezing and gasping on my hands and knees, slowly coming to my senses, I noticed my board was already on the beach high and dry. As I stumbled to my feet, surfer guys and girls were giving me the brightest of smiles. It wasn't a high-five surfing-fellowship grin. They were laughing because I was staggering like an idiot. I left California the next morning humbled, surprised, black-eyed, shaken, and happy to be alive.

Later that day, back home in Toronto, I took my two-year-old son Jake for a walk to the beach on Lake Ontario. It was a perfect warm, sunny, September Sunday afternoon. Lying back on a blanket, I felt privileged to be a Canadian. I liked where I lived. In Malibu, I woke up and looked out over the blue Pacific. In Scarborough, I woke up each morning, and looked out over big blue Lake Ontario. I arrived in L.A. a naive tourist, but Henry Morgan's take on it quickly sunk in. "Once you scratch away the phony tinsel of Hollywood, you see the real tinsel underneath." But one thing that impressed me about Americans was that they would hear you out, and give you a chance. I could have found work there.

Life was slower, easier, here in Canada. Especially for staying married and raising a family.

In a cloudless sky, from out of the sun, a swarm of about ten dragon flies began circling us. Jake got excited. I told him they are our friends because they eat mosquitos. I also added that they have an extra set of wings to carry an angel who has come down from heaven to see you.

I pushed him home in the stroller feeling content with my surroundings. As we entered the house, the phone was ringing. It was Archie Cheechoo.

"Lloyd," he said, "Harry and his group took off from Moosonee this morning in a fog—they were on their way to Timmins to catch their connecting flights home. Their Otter hit a power line over the Moose River and exploded. All ten aboard were killed. Harry's gone."

All I could think about were the ten dragonflies.

The London Free Press reprinted star reporter Joe McClelland's last story as a tribute. Joe was also killed on that flight.

> "There is no electricity here, but the Ontario Royal Commission of Electric Power Planning has come to Winisk to hear what the people think about the future generation of electricity, perhaps by turning the Winisk river around so it doesn't flow down to the bay anymore.

> Chief Charlie Okees of Fort Hope bluntly told the commission, "We have a right to say what happens on our lands. We have a right to say no. Where else will you find water as pure and clear as it was a hundred years ago? That is why our land is so dear to us."

The Winisk River

"Chief Nakogee of Attawapiskat, dignified, tough, and unquestionably in charge, cut off the discussion. "As we stated before, there's not going to be any more damming of rivers. We would not like anyone to destroy our life for the benefit of others."

Band elder James Kotak, a First World War veteran who speaks no English and doesn't know his age, made an eloquent plea that the white society and the native people be at peace, but he said, "We will not lie and cheat." He said demands are being made upon the Indians, but they ask only to be left in peace, "as before you people came. We must not destroy the things that give us life."

Harry had organized an influential trip. There was a massive funeral in Timmins. In one of the eulogies Harry Achneepineskum was called "a prince."

SHE GO BEE (BLACK SPRUCE)

The production for Treaty Nine that I was about to begin as a volunteer, in my free time, took on a new intensity. The multinational forestry company, Reed Paper, had the worst forest

management record of any company operating in the province, and it was responsible for the mercury contamination of the English and Wabigoon Rivers in northwestern Ontario. In 1970, it was charged with polluting the river, and forced to install pollution-abatement equipment. Seven years later, it was still being charged for the same offence. Although Reed had cutting rights to four million acres of northern Ontario, it wanted to quadruple its cutting limits by adding sixteen million acres of predominantly black spruce forest, an area the size of New Brunswick. Being the most highly mechanized company in the province, it insisted on clear-cutting the area.

Future Booker Prize winner John Bemrose volunteered to write the voice-over for the film, and actor David Hughes, as a seasoned northerner, gave a spirited performance as narrator. The National Film Board donated time at a sound-mixing studio. Archie Cheechoo and his friends wrote and recorded an original soundtrack. I got a co-writer credit for Archie's song "Child of the North."

Ojibway elder and orator, Fred Plain, showed up at a makeshift recording studio in my basement. Fred sat by the microphone, closed his eyes, and gave a hypnotically passionate speech right off the top of his head.

> "Living in the vastness of the northern area of Ontario is a people who, for centuries, have maintained a vigilance over the land that is part of their heritage. They must feel with the land its movements; they must feel with the land its hurts; they must feel with the land and its resources all that has been imparted to them by Kashemnido or the Great Spirit—for the Great Spirit placed these people here to be stewards and guardians over that which he entrusted them to."

Historian Jim Morrison provided an interview (recorded in 1974) with Robert Lawrence, then eighty-four, who witnessed the signing of Treaty Nine in 1906 in Matagami, Ontario. Robert Lawrence was the clerk for the Hudson's Bay Company post there.

A signing ceremony of the Treaty Nine (Public Archives of Canada)

Witnessing the signing (Public Archives of Canada)

Witnessing the signing (Public Archives of Canada)

"My impression, and I know the Indians' impression, was that they had this land, but they would be able to hunt just the same as they were hunting at the time. If there was any clause in the Treaty that was put against that, then the Indians didn't understand it and I know that quite well, because they didn't understand half of what was going on anyway, you see. But that thing isn't right, you see. They fooled the Indians on that. Yes, yes, it was the clause, 'Subject to other regulations'. Well, how would the Indians know that? To my way of thinking, it was a one-sided agreement. All bunkum, as far as I could see."

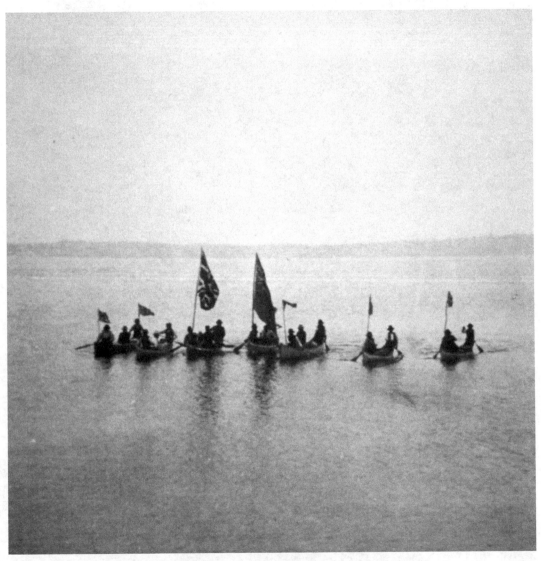

Treaty party arriving (Credit: Public Archives of Canada)

Treaty party throwing candies on the ground (Credit: Public Archives of Canada)

Treaty party throwing candies on the ground (Credit: Public Archives of Canada)

Images of a parade of canoes with billowing Union Jacks, commissioners throwing candy on the ground in front of scrambling villagers, and the treaty-signing ceremony, accompany his recollection.

Robert Lawrence continued:

> "And the poor Indians…. The treaty party came in there with big canoes, union jacks flying, and mounted Police, and all this kind of stuff, and made a big thing about the Great White Father, and how they were going to look after them and protect them. And they gave the Indians—what was it?—a square mile per family of five, and these fellows had been used to roaming all over the country as their own."

The show ended with Fred Plain's voice. "We must be bold, we must be brave, and we must continue to hold on, even though we live on the last vestiges of what was once totally ours."

I titled the show, *She Go Bee,* which is Ojibway for black spruce. Copies of *She Go Bee*, with a timed cassette and tray of one hundred forty slides, went out all over the province to be shown to interest groups and stakeholders. The master version had two trays with a dissolve unit and reel-to-reel sound. Archie asked me to take that master version to Ottawa to show to a high-level meeting of federal and provincial cabinet ministers and business people. My participation had to be covert.

While I was setting up the show in the nation's capital, I learned that my minister, Frank Miller, Ontario Minister of Natural Resources, would be at that meeting. At show time, I waited until the lights went out, and then I virtually crawled into the room. I operated the show manually, clicking the slide changes to sync to the soundtrack from memory. Right near the end, a slide jammed. I had to run up front to fix it, and then I beat a hasty retreat. Right about that time, I decided that I was not cut out for under-cover work.

Reed Paper lost the deal. Treaty Nine won. The massive project was cancelled.

Some Americans who had been visiting northern Ontario caught wind of the show and heard that the guy who did it had a code name to hide his identity. (I was referred to as Dylan.) I received an invitation to visit them in Ithaca, New York, which coincided with a family trip we were taking to Cape Cod.

Although they said they were college professors, I felt a bit uneasy around them. The farm house we visited had the unlived-in quality of a halfway house. They talked about having their phones bugged by the FBI. Were they Weathermen, a resistance group? I was paranoid enough to think that they could have been CIA. They had probing questions, but the only answers I could provide were positive impressions of my associations and adventures with my native brothers. One of the group, Norman, returned to Toronto. He called me several times, urging me to join a men's confessional group. I told him that I was happy with my life and had nothing to confess. He eventually gave up and stopped calling.

Overall, though, it felt good to be doing interesting volunteer work. My boots blazed some new northern trails. With the will of the people, and a noble cause, we slew the giant.

Slaying the giant

CRICKETS MAKE ME NERVOUS

While serving the many branches of the Ministry of Natural Resources, my small department of two, with partner Gerry Merchant, produced about a dozen or so inexpensive animated slide films on 16-mm film before I was able to convince management to allow me to shoot an actual live-action film.

To learn the nuances of shooting live action, I spent a week at the National Film Board headquarters in Montreal, meeting with experts in every aspect of movie production. They were generous with their advice and candid in their impressions of their workplace. On one hand, I desperately wanted to work there; on the other, every member I spoke to told me that I had a good thing going in Ontario. I had a large degree of creative control, and a wide subject base. Although the grass was not necessarily greener in Montreal, I was still star-struck. One key piece of advice stood out. "Put everything you've got into your project. Otherwise, it's only a film."

The Ontario Ministry of Education was shutting down their audiovisual department, and they graciously gave me their old Éclair 16-mm movie camera. My first full-motion film would be a comedy called *Crickets Make Me Nervous*.

In the story, a city bumpkin, dressed for disco dancing, goes camping, and he takes everything but the kitchen sink with him. Our hero, wildly out of his environment, becomes smitten by two women on the next campsite. His white shoes, among other things, turn them off. Two seasoned forest rangers try to teach him camping skills, with amusing results.

While scouting locations, I found myself on the threshold of being attacked by a black bear. While scouting in Killarney Provincial Park, the big news was about a bear killing three young boys in Algonquin Park. Shooting the breeze with Killarney staff late one night in the bunkhouse, I learned that bears were breaking open car trunks in the nearby campground. Families were being terrorized. I had a long hike planned in the morning, so I asked Tom Linklater, the ultimate bushman, for advice on being confronted by a bear. Tom said, "Carry a big stick or log with you. It will make you look bigger."

The next morning, with two park naturalists as guides, we parked the truck at a jump-off spot and began the trek to Silver Peak, the highest point in the park. It was a three-and-a-half-kilometer hike to the base of the mountain. In my pack was my 16-mm Éclair camera, lunch, water, and film magazines. A heavy tripod with wooden legs was lashed and balanced across the top.

After a winter of office work, I was breathing heavily to keep up to these nature-loving athletes. The view was spectacular from the summit of Silver Peak. It was like being in a Group of Seven painting. My two guides then told me they planned to continue on, check out the trail, and camp out overnight before getting back to the park office. I had to get down the mountain and back to the truck before dark, alone in bear country!

Climbing down a mountain is harder on the legs than going up. As my thighs began to tense up, my swagger became a stagger. Weaving on and off the footpath, my arms were aching as much as my legs. It was the stupid log I was relying on to scare off bears. One of the purposes of this new film was to dispense camping wisdom. I then remembered the bush wisdom in the script that Tom Linklater, the ranger, tells the greenhorn, "If you get tired of walking in the bush, stop by a stream, take your boots off, and wash your feet and socks. It is surprisingly refreshing."

Up ahead a stream gurgled under a footbridge. I dropped the log, untangled my shoulders from the pack, plunked down on a rock, pulled off my boots, and washed my socks and feet. I began to doze off, but the notion to get back to the car before dark jabbed me awake.

I laced up, and threw on the pack. My feet really did feel better. "Thanks, Tom," I said. Now for that log. I rooted around and struggled the heavy limb into my arms. It looked ridiculous. "Screw this," I sneered, and threw it into the bush with a crash and a thump.

I looked up to see a startled big black bear walking down the trail right in front me. It stopped, and stood up on its hind-legs. Our eyes locked. It snorted. The intensity of the moment entered through the top of my head and shot down my core, exiting my fingers and toes. The bear twisted around on its hind legs, and shot off down the trail, in the direction I was heading. Would it

be hiding up ahead to jump me? My body was charged with adrenaline. I rooted around in the bush, picked up that log, and marched down the trail with a newfound sense of strength. Surging with adrenaline, I was ready to fight it off with a whack of that log. My eyes pierced every dark shadow along the way. I was given a gift of energy. It was a teaching of bear power.

Brent of the Bush goes camping

The *Crickets* film was fun to make, although we had enough film for only two takes of every scene. The film's stars were raided from the office. Fellow worker Gerry Merchant was a natural for playing nebbish "Brent of the Bush." The story ends with Brent reading the book *Bear* alone by the fire. He is startled out of his wits by two lovely ladies bringing him a tray of brownies. *Crickets Make Me Nervous* became a cult film into the '80s with campground audiences. The movie, charming and funny as it was, was so bad that it was good.

Its popularity called for a sequel, *In Search of the Perfect Campsite*. The same city bumpkin Brent is on his honeymoon. He surprises his new bride by taking her camping in the provincial park instead of the more usual Las Vegas or Niagara Falls, for which she has prepared. I used every trick I could think of for subliminal messaging, even to arranging the direction of the driftwood logs on the beach in the background to direct the eye to the centre of interest in the foreground. The angle of the axe handle to the side of the actors on their wedding night reflected the groom's state of erotic readiness. In another scene, the angle of an upright log on the beach did the same.

I was doing a government film that was a romantic comedy, and getting away with it.

The bride and groom at a crossroads in their relationship

Honeymooners on the brink

The script called for the hero to take his bride canoeing, and a moose walks up to them in the water. The payoff was a very adult joke that, although the kids wouldn't understand, I wasn't above using. It was a challenge getting a wild animal to walk in on cue for that scene, but I did it. In the process, I got up very close to a few moose. Making close eye contact with these strange creatures stirred me in an unusual way. There was a connectedness of spirit. I drew a sketch of one of them looking at me, asking someday to be in a movie.

This guy wants me to make a movie about him

A COUPLE OF GREAT SAVES
LATE IN THE THIRD PERIOD

Bill Mason received an Academy Award nomination for the first film he did for the NFB, *Paddle to the Sea*. Through our chance encounter on Lake Superior, we began a correspondence that led to him becoming a mentor to me. He convinced me to shed the writers I had been working with, and reach into myself to make my own kind of movies. Bill was right. He convinced me that we really didn't want to encounter uninitiated city slickers in the wilderness. Bill advocated the canoe as the only vehicle for entering Canada's most important treasures, our wilderness. His attitude to work was infectious. "If it's worth doing, it's worth doing with enthusiasm and joy."

Bill Mason and son Paul

It began as pure seat-of-the-pants filmmaking to take the audience with me up and over the hill to show the lands, lakes, and rivers far beyond the end of North Street. To paraphrase Norman Rockwell,

"I was showing the Ontario I knew and observed to others who may not have noticed it." I called my new film *Natural Journey*.

Natural Journey, and its sequel, *S*N*O*W*, allowed me to push the tourism film genre further by injecting subliminally layered storylines, revealing rugged natural wonders in a totally different

way than Ontario tourism films were produced at the time. It was also my chance to introduce pictograph and petroglyph images in a respectful way.

Natural Journey was a simple-yet-complex-as-you-want-to-make-it story. Both *Natural Journey* and *S*N*O*W* told a story within a story about an attractive woman moving farther and farther from the city, seeking something. I left just enough mystery for the viewers to make their own conclusions as to her motives.

Her name was Biba Tharp. Originally from Calgary, she had just returned from ten years of schooling in England and France. Biba carried with her a traffic-stopping sophisticated European flair. I loved the idea of placing a beautiful and exotic-looking woman in the wilds of Ontario, and making the audience wonder what was on her mind. Biba carried the role very well. Acting is all in the eyes.

Biba in Natural Journey

Biba in S*N*O*W

She was still wearing full makeup from filming when we raced into the Sault Ste. Marie airport at our departure time. The ground crew was pulling the stairs away from the plane, and the jet engines were firing. Partly as a joke, I said, "Why don't I return the rental car while you see if you can get the plane to come back?"

There was no way any booth agent worth his manhood could refuse this striking-looking woman. He got on the phone. "We have some stringers here."

The plane rolled back, the stairs were wheeled back out, and we were welcomed aboard. That was the exotic part of filmmaking. Occasionally danger also lurked. To reach a floundering shipwreck on moving ice on Georgian Bay, we had to carefully dance over floating ice pans.

While collecting my considerable film gear at the Thunder Bay airport, I noticed a larger movie crew doing the same. The film director from the other crew, commissioned by the Ontario Ministry of Tourism approached me with a stern, "What are you doing here ?"

I told him that my team of two (cameraman/actress) was shooting a love story. He seemed irritated that I would be filming the same event, a massive cross-country ski-race in Sleeping Giant Provincial Park.

With my camera at the ready, two hundred skiers were ready to race. Minutes before the starting pistol, a helicopter with the director sitting in front seat and cameraman hanging out the side door approached, then hovered directly over my head. I fell to my knees holding down the tripod legs in a blinding, swirling, downwash blizzard.

It took fancy footwork on floating ice pans to reach the listing wreck
for filming out on Georgian Bay.

Back in Toronto, there were outside forces mounting to close down my department. I would have to muster all of the life lessons I had learned, and adapt them to skills of high diplomacy. To save my job, I would have to resurrect even my goaltending instincts. A new team was coming in to try to score on me.

The Toronto office of the Ontario Ministry of Tourism would not distribute *Natural Journey* or *S*N*O*W*. Tourism policy at the time was to support Toronto, Niagara Falls, Ottawa, and Algonquin Park. I did show Niagara Falls in my film but didn't identify it as such.

To the people making tourism policy at the time at Queen's Park in Toronto, the north was Barrie (100 kilometres north of Toronto). My idea of "north" went well beyond that. I was told, "Nobody wants to see rocks and trees."

Furthermore, the government mandate was to have private film companies make tourism films. I was an embarrassment to that policy, because *Natural Journey* made their most recent privately-produced film look very bad. I felt that I knew more about Ontario and tourists than any politically appointed, high-priced Toronto consultant could, let alone the Tourism Ministry people stuck in their Toronto office cubicles. But I was up against the wall in Ontario.

Fortunately, the National Film Board and the Government of Canada took notice. After screening the films in Ottawa, I obtained federal government funding to distribute *Natural Journey* worldwide in five languages: Dutch, French, German, Japanese, and, of course, English. The NFB sent the international consulates of Canada and Ontario several hundred prints, unbeknownst to the Toronto Tourism office. Millions of people viewed them in the United States alone. I was asked by the French and German tourist offices to travel there and speak to prospective audiences, but my managers would not let me go. I later learned from one Ontario Tourism ministry official that it was bad protocol for me to work with the federal government because it was Liberal and the provincial government was Conservative.

Around the same time, government communication strategies were becoming highly political, and directed from the top town. The voice of government was being centralized. Any grass root initiatives (those with budgets) were to be sent to an outside advertising agency.

Government communication staff were being laid off. In-house productions like mine were becoming taboo in government. All audiovisual departments in the Ontario government were being shut down, and their staff laid off.

The new political person who was parachuted into our ministry began by laying off our highly talented graphic design department. This "government downsizer" was highly ambitious, and I was her next target. Using my goaltending instincts, I tried to figure out how this lady would skate in and try to put the puck behind me. Using situational awareness, vigilance, and mindreading, I watched, planned, and crouched, waiting for her shot.

She had heard about the recently completed *S*N*O*W* film, and asked for a screening in the board room with my managers. I was, of course, nervous. Admittedly, the story was elusive. A woman gets out of her car (a cherry red checker cab) on a ferry and looks up to a sky full of frantic whistling swans. She seems to go into a dream. The swan-filled sky pulls the full force of winter behind, as her dream continues to a frozen Great Lakes shipwreck in Fathom Five

Provincial Park. We continue a tour of Ontario parks draped in snow. We are taken out of her dream back on the ferry with the swans returning in spring.

When the lights came up, there was a chill in the air, and not because the film was about winter. She hated the movie and announced to my managers that it was to be removed from circulation, immediately. To be fair, it was her job to dismiss the film. My colleagues that day were reluctant to defend me because of her position. A civil servant is never to disagree with the highest-ranking person in the room. Out of fear and embarrassment, the room quickly cleared out.

Then there were just the two of us. I was face to face with the intimidating woman who was about to end my so-far successful career as a government audiovisual producer. I waited for the verdict, and the bang of the gavel. Her voice cut the silence with just a trace of sneer. "Do you have anything to say?"

I replied, "Actually, I have already let the media in the north know about two Sault men—Super Minister Russ Ramsey and filmmaker Lloyd Walton—who collaborated on a new winter film that has been nominated for an award by the Academy of Canadian Cinema."

"You_know Russ Ramsey?" she sputtered. (Russ Ramsey was what was then called a Super Minister, who oversaw the operations of four other ministries including our Ministry of Natural Resources.)

"Yes, we go back to our TV station days; we're old buddies."

That statement was a bit of a stretch. When I worked as a student at the TV station back in the Sault, Russ Ramsey was the station manager. At the time, he was running for a federal seat in parliament for the Conservatives. Because he was the boss, I did some extra work for him after hours, designing print and TV ads for the coming election. Russ was a seasoned newscaster, so he was happy to help me out with a voice-over in the film when I called his Toronto office.

I said, to her shock, that Russ Ramsey played the role of news announcer in the film *S*N*O*W*. Truth be told, I had originally used another announcer, but I decided to stack the deck, and re-record it with Russ, who in fact did a better job. Office politics can be like playing chess with loaded dice.

I said, "How should I tell Russ that it won't ever be released, especially after our collaboration has been on the news up in the Soo?" I also reminded her again that *S*N*O*W* had been nominated for an award at the Academy of Canadian Cinema Film Awards. That also took her back a bit. She allowed the film to go out to the public, but with no more publicity.

Two weeks later, *S*N*O*W* won a Bijou Award from the Academy of Canadian Cinema. The Bijou awards were a precursor to the Gemini Awards. I had enjoyed winning numerous awards in the United States, but, winning "Best Promotional Film in Canada" against some hefty competition was the greatest recognition so far. It also saved my job, again. Or was it knowing Russ Ramsey?

She came in on a breakaway to score; I foresaw her move, and kicked it out with my "buddy Russ" save. I stopped it again with the Bijou on the rebound. Life lessons in hockey. I was still only getting started in making movies. So many new ideas had caught my imagination, and I was burning to get out of the office, back into the wild. The star in the indigo twilight sky was lighting the trail.

THE THUNDERBIRD

Another reason I stayed working with MNR were the many interesting staff members and fascinating characters who worked in the field offices. They were the ones who had real contact with the people and the land. One such character was the naturalist for Quetico Park, Shan Walshe. Quetico, west of Thunder Bay on the Minnesota border, was a jewel of a wilderness park, blessed with myriad canoe routes.

Shan, a botanist who could recite the Latin name of any plant in the park, was also a highly competent woodsman. He lived with his family in a staff house in the park. A cousin of mine, John Switzer, remembers him this way:

> "Shan was a pretty remarkable person, and his family and our family were pretty close when I grew up. All his kids were pretty interesting as well. His son Patrick and I pitched a tent once (he was about ten), and instead of swatting the mosquitos that made it inside once it was set up, he promptly caught a dragonfly and left it in there until night time. It ate all the bugs, then he let it back out."

I had an assignment to produce five thirty-second public service television announcements about the five different classes of Ontario parks. When I mentioned to Shan that I wanted to show that wilderness parks meant "roughing it, and weren't for everyone," his eyes lit up. Part of my job was also filming historic zones in provincial parks. Shan mentioned that there was a thunderbird pictograph in the park on McKenzie Lake that he could take us to.

The word "thunderbird" has always intrigued me, and I don't mean the car. While doing archival research, an article from the *Winnipeg Free Press*, from March 7, 1918, caught my eye.

> "There have been strange electrical phenomena over the hills of Thunder Bay for almost a week past, in the midst of which Ojibway Indians from the Mission Bay claim to have seen the sacred thunder eagle depicted in the fire and in full flight over the lake."

Shan and his sixteen-year-old daughter, Bridget, acted as guides for me and my two assistants, Peter Elliott and Felix Barbetti. We set off in early June. The canoeing was fast, long, and tough, but the portaging was worse. The heavy tripod was cached at our first night's campsite, to save weight. To get to McKenzie Lake, we carried canoes, food, and camping and camera gear over eight kilometres of soggy portage trails. If we stepped off the trail, which, quite often, was just a single slippery log floating over bog, we were thigh deep in loon shit. The mosquitos were so dense, I had to keep my teeth clenched to prevent inhaling them. Meanwhile, several times Shan halted, and called the city stumblers (the three of us) away from the trail, dropping to his knees, and cupping a plant in his hands. "Golly, look at that," he'd say in astonishment. "A maiden-hair spleen wort."

Slogging the Quetico portages

Bridget slogging the Quetico portages

INTO THE STONE

A storm hit halfway in, and the trees waved wildly like hippies' arms at a rock concert. With the camera perched on a tree stump, Bridget leaned into me to hold me steady as I filmed into the wild wind. The scene of stumbling portagers shouldering twisting bobbing canoes overhead looked stunning through my eyepiece. The sky was saturated with lines of lightning, in forms I have never seen before. Soaking wet, cold, and exhausted, we arrived at a ranger station, a cabin on McKenzie Lake.

Later that evening, while we thawed and dried out by the woodstove, sipping tea, Shan told us a story about how he and Bridget (at age twelve) had been on a job deep in the interior of the park to clear fallen trees and brush from a trail. They were staying at a ranger cabin. In the middle of the night, a bear broke the kitchen window and was trying to enter the cabin. Shan stayed up all night waving an axe to keep the bear out. They went about their work all the next day, and then went back to the cabin. Bridget continued the story:

> "My daddy fell asleep because he was up all night trying to keep the bear from coming in the broken window. I couldn't sleep because I was afraid he would come back. He did! He came to the door. I tried to wake my daddy, but he wouldn't wake up. I got a stick and poked him in the nose. He moved back, crouched, and snorted. Finally, my daddy woke up, and scared him back into the bushes."

The next morning, we started filming around the shore of McKenzie Lake. To allow for easier movement of the camera gear, we left our life jackets back on the dock. Crouched in the middle of the canoe with the camera, I directed Peter and Felix to paddle our craft around our subjects, resulting in beautiful sequences of Shan and Bridget pulling flashing rainbow trout into their canoe. One thing led to another, and we were lured across the big McKenzie Lake to find the thunderbird pictograph.

There it was, painted on a rock face—perhaps centuries ago—its red pigment still bonded into the stone. Overhead, the wind suddenly began to speak in a low, mean groan. Was that an omen? I perched my camera on the top of a pointed rock about three metres across from the image. Again, Bridget leaned into me to help steady the camera against the mounting wind. I clicked the start switch, and nothing happened. The battery cable had become disconnected. Peter, my camera assistant, jiggled the cable to start the motor; but every time the camera started, the wind blew the lens away from my focus point. Capturing the image was becoming hopeless. Thinking that I had at least three seconds of footage—I could do a freeze frame back at the lab—I said, "Let's get out of here." Something didn't feel right.

Facing a sea of white caps as we entered the big lake, the wind picked up even more. Shan recalls that he had ominous thoughts, including the lines in the poem "Rosabelle," "Nor cross the stormy firth today."

With assistant Peter Elliott jiggling the battery cable

Halfway across the lake, a sudden rogue wave swamped the canoe, sending cameras, film, and gear scattering in the foam. Clinging without a life jacket to the overturned canoe, I was shivering, cold, and disconsolate. "So it all comes down to this." I thought. Looking over my shoulder towards the sun, I thought of my wife and kids.

Shan and Bridget, nearing the far shore, looked back to an empty lake and quickly turned back. After a few passes, they were able to throw us a line and, through awesome strength and canoeing skill, pulled and pulled the cold wet three of us—hanging on and hanging on—across the heaving lake. We made it to a small island to wait out the wind.

Their tenacity and canoeing skills saved our lives. It was a trip of many lessons. I put more value on water safety in general, and life in particular, after that. And yes, wilderness parks aren't for everyone. The thunderbird on the rock—and perhaps one captured from the wild wind sky the day before—were taken back by the water.

Shan summed up the adventure in his June 1979 newspaper column for the *Atikokan Progress*, Lynx Tracks:

> "Reminiscing at the cabin five hours later, after a much-appreciated meal, none
> of us really regretted the capsizing. True, we had lost some film, become very
> hungry, and had a close call with hypothermia. But we had gained something
> intangible. We had tasted the wild, dangerous, exciting life close to nature,
> experienced by countless generations of our forefathers, but lost today in the
> dull routine of modern civilization. In Quetico, we all agreed, we had not
> merely existed, we had lived."

Fred Wheatley was visibly upset when I told him of our ordeal. In addition to his concerns about travelling over water without life vests, he told me, "You must approach these sacred places with the greatest respect, and offer tobacco."

We had just blundered in without respect, stolen an image, and paid the price. For some unknown reason, the Meshepezhew, sweeping his mighty tail from the depths below, spared us.

In late autumn of that year, I drove to the petroglyphs near Peterborough to film the historic-park part of the series of TV spots. Hunters lined the road as I approached. It was the first day of deer season. It was also the wrong day for me to be wearing a buckskin jacket. I had the key to the gate, and I entered the park alone.

I cleansed myself with sweet grass as Fred had instructed, and then I walked onto the large rock, which was filled with hundreds of carvings. I laid down tobacco, and spoke my intentions.

I did not feel alone. I could hear echoey sounds. This place was not chosen arbitrarily by a people long ago. There was something about it, something in the air, and something deep down below. After I did the filming, and packed up, I went back to the rock and placed some tobacco. I asked to have someone sent to me to read the messages that they contained, and then I looked up to the sky.

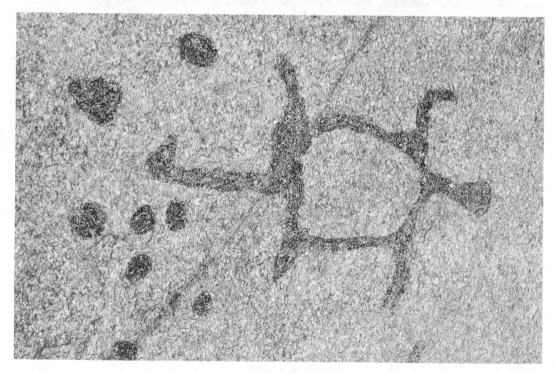

Turtle Image

KISSED BY A MOOSE

Indeed, I was a devoted student, learning the ways of nature by throwing myself into it. After a full day of shooting the *Perfect Campsite* movie, I spent my evenings stalking locations where a moose might walk into a dramatic moment between two people. In the process, I got to meet a number of moose close up; close enough that I felt we had a meeting of minds. I drew a picture of one moose smiling at me. It was asking to be in a movie about moose. That drawing kept turning up in my sketchbook as a reminder, then bang! It happened.

The Ministry's Wildlife branch had instituted a new practice for hunting moose in the province; hunters were given tags for hunting bulls, calves, or cows. It was an idea proven elsewhere to increase the size of the herds. But how was a novice hunter to know the differences? I was enlisted to make a movie to show to distinguish between bull, calf, and cow moose. As a bonus to this new policy, Ontario's herd was expected grow by 20,000 animals. It seemed like an onerous job, but I said I'd do it.

I went to Fred Wheatley again, and asked for advice about working close to moose. He told me that my voice would tell them that I meant no harm, and also my eyes would tell them. He said,

> "Talk to them. Tell them what you are doing. Your voice indicates that you mean them no harm. They look you straight in the eye…those animals look you straight in the eye and if your voice may not be lying, but then your eyes can be lying—so there's two ways that they can evaluate you. But I think it's the softness in your voice when talking to them."

On my first day of shooting outside of Thunder Bay, I came across a cow moose sitting in the grass, dappled in the warm light of a sunny June afternoon. I put down the gear I was carrying, smiled, and said, "Hello, I'm Lloyd. I have just begun to make a movie about moose, and I would dearly like to film you because you look so beautiful sitting there. Now don't mind me. I won't come any closer. I will just set up this low tripod called Baby Legs, mount the camera, and begin."

When I told her how beautiful she looked in the dappled light, she batted her long brown eyelashes.

I was on my knees panning left then right, and zooming in and out slowly till I felt that I had everything I needed. I then said, "Thank you, sweetheart. I'm going to make you a star."

She awkwardly got up on her feet. I turned the camera back on. She walked slowly towards me, bent down, kissed the lens, then turned her head and slowly walked away. I think she went ahead to pass the word on to a few others, "This guy is OK. He has some contraption that won't hurt you."

I attached the longer tripod legs as I approached a pond where a bull moose was swimming towards me. I kept the camera rolling as he slowly got out of the water and walked up to check me out.

Close encounter

I was not the kind of wildlife photographer who could wait for days for an animal to appear. I had a lot of other duties in my job. Working with a group of highly motivated wildlife biologists, I would get a call late in the afternoon to alert me that a herd of moose had been spotted. I would catch a morning flight to Timmins or Thunder Bay, or drive to Algonquin Park, do my filming, and return home that same night.

Directing the actress

I seem to get along with moose

For the last shoot of the film, I left Toronto after work with my canoe on top of the car, and drove to a wildlife research centre at the north end of Opeongo Lake in Algonquin Park. I pulled in around eleven o'clock in the evening. Before five o'clock the next morning, I had someone ferry me and my canoe, by motorboat, to the top end of the lake, and drop me off alone at the mouth of Hailstorm Creek. Up ahead and around the bend, it was as if, through some secret language, the Algonquin Park moose had spread the word that it was Lloyd's last shooting day for his film.

"Hey gang, it's your last chance to star."

With the camera on a tripod at the front of the canoe and me in the back, I rounded a curve in the river to find a herd of moose snacking knee-deep on aquatic vegetation. I paddled in, coming out of the sun, making it difficult for them to see me. Whenever a moose dipped its head underwater, I paddled closer. As its head came out of the water, I remained motionless, with the camera purring silently. To a moose, I could have been a floating log. More and more moose wandered out of the woods to check out the scene and pose. Mom-moose played with their kids. I filmed one female that looked like she was dangling a cigarette out of her mouth. Save that for a future forest fire film.

By ten o'clock that morning, I thought about heading back, but first I thought that I would try a silly moose call that my friend Archie Cheechoo used on some gullible American hunters at his dad's commercial hunt camp. They had been up all night partying, making lots of noise, and scaring all the game away. So Archie wanted to make a point. Mimicking Archie, I pursed my fingers to my nose, and shrieked, "Here, moosie, moosie, moosie!"

Behind me, directly over my shoulder, I heard a loud "snort." I slowly turned my head and looked up at a big black bull moose standing hip-deep in the water and breathing down my neck. I very slowly and nervously turned the canoe around to face it with the camera. As it left, leisurely walking away, a gentle puff of wind blew the canoe in a sideways motion, creating a tracking shot with the bow of the canoe and Bullwinkle moving in unison. A classic scene.

Spread out over a year, it was only nine days of filming, but I had captured the yearly life-cycle of moose, and the body changes they go through in each season. I called the film *Of Moose and Man*.

Something still kept luring me back to the edge of yet another world, far from the city. I was getting closer to the intimacies of nature. Northern skies were calling. Older doors began to open. Some were merely tent flaps.

BEYOND THE POLAR BEAR EXPRESS

As a kid, I was sure I'd be an air force pilot flying an Avro Arrow out of a secret air force base on Hudson Bay. Well, I did go to Hudson Bay often, but the only military presence I found was a rotting Dew Line radar base abandoned since the end of the Cold War. It no longer searched the skies for Russian bombers.

It was not always easy, leaving my family and the comforts of life in the city, wondering how I could make this land of stunted trees, countless bogs, and endless tundra appealing or interesting to the average person. But it's what I signed up for, trudging up North Street, so long ago. It can be a bleak, unforgiving landscape.

Site 415, an abandoned dew line radar base on the Hudson Bay lowlands

Would I rather be working in the film industry in Los Angeles? No. The power of the northern sky meeting the horizon kept drawing me back. Interestingly, it has recently been discovered that the earth's gravity is slightly less intense along the Hudson Bay coastline, partly due to the glacial rebound effect on the land, and partly due to the plate tectonics deep down below. That may explain why I seemed to have an extra spring in my step when I visited.

Camping in a tent with a group doing a scientific study of polar bears, I was advised to stuff ten pounds of steak in my sleeping bag at night to slow the polar bears down. Beside my cot was a loaded 45-calibre pistol. Just in case.

Surrounded by scientists, a large white polar bear, darted and drugged, lay in the early autumn snow of the Hudson Bay coastline. Crouching to my knees, I moved my microphone to its mouth to record its loud snoring.

Noticing its eyes were open, I leaned down real close to look him straight in the eye. He blinked. My whole life passed before me. Eternity in the wink of an eye.

Sleeping bear

One morning I took a lone walk toward a blip on the flat distant horizon. As I got closer, I could see that it was a solitary sand dune about ten metres high. I climbed to the top to scan the horizon in all directions, and then I looked down. Below me on the back side was an empty polar-bear den.

Polar bear den

On another shoot, I employed an attractive young Cree woman from Attawapiskat, Jackie Hookimaw, as an actress to give a flow to the James Bay/Hudson Bay story I was trying to piece together. Walking along the Hudson Bay coastline with Jackie late one August night, the sky was saturated with vibrant, throbbing, crackling, laser-like northern lights. Off in the distance, flashes from a distant lightning storm also lit up our surroundings. We were searching in the dark for the bridge to cross a river to visit an old trapper.

The bridge to his teepee was made up of old rubber snowmobile tracks wired end to end on top of a radio antenna. Because of the darkness, I was dreading trying to walk on black snowmobile tracks high over the water with no railings and only a flashlight for guidance. Adding to my uneasiness, it was polar bear country. We had seen upwards of thirty white bears along the shore when we flew in to our camp earlier that day. Jackie and I pressed on until we arrived at the river, and found the bridge. To our delight, the black rubber tracks were illuminated from below by the contrasting frothy-white foam flowing upstream from the incoming ocean tide. It was a perfect invitation to trapper Tobias Hunter's teepee on the opposite shore. I held my breath and crossed.

Tobias Hunter, age 75, ran a sixty-mile-long trapline in winter. He greeted us warmly, and we sat down to listen to his stories. He told about being trailed by a polar bear once, when he had only one bullet left in his gun. He heard it sniffing outside his tent one night and lay, rifle-ready. Like a miracle, another bear appeared and attacked his predator in a fight to the death. By the light of a coal-oil lamp, old Tobias demonstrated the gnashing, roaring, and gnarling sounds of

two polar bears in full fury. Scattered around his tent in the morning were the remains of the loser. The intruder was gone, its hunger satisfied. Life on the trapline.

We left the teepee at about three o'clock in the morning, and the white foam was still on the river surface, illuminating the black walkway from below. Jackie said, "When something like that happens, it means that you have a spirit guarding you." After that, the polar bears didn't worry me anymore.

Jackie Hookimaw

One cold February, a conservation officer named Whitey and I loaded my camera gear into a Turbo Beaver aircraft on skis at the Timmins airport. We flew north toward James Bay to join another Cree family on their trapline. Landing on a frozen lake, we were greeted by Luke Diamond, his wife, Gertie, and their teenaged daughter, Linda.

I quickly unpacked and assembled the camera to film the family building a teepee for us to sleep in. A small wood stove was set up in the middle of the teepee, and it was quite comfortable inside even though it was minus forty-four outside.

As we dined with the family in their tent, I was shocked to find how comfortable we were, sitting on a bed of fragrant balsam boughs in a circle around a dinner of roast beaver and rabbit dumplings. I remember saying to myself, "This is not roughing it."

As per wigwam etiquette, we reached over and tore off a piece of meat that looked good, using our fingers. Gertie told me that on Saturdays, to spruce things up, they would roast the beaver. The beaver would hang and spinn beside the stove all day, basted on the outside with raspberry jam. Yum.

As he chewed the tiny bits of meat around the beaver claws, Luke compared eating moose to beaver. He said that when you eat leftover beaver for breakfast, "it can keep you going for most of the day. As for moose," he said, "I like the part behind the eyes."

It occurred to me that perhaps there is a vital vitamin stored in that part of the moose, essential for a balanced diet. The evergreen branches in the moose's diet are very high in vitamin C. Using every part of the animal also honoured the animal that gave up its life, by not allowing its body to go to waste. There was no chance of running to the store to buy fresh vegetables. This was a family spending most of the winter on the trapline, rather than sitting on the reserve hoping for piecemeal work.

"Here I can be my own man," he said defiantly.

I used Archie Cheechoo's song "Child of the North," again to play along with the "life on the trapline" sequences in the movie *Beyond the Polar Bear Express*.

Adopted for life
The land is her home
Living a life
With freedom to roam.

On our last evening in the starlit frozen forest, the cold was so deep that the frost made the trees pop and crack loudly. Aside from that, it was completely and utterly silent. I crawled into my sleeping bag wearing a balaclava. As added insurance, I spread a thin, aluminum, space blanket on top to keep the heat in. My sleeping bag was only rated for minus-fifteen degrees. In the middle of the night, the fire in the wood stove went out, and very quickly the outside temperature of minus forty-four degrees Fahrenheit flowed into the tent. Moisture from my sleeping bag collected on the underside of the space blanket. The dampness collected, condensed, then turned into icicles. Then the heat emanating from my body caused those icicles to melt and drip, drip, drip, back into the bag. Needles of wet cold penetrated my bones, stabbing deep

into my core. The frigid sensation was paralyzing; yet it seemed to enhance a wonderful deep sleep, and it was taking me away. I remember thinking that this would be a good way to die. Something sweet was drawing me deeper and deeper and deeper, down into the black.

Out of the depths of the abyss, a slow, stirring, swelling, mounting urge to urinate urged me very gradually out of my stupor. It took long serious internal reasoning to summon the strength to unzip my bag and crawl out of the teepee to relieve myself. It was as cold outside as it was inside. The brightness of the stars lit up the night like a full moon. The silence was deafening, save for the popping of the trees. Crawling back into my wet bag, weak, dazed, and shivering, I woke Whitey, suggesting—no, begging—that he start the fire.

I felt very sick the next day but I did not tell anyone. There was still work to do.

On that last morning, a flock of grouse settled in a tree behind the camp, and Gertie shot about a dozen. Before I left Toronto for that trip, I asked Fred Wheatley what I could bring to the Diamond family as a gift. He told me, "Salt pork." So that's what I did. The Diamonds would be having "chicken" dinner that night. And salt pork was the perfect cooking fat.for the grouse.

After a leftover beaver lunch, the de Havilland Turbo Beaver picked us up and flew me to my Air Canada connection. I stumbled through the Timmins and Toronto airports in a daze, and somehow made it home. Under a pile of quilts in bed, I shivered for two full days, thinking I must warn the world about the dangers of space blankets. I had drifted up to death's dark door once again, and got turned away. I was now ready and prepared physically, mentally, and spiritually to face the mystery.

THE ROCKS THAT TEACH

It wasn't so much the star over Lake Superior that shot through me. It was the quiet voice that came into my head at that Agawa Rock fifteen years ago. "There is somebody out there that can still read them. The meanings are not lost. There is somebody out there that knows. Someday you will make a film about what they mean."

In May 1954, two geologists north of Stoney Lake sat down on a rock to have lunch. When one of them knocked over his tea, the liquid ran into a gouged-out form of an animal. In surprise, they cleared away more of the forest debris, revealing even more exotic shapes and forms. After the authorities were alerted and the place examined, the number of carvings turned out to be in the hundreds. In 1967, the Department of Lands and Forests, to protect this site from vandals, declared the area a provincial historic park and put a chain link fence around the images to keep vandals away.

Preliminary protection of petroglyph site

But as the years wore on, without the protection of the forest debris, acid rain started to eat away the rock and the symbols. Originally, they were two or three inches deep, but now the carvings were less than half an inch deep. Many had even disappeared. After being uncovered for thirty years, the government decided to protect what was left. A building was constructed, housing a raised viewing platform surrounding the images. A nearby visitor centre was also built, including a theatre. I was asked to make a movie that would put visitors in the right frame of mind before they approached the site.

My clients from Parks' main office and regional office in Huntsville gave me three guidelines. "Don't mention religion or politics, and seek out the academics that know about the site."

Years earlier, when I stood alone on the rock, offering tobacco as thanks for my being there, and also asking for someone who could read them to come into my life, I was not asking for an anthropologist.

A new structure was added to protect the carved images

I tried to reread the academic literature about the site, and I had to stop. It made my mind numb. They were still printing, "At some point in the distant past, the carvers ceased coming to the site and their bright white images faded to a dull grey as knowledge of the site faded from mankind's consciousness."

I didn't want to use second-hand speculation. I wanted to go to the source. I approached my teacher, mentor, and friend, Fred Wheatley, and asked if he would help me. This is how he answered.

> "My grandfather told me about them [the petroglyphs]. My grandfather lived to be 112. He brought people there. The onus was on the strong people to bring the young people there. They paddled, that's how they came, and he brought people there; he went over and stayed with the Indian people on Stoney Lake. There were some people who knew; these people originally came from the Mississagi River near Sault Ste. Marie, and how he knew about them I never bothered to ask. He went there for two days—two boys and four men—then they paddled back. My grandfather used to make these oversize canoes—twenty-two footers—you could put oars on them if you wanted to but they just used paddles. This was the reason they got him to go. But when I became old enough to ask about them he became blind and could not help me. But I will help you to find a way to talk about it.

INTO THE STONE

"They were called Kinomaage Waapkong, the rocks that teach. Certain people came there to teach. We do not possess that wisdom today, to outline what their wisdom was. These things have been hidden for so long that it will be difficult to find the words to describe it, and then to find the words to communicate it to the average person. Many preachers give sermons every week, but do they really reach people?

"We will go by the pictures you get and assemble, and then I will fill in the words where necessary. The English word that describes the things of which I will speak is metaphysical. As far as many old teachers are concerned, none of the messages that the rock conveys will ever be put to paper. But, I will help you find a way.

"The way one of the men explained it, the rock is like coarse crystals of salt, and when they hammered away at, it would break and could be gouged out that way. That's the only way that I could explain it. Usually rock like that has a cover over it and once you break through the surface it's easy enough. That's likely why it was covered after it was done. Whenever they would go to teach they would open it up and cover it back up again. When it was found by the dominant society, they removed everything from it and then the deterioration began to take hold."

Curve Lake is the closest First Nation reserve to the site. I paid a visit to the Chief of the Curve Lake Band, Aubrey Coppaway. Aubrey was getting to an advanced age. He told me that years ago, an old man in the village was having dreams, and asked Aubrey and another man to take him into the bush. He said they went by canoe, but they also did a lot of portaging. They came upon this rock and the man began peeling moss off of it. Under the moss, the rock was covered with symbols carved into the rock. He said, "He sat and prayed for most of the afternoon. We sat behind him, and when he was finished, we covered it back up and went home. The man died a month later."

Aubrey agreed that Fred Wheatley would be a good man to help me.

I was eager to begin shooting. But shooting what? Fred and I began by approaching the site by water. We travelled to the eastern end of Stoney Lake through rocky islands of gorgeous white pine. These islands had an uncanny similarity to the 30,000 islands of Georgian Bay. When we reached the eastern end of the lake, we listened for the sound of the mouth of Eels Creek, the southward route that the old-time Indians used to get to The Teaching Rocks, as they were once called..

Canoeing is a wonderful way to get into a distant time and space. We stopped and sat by the shore of the creek, absorbing the sounds, the smells, the pristine surroundings. Sitting on a log, Fred told me about his brother Cap, who he held in high esteem. "We were sitting together, quietly like this," he said. "He told me to slowly turn my head and look for a black

dot surrounded by a white circle behind us in the forest. I slowly turned and found the black dot; then I realized that it was the eye of a deer surrounded by a white circle of fur. The rest of the animal blended in so well. His Ojibway word for deer, as I remember it translated, was meaning "he blends where he stands."

We saw deer that just looked at us as Fred spoke to them.

"You see," he said, "animals were always plentiful in these areas because they knew that when Indian people came here, they meant them no harm. This was hallowed ground. The people came here to think and to pray."

My senses were being opened, and my imagination was exploding. I asked him if he knew much about medicines.

"When I got around to asking my grandmother to teach me, it was too late. I never became a medicine person. You could poison someone if you pick a plant for use at the wrong season. So many plants you pick before they flower, some right after they flower. Some you pick in a marsh when the ice is still on."

I recalled him once quietly calling me over to see a plant growing on the shore of Georgian Bay. In a half-whisper, he said, "If a woman for some reason had to terminate her pregnancy, she would take this plant. It's a decision not to be taken lightly because she will have to carry that choice with her most of her life."

We rented a boat and towed my canoe down Jack Lake to Jack Creek, the ancient northern water entrance to the sacred sites. We tied up the boat at the mouth of the Creek and loaded the gear into my canoe. Paddling downstream, we got stuck in rapids, and gashed up the bottom of my canoe on the rocks. Fred remarked that in the old days the rivers had a steadier flow, making transportation much easier. The giant majestic pines had vast and deep root systems that held water in the soil, acting as regulators, maintaining a deeper, more constant stream flow.

"When you cut the big trees, the rivers will flush out faster."

All along the journey to The Teaching Rocks, I was being taught.

Fred had a broken foot that was still mending, so he was unable to carry any load. I found myself portaging the canoe and camera gear with no problems, after suffering a winter of near-constant back pain. When I asked him why I wasn't suffering, he told me, "All pain starts in your head."

Stumbling through the woods off the portage trail, I came across some lichen-covered rocks in a pile with an arrow-shaped stone at the top. One might walk right past them, but the care and subtlety with which they were arranged fired my imagination. Fred said that they were "Zhinogewapkong, the rocks that point to the area that we are looking for." It was an ancient sign post.

The largest of the carved images on the Teaching Rock is that of a heron. One night I set up moving lights over the petroglyphs to bring the images to life. The large heron appears to grow upwards with the help of my moving shadow. The very next morning, I filmed a great blue heron silhouetted in the mist, "going about its given duty of arresting the population of diseased fish," as Fred described.

"They walk along the shore and spear the fish that are becoming sick. The minnows have always been noted for tail rot and things like that; were it not for the heron, I think there would be a lot of illnesses by the smaller fish that would transmit to the larger fish that live on them, and that is why that bird is held in high regard."

I needed more aboriginal voices of authority speaking of their own experiences with the images in the rock. Archie Cheechoo offered to help. Archie took me to a three-day assembly of peace put on by the Chippewas of Cape Croker on Georgian Bay. Guest elders from various parts of the continent would be speaking from the Mohawk, Cree, Cherokee, Ojibway, Potawatomi, and Kiowa Nations. Because of my technical background, I was asked by the Cape Croker folks to help record some of the speakers for their own records.

At this Cape Croker gathering, there was some buzz about a ceremony that medicine man Albert Lightning from the Cree Nation in Alberta would be giving in a large teepee on the last day. The more people talked about it, the more excited I got. It was made very clear that no cameras or recorders could be used in that ceremony. In my imagination, this old medicine man would glide in to the ceremony in full traditional regalia.

One half hour before it started, two eagles began circling Albert Lightning's large teepee. Inside, there were three circled rows of guests seated cross-legged around the sacred fire. It was very quiet. The feeling in the teepee was like being in a cathedral. In marched a short man with closely cropped hair carrying a briefcase and wearing a dark suit and trench coat. It was Albert Lightning. He opened the briefcase and took out his pipe.

The ceremony began. Food was blessed and passed around. Then came the pipe. In a moment of silence, I heard someone above and behind me call my name. I turned and looked up. I was startled and pleased to see my Aunt Grace, a woman of grace, looking down at me and smiling. I hadn't seen her in years. My father's sister, she was the artist in the family. Her home and family were twelve hundred miles away, near Quetico Park. Aunt Grace had passed away a few months earlier.

At the conclusion of the assembly, back in the main tent, Albert Lightning gave a speech to the crowd, and I was given permission to record him. At last, I thought, I will be getting some substantive words for my soundtrack. While recording, I paid very close attention to the VU meter, making sure that his voice would be clear and free of distortion. The first thing I did when I got back to the city was to put the tape on and play it back. It was blank.

Fred and I took my footage of the Teaching Rock to various First Nations groups in the area, explaining what we were trying to do. As we spoke of the place with reverence, we were greeted with knowing glances and cautious enthusiasm. We asked them for input and heard variations of this:

"These teachings are for us, to meet and face the events in everyday life. People will be moved by it, if they see it in everyday life."

"We would go there for a week for our ceremonies, then cover the area up with leaves and pine needles. We didn't call them petroglyphs."

"You will find those medicine wheels, which you have shown us in your film footage, all over North and South America." They represented aspects of a universal "religion" covering both continents. As a result, others claimed,

"There was never a holy war in North or South America. We did each other in for many other reasons though."

More and more people mentioned the medicine wheel teachings, as there are numerous medicine wheel symbols on the rock.

When I asked to learn more about the medicine wheel, I was advised to meet a certain highly revered ceremonial person from the west. They referred to this man as the Mishomis, the Grandfather. He was mentioned in every meeting.

THE MIGRATION WEST

The Mishomis was a descendant of the Ojibway and sub groups Chippewa, Mississaugas, Saulteaux that migrated west from the Great Lakes area of Ontario in the 1700s and 1800s. East of Sault Ste Marie, at a place now called Blind River, there was originally a community of two thousand Mississauga Ojibway living by the mouth of the Mississagi River. That settlement vanished, either as a result of the migration, or because of the oncoming plague of diseases. Upstream, along the north channel, the Ojibway Bawating, now the two Sault Ste. Marie communities, also began to dwindle in population

It was a significant migration. In his travels, Fred Wheatley met many elders from Ontario, western Canada, and Montana who told him their versions of the story of the migration. Ojibway were fearful of news of the advances of the new civilization that was moving into their territories, spreading plagues of smallpox and flu. Even though some of the Black Robes spoke of peace and love, some acted as spies for the French and were treated with suspicion by the spiritual leaders. An American missionary on the western end of Lake Superior commented, "The Ojibway believed that the whites were very wise, very strong, but very deceitful and dishonest, great liars, and ought not to be trusted by the Indians."

Henry Schoolcraft was an Indian Agent for the American government, stationed in Sault Ste. Marie, Michigan, in the early 1800s. He learned the Ojibway language, and he lived and travelled with the local aboriginals up and down the St. Mary's River, and north and west on the coast of Lake Superior. From the elders, Schoolcraft transcribed much of his instruction and teachings of the history and culture of the surrounding Chippewa, Saulteaux, and Mississauga peoples.

Excited by what he had learned, Schoolcraft travelled to England, France, and Germany in 1836 to try to sell his collection of legends and myths to scholars in Europe, but he received little interest. Back in Bawating, Sault Ste. Marie, a visitor appeared who would change that. It was the poet, Henry Longfellow. Longfellow studied Henry Schoolcraft's detailed transcripts

of interviews with elders, and brought them to life through his own brilliant poetic use of the English language.

One character from Schoolcraft's transcriptions stood out. He was a wise man, a prophet clothed with all of the attributes of a human but who could perform miraculous deeds. Henry Schoolcraft first learned of the exploits of this sometimes Christ-like character, Nanabush, in 1822. Nanabush, he was told, was a messenger from the Great Spirit, who also influenced the move west. Henry Longfellow changed the name Nanabush to Hiawatha for his epic poem, "The Song of Hiawatha."

Longfellow was an easterner living in Cambridge, Massachusetts. It has been suggested that he got the name Hiawatha from an Iroquois statesman-shaman and lawgiver Haion-hwa-Tha, who lived around 1570. It had a good sound to it, and he, too, was a powerful leader.

Around the same time, Ojibway Chief George Copway spent time with the Lake Superior Ojibway, hearing their stories and, after writing his book, *The Traditional History and Characteristic Sketches of the Ojibway Nation*, he became a noted lecturer on the American eastern seaboard. Copway, too, influenced Henry Longfellow's "The Song of Hiawatha."

Copway, originally from the Rice Lake/Peterborough area near The Teaching Rocks, wrote:

"There is a place where the sacred records are deposited in the Indian country

These records are made on one side of bark and board plates, and are examined once in fifteen years

Here is a code of moral laws, which the Indian calls 'A path made by the Great Spirit.'

With this great awe of spiritual things in his mind, he feels reluctant to reveal all that he knows of his worship and the objects and rights which perpetuate it.

The records contain certain emblems which transmit the ancient form of worship, and the rules for the dedication of four priests who alone are to expound them."

Reading the last line, about the four priests who alone are to expound on them, shook me a bit. If I was making a film about these emblems, would I not be expounding? Was I on shaky ground here?

Copway, too, spoke of the Midewiwin, a secret medicine society of the Ojibway. In their history, the Midewiwin talked of the betrayals of the Black Robes and the imminent need to move west. Regarding the migration, the great leader, Hiawatha, was troubled by the Black Robes. He had a vision, a prophecy of "distant days that shall be."

I beheld a restless, struggling, toiling, striving, people; painted white were all their faces, speaking many tongues, from wooden canoes with wings, over water bitter so none could taste it. The westward marching of unknown crowded

in all their valleys, and over all the lakes and rivers rushed their great canoes
of thunder.

(Longfellow, "The Song of Hiawatha")

Following that vision and a subsequent meeting with a Black Robe, Hiawatha bade farewell
to his people and paddled west, into the glory of the sunset.

To the regions of the home-wind
Of the Northwest-Wind, Keewaydin.

(Longfellow, "The Song of Hiawatha")

A way of life, a way of speaking, a way of thinking was under threat. A group of Eastern
Chippewa collected and wrapped their ancient records in sacred bundles and the migration west
began. Of those that stayed back, seventy percent died of the new diseases. A Methodist minister
from Alberta Robert Rundle, noted in 1841 that these Ontario Ojibway had adapted to prairie
life and that most of the other Indians were afraid of them because of their spiritual powers.

In my imagination, my dad could have met one of these unregistered bands on his journey
west in 1935 on his Harley Davidson. They were, as he described, "true Indians." Wouldn't
it be something if the Mishomis, was in that band on spotted horses Dad came across in the
mountains? My father was twenty-two. The Mishomis would have been in his late thirties. The
impact of that event on my father is what set me off on this long and winding journey.

Rumour had it that the Old Man was coming to Ontario. If we could meet, I hoped I could
stick around and talk to him, rather than speed off as my father did when confronted with
antiquity. It would be a full-circle thing: my dad, from the Sault, meeting descendants, perhaps,
of the old Saulteaux out west, and now me, the son from the Sault, meeting the old Saulteaux
descendant returning to the original homeland, Ontario.

HITTING THE BULL'S EYE

Fred Wheatley had met the Mishomis. He told me,

> "His English is not that good but he speaks enough of it that you can under-
> stand what he means. He's just begun to speak English in the past four years.
> When I first met him in 1981, he could speak Cree, he could speak Ojibway,
> and he can speak Stoney, of course. I couldn't understand Cree but I could
> understand Ojibway. The western Ojibway is very difficult, and it took me a
> long time. He would throw in a couple of English words here and there, and

I found that, the more I listened to him, the words were basically the same like any Canadian would listen to a Scotsman, and really be thrown off base for a while and then the words are the same, but they're spoken in a different manner. This is the equivalent of the western Ojibway they call Saulteaux."

When I learned that the old man himself was coming to speak at an elders' conference at Trent University in Peterborough, the Native Studies department helped arrange to have him view our movie footage at a private gathering. Fred warned me before going into the meeting.

"You are asking for something that you are not ready to be given. He may wait three years." Undaunted, I was determined to press on into unknown territory, but fully aware that I should not press too hard.

Circled by a respectful audience, there he was, looking much younger than I expected, glowing in a quiet serenity. Setting up my 16-mm projector, I awkwardly explained to him my intentions in making the film. In the darkened room, while the silent footage of the petroglyphs was running, he spoke in Ojibway to those around him as various symbols appeared on the screen.

To my ear, he sounded excited. When the lights came on, he looked at me and said, "Those things are not new to me."

I was surprised because he had never been to the site before.

The next day I had the ministry park superintendent, Dave McLennon, take the Mishomis and some other elders, by snowmobile, to the rock, which now was enclosed by a large glass-sided building. Over the next two days of the conference, he spoke to me about many things, but not about The Teaching Rocks. As I offered him some tobacco, he spoke about a treaty between two people:

> "I will treat you with kindness. You will treat me with kindness. I will treat you with honesty. You will treat me with honesty. I will share with you. You will share with me. I will offer you my strength. You will offer me your strength."

I understood that we had made a treaty between the two of us.

To end the conference, in a quiet voice, he gave a mesmerizing two-hour talk on the seven steps to The Good Life. He began by talking about what potatoes used to look like a long time ago, and progressed to other seemingly mundane topics. People kept getting up to leave as he went on. It looked like he was deliberately culling his audience to those who really wanted to learn.

After the room finally settled down, his stories became more profound. My ears were naturally turned in his direction; I didn't want to miss a single word. That was the first time I could recall having that sensation. He used a marker on a flip chart to illustrate the path to this life. The drawing, when completed, took the form of the so-called "Sun God" symbol found on the Teaching Rock. I was flabbergasted. The top of the figure had a medicine wheel over its head—a circle with lines emanating from all around the circumference. He mentioned something about Jesus having a medicine wheel "halo" over his head too.

"When you walk with this feeling, you shine. It feels, inside, like you do when you hit the bull's eye."

The path to a good life

He also spoke about peace. Peace begins within. You must first be at peace within yourself, then at peace with your family, then at peace with your neighbours, and at peace within your community, and so it spreads outward. Going to church and listening to sermons was seldom like this for me.

Alone, the drive back to Toronto was invigorating. Normally, on longer drives, I have my music all planned out. This time, I remained in silence, and my mind was spinning, teasing out the meanings of the stories he told.

He returned to Ontario the following spring to lead a group of aboriginals as they fasted on a vision quest in the Haliburton Hills. I met him again, sitting by a campfire. We sat alone.

He made me fully aware that I could not take his picture, record him, or take notes as he spoke. The old man told me that one's attention would go into the notes rather than focusing the mind totally on what was being taught. And later on, when asked about what the person was taught, that person would say, "Yes, I know. The answer is written down in that little book up there on the shelf."

He pointed his finger to between my eyes. "You have to learn it and understand it in there."

He asked me to bring out the provincial park poster that illustrated the symbols as they were found on the rock. Spreading it out on his knee, he pointed out how a symbol, alone, can mean one thing, but the meaning can change when spatial relationships to the other symbols are considered. When others gathered to look over our shoulders, a gust of wind blew the campfire smoke around behind us up into their eyes. They backed away.

Later that afternoon, I watched a young woman approach him and give him some tobacco. She looked troubled. He summoned me to let him use the poster of the images on the petroglyph park map. He spoke to her, pointing to images as she sat by his feet nodding. When he finished, she looked like a huge weight had been lifted from her shoulders.

Afterwards he said to me, "When you help people, you make them strong. When people feel strong, they feel good. When you make people laugh and make them feel good, you are a healer. You don't have to be a doctor to be a healer."

The poster map

CHASING THE MUSE: CANADA

The next day, I visited Fred Wheatley and excitedly passed on some of the image relationship stories the Mishomis had told me. I was hoping Fred, in turn, would repeat some of those phrases into my tape recorder. I was under some pressure to come up with a film. Fred, of course, could not repeat what I said, because he was not told directly, so it wasn't his story to tell.

To progress with the film, I felt that if the old man, Fred, and I could visit the rock together, perhaps then Fred could re-tell, in his own words what was appropriate for the film. That was a lofty goal. But, after all, we did make a treaty, to treat each other with honesty, kindness, sharing, and strength.

WE MEET ON THE ROCK

It took months of negotiation, but eventually I persuaded the Mishomis to come back to visit the rock. In the weeks before his arrival, I was given many warnings from various elders:

"You still function in white man's society, but you have crossed a bridge."

"You have to earn the knowledge. Earning that knowledge is a life process."

"He will speak in parables. It may take you a few weeks to figure things out."

"To learn, you have to be in the right frame of mind."

"He doesn't want anyone to get too far ahead of it."

"If he says none of this should be used, don't use it."

"If things are made too easy for people, they don't have any interest in it."

"When he is here, don't mention the film at all."

Archie Cheechoo, Fred Wheatley, and I greeted the Mishomis and his wife when they arrived from Edmonton at Toronto's Union Station. We went out for dinner at a nearby restaurant. Amid all of the talk, one thing he said over the meal stood out.

"You have no right to ask me a question until you have done certain things,
and I have no right to answer you. A teacher knows what he has to teach you,
and what you have to know. He will know what you need to know."

In the car en route to Peterborough, I also remember him saying, "I have no reason to lie to you."

I called home when I got settled in my hotel room. My wife was upset. Our house was being renovated. Walls were knocked out and a rat had scuttled in; it was boldly walking around inside the house, frightening her and the children. I felt it was an omen that forces were against my

efforts to continue. I couldn't go home because I had invested too much of everyone's time—I had to continue.

It was a cold, white November morning as we embarked upon our journey to the site. In my mind was "no questions, no notes, no photographs." On the rock, Mishomis seemed to stay in one small area, dealing simply with the basics of the medicine wheel, the wheel of life.

"You must understand the basics, and show that you understand them before you can go on," he said.

There is so much to the medicine wheel. Each direction stands for many things, including character traits allowing us to perceive things, times of our lives, totems, seasons, powers of the directions, and on and on. In order to grow as a full person, to become illuminated, a person has to learn and live the characteristics attributed to each direction.

A few times, he rubbed a flat area and said that there should be another symbol there. It had faded away with time. He did this several times.

That made me wonder, but I couldn't ask. He also said, "These are not the things of dreams. Everything here can be proven."

He showed me an image of a female moose giving birth. Water bubbled up long ago from an underground stream to run in a crevasse down the rock to the mother's mouth. Water, the gift of life.

As a cinematographer, I felt that I was missing some spectacular images of the Mishomis on the rock. A backlit glow around his long, braided hair, his beadwork moccasins, and his multi-coloured woollen coat alerted the photographer in me. But I understood that my instincts would turn to lighting, sound, composition, and edit points, as opposed to gaining an understanding of the symbols. If I was to tell the story, I had to understand.

Walking out through the snow at twilight that evening, I could hardly keep up to this amazing man. I was burning with questions, yet afraid to ask: *How did he know there should be certain carvings in places that appeared to be completely worn away?*

No sooner had I put that thought in my head, when he stopped abruptly and turned around to face me.

"You see, out west we have a hide. A deer hide." He stretched his arms out wide.

"It's white, and it's very old. All of those symbols are on it."

It felt good to associate that with the migration story. It was part of the sacred bundles carried west so many years ago to keep them from the hands of the oncoming hordes of newcomers.

The evenings were given to storytelling around a fire. Some of the stories of hunts gone wrong were hilarious.

For three more days we visited The Teaching Rocks. Each day brought more aboriginals from various parts of the province to share in his knowledge. Some were of the Midewiwin (Grand Medicine Society). Formed centuries ago to preserve traditional Ojibway beliefs, Midewiwin enter an apprenticeship under more advanced shamans. The apprenticeship includes vision quests and revelations passed on from ancient times through carvings, rock paintings, and birch bark scrolls.

One of the Midewiwin revealed to me that there were five other sites in a straight line, and the key to finding those places was outside the building that covered the carvings. A few of the Midewiwin told me there was another large site nearby, still hidden.

On the rock, carved above a big boat with a flag, there were symbols of life that were here before that type of vessel came. Below that image, there were signs pointing to what this large boat would bring in the future. There, below the boat, Fred pointed out moose tracks carved into the rock; but he said that the way the moose was walking, it had to be sick. He also said,

> "There are two parts, the good and the bad, and the bad is usually stronger.
> Sooner or later the dominant society will know what is happening. and they
> will turn and do something to make the environment better."

One afternoon, as a sweat lodge was being set up, an elder woman approached me, and looked deep into my eyes.

"I have to speak to you. When you tell me of what you are doing, I feel very sad," she said with a tear.

> "You are learning things that are very sacred, things that come very slowly with
> time, things that are deeply personal, and you are making them into something
> that is money-oriented. I do not say this to make you feel bad. I am only saying
> how I feel personally. I hope we can still be friends."

Tears flowed into my eyes. *Should I stop? Have I undertaken something that shouldn't be done?* I wondered.

"But there must be a way," I said, "—a way to show these things that will make you feel good. My films are different."

"That may be very well for you," she said, "but I can only speak for myself. I feel sad. It's not the old way, the way things are taught. But go to the Mishomis and ask him. He will help you. He will give you an answer."

I felt numb.

Should I go home right now and deal with that rat? I thought, as I drove into town to buy return train tickets back to Edmonton for the Mishomis and his wife. When I returned, the sweat lodge was in full swing. I had missed the first three rounds. The Mishomis eagerly invited me in for the fourth. I felt most welcome. It was my first sweat lodge experience. It was like being in a church of unspeakable profundity. I felt much better when we emerged.

That evening around the fire, traditional food was passed around, and stories of old were told. There were tales of the old days of buffalo hunts, and how all parts of the animal were used, leaving waste the size of a fist. They spoke of the differences between the Agawa pictographs from my Lake Superior homeland, and The Teaching Rocks. The red pigment has ingredients that make it go into the stone. There was also mention, again, of another teaching rock site hidden near where we had been spending our days.

The elephant in the room was this movie I had been assigned to make. Concerns were raised again that making a movie about it would cause people to think that they know all about it. The Mishomis added, "This information is too important to hand out to people on a plate. When people watch movies, they eat popcorn."

Everyone looked at me. I packed some sage inside my lower lip to help give my mind clarity. Adjusting my turquoise coyote bolo tie, I slowly rose to my feet. It was time for the white boy to dance.

I swallowed the wet sage saliva and began to speak.

> "I would first like to thank all of you for showing me, a shaganash [white man] such kindness over the past several days. Not only that, you did it for someone who works for the government." (That got a big laugh.)

> "Over the past few years, I have been given many extraordinary experiences and images for this film, for which I have suffered. I even saved a shot of a moose kissing the camera lens for this film, because it showed how animals can react when they are in the presence of a good heart.

> "With these gifts, I felt that I could help in my own way to rekindle a respect for a way of life and an attitude toward the Earth that I admire deeply. Perhaps it could encourage people to seek out more, to ask an Elder, to re-balance, to spread the circle. Throughout the years of searching for answers, many obstacles have been thrown in my path. But, I found that If I kept moving on with a good heart, these obstacles would disappear. Whenever I despaired of continuing, something or someone would appear to encourage me to go on.

> "There are concerns about whether the use of movies and books is appropriate for the true traditional type of teaching. I would now like to tell you a story about how looking at a photograph and reading a printed page had a profound effect on the fact that we are all gathered here tonight."

I went on to tell in detail my surfing story of facing death in the Pacific Ocean, floundering helpless in a sea of foam in California.

> "That magazine story I read as a teen, and the photograph with it, imprinted deep in my unconscious. When needed, it emerged in a flash and consciously focused my actions to save my life. If I hadn't read that story or studied that photograph, we probably wouldn't be gathered here tonight laughing and telling stories."

Did I make my point to the group? I felt inside like a goalie making a great save late in the third period. It was a rush, to be sure. I kicked the puck out, but someone could still take a shot. The game was not over.

It had been a long day. I drove the old man and a few others back to the hotel after midnight. We all gathered in my room for a few more stories; then everyone went off to their rooms, everyone except the Mishomis. There were just the two of us sitting at a table by a dim lamp.

He asked for my sketchbook and pencil and spoke as he drew. I pulled up my chair, so I could see well. The hieroglyphic-like symbols, strange at first, became a map—North America, long before the white man. The major separations were seven different soil changes. The soil-change edges seemed to be boundaries of a sort. It made sense. Each different soil would account for a different type of vegetation, food, animal, and medicine. Eastern North America was linked to the West by a series of sacred areas drawn as circles dotted across the country. Something in each sacred area pointed in the direction to the next. He pointed to a sacred place just inside what is now the Manitoba border, near Ontario. I remember another in the Cypress Hills of Saskatchewan and four circles for the line of sweetgrass hills in what is now Montana. The Rocky Mountains were two parallel north-south lines. Four horizontal lines crossed them. Each of these lines represented a river and passage running up to the glacier on top of the mountain and then down the other side. These rivers were the mountain passes to the westernmost sacred area and, of course, the sea. Some of the sacred areas he highlighted are still hidden from the dominant society.

This map, the Holy Grail to me, represented a time before railways, cars, and motorcycles, when people moved great distances at human speed over land and across water. As Fred Wheatley once told me, people navigated by reciting songs that described a certain trip—what the lake looked like, where the portage was located, and so on. The songs had to be memorized. There was a song that could take you from Toronto all the way to Hudson Bay. I suppose you could call them song maps or song routes. In Australia, the aborigines called them song lines.

I once told Fred that my wife and I were going to take our canoe to Lake Mozhabong.

He said, "Oh, that is a long narrow lake that has a narrows in the middle and the lake bends a bit there."

I said, "Oh, so you have been there?"

He said, "No I haven't. That's what Mozhabong means."

We discovered the lake to be exactly as he described.

It was late. My mind was drifting. Stifling a yawn, I thought that because the old man drew it in my book, I could study it later. I would own a treasure that I could frame.

There was an awkward pause. He tore the page out of my book.

I thought, "Maybe he will put it on the wall?"

He folded it three times and tore it to pieces. OK, I smugly thought. I'll retrieve the shreds from the garbage can, and reassemble this exceptional prize. He gathered the pieces like a dealer scooping up a deck of cards, and put them in his pocket. "Time for sleep," he said and walked out.

He had shown me many things. Again, he was showing me his way of teaching. You focus hard, and imprint the teachings on your brain. It stays with the brain, not on the paper. Earlier in the evening, I thought that I had kicked out a save late in the third period. He slowly skated

in on me in overtime, and gently tucked the puck behind me. He had made his point. I think he was also saying that he believed in me.

THE SONG OF HIAWATHA

The next day, the last day on the rock, the old man pulled me aside, and pointed to two images that he said reflected my relationship with my wife. I began to understand how these symbols could be used for sorting things out in everyday life, as people had told me. One image was a rabbit figure with long ears, and the other a man with his legs spread wide. Underneath the man with the spread legs was a wavy line, representing shaky ground. I would have to think deeply about that. I still think about it. That had to be me on shaky ground. That rat was still in our home.

These two images were directed at my present predicament

The Mishomis sent a young helper into the bush to come back with a wood stick of a certain size and length. He told the youth he could find it lying near where we had a bonfire the day before.

The young man quickly returned, beaming and handing the old man a most graciously accepted item. A late afternoon golden sun cut through the clouds and onto the rock.

Mishomis knelt before three images and moved the tip of his stick to a circle figure on the right. "The medicine wheel," he said, "The medicine wheel's teachings guide our thoughts to goodness."

He slowly waved the point of the stick far to the left, stopping at a carving of a snaky lizard-like figure.

"They scurry around at night, in the dark, like dark thoughts. Dark thoughts that can control us."

His stick moved to the figure between them, a straight vertical line with a ball at the tip.

"And this, the drum stick, is in between the good and evil. It represents the heartbeat of Mother Earth. We must listen to the heartbeat of Mother Earth. The heartbeat of Mother Earth protects us by coming between dark thoughts on one side and goodness on the other."

His pointer then became a drumstick, and he began to beat slowly right on the tip of the engraved drumstick. A thrum thrum thrum thrum, then boom boom boom boom filled the room.

The entire rock we were standing on began to vibrate with a deep resonant sound, almost like a beating heart! Its echoing rhythm throbbed up through our feet, up into our bodies. He sang a sacred song in his language.

The engraved images that inspired his song matched the three images from a passage in "The Song of Hiawatha," which came from the Chippewa elders' songs, and transcribed by Henry Schoolcraft, who passed them to Henry Longfellow.

> *Gitche Manito the mighty*
> *He, the Master of Life, was painted*
> *As an egg, with points projecting*
> *To the four winds of the heavens.*
> *Everywhere was the great spirit,*
> *Was the meaning of this symbol.*

Then to the other side of the drumstick was the lizard-like figure.

> *Mitche Manito the mighty,*
> *He the dreadful Spirit of Evil,*
> *As a serpent was depicted,*
> *As Kenabeek, the great serpent,*
> *Very crafty, very cunning,*
> *Is the creeping Spirit of Evil,*
> *Was the meaning of this symbol.*
> *And each figure had its meaning*
> *Each some magic song suggested*
> *For each figure had its meaning*
> *Each its separate song recorded.*

Through the magic of this ceremony came a connectedness to a celestial order for everyone there. The song ended. There was silence. How did he know that the rock was hollow underneath that drumstick point? How could it possibly give that powerful sound?

Overall, the four days made for a potent experience. Some people and events may have conspired against me, but the old man was always very kind to me. He told me, "Now that I have told you a few things, I am responsible for you, and you are responsible for me."

I drove home that Sunday night with my mind spinning. There were so many thoughts, words and parables to ponder. One warrior told me, "We gave away some things to the white man, like the trickster, but we have kept the core beliefs."

Other people pulled me aside with, "There is a reason that it is hard to keep this knowledge in you. You know it clicks something inside you. In our ignorance, we want to release it right away. So you don't, or you release the power right away."

"This is a test, because what you are being told is not according to the norms of this society."

I supposed the reason I couldn't ask him a question was that I would be asking for something I wasn't ready to be given. I had to learn the basics first.

But he also did acknowledge that I had a head full of questions.

He replied, "You bring your questions to an elder, and he answers you. These answers give you strength. When you walk with this strength, people look up to you. People trust you. When people trust you, you must be good to them. This makes you even stronger."

I would need that strength back at the office when the park people who were losing confidence in my ability to deliver, would be asking to see the film rushes from the big event I had just experienced on the rock.

On Monday morning, I dispatched the rat with the blunt end of my axe head.

THE FINISHING TOUCHES

The scope of this knowledge abounds all of mankind.

—Liana Wolf Ear, Blackfoot Nation

I was now ready to block out the footage and engage Fred with a series of questions and images. Fred spoke very eloquently into the microphone. "It tells of life long ago, and what was to happen. And there are things there that tell us how we should live."

In other words, there is history, prophecy, and guides for living a good life, just like in the Bible.

Thunderbird figure

Moose giving birth

I met a Blackfoot medicine man, Jim Small Legs from Alberta, who agreed to be interviewed on tape, along with another beautiful and intelligent Blackfoot lady, Liana Wolf Ear. She talked about the prophecies on the rock.

"The Creator has always sent prophets to help guide mankind so that our lives could be in balance."

In other words, people that made those carvings were among a long line of prophets that appear from time to time in mankind's history. She added, "They don't change what was said in the past, but they might add to it."

In the soundtrack, Jim Small Legs, talked over the sweat lodge images on the rock: "the water is poured into the rocks; the water has spirit, too. That's what cleans you up."

To me, that notion was a revelation. When I heat rocks in my sauna, water comes out of them, even though they have been sitting, cold and dry, for weeks. So the water really does go into them. Mind you, they were no ordinary sauna rocks. They were from the sacred shore of Lake Superior.

For additional images for that sequence, I was invited to a sweat lodge ceremony in Matachewan in Northern Ontario. It seemed at first like a real achievement, if it could be pulled off. Liana Wolf Ear would accompany me. Because our plane was delayed, most of the day Liana and I left Timmins at about nine o'clock in the evening. Pedal to the metal en route to Matachewa I received a $160 speeding ticket, We pulled into the Matachewan Reserve around midnight,

concerned that we were not given an address for the event. I pulled over under a street light to think this problem out. Immediately there was a knock on the car window. It was the medicine man who had invited me. He said, "I just told the people waiting inside that Lloyd should be here now."

The sweat lodge was built secretly in someone's garage. These "pagan rituals" were still frowned upon by Christian priests, ministers, and their flocks in many First Nations communities at the time. In mid ceremony I was allowed to bring in the movie camera, and a dim light. Despite encouragement from the elder in charge, I felt uneasy at recording certain spiritual artifacts.

Back in the city, with *The Teaching Rocks* in the rough-cut stage, I invited two lady friends, one an Ojibway and the other Shushwap from B.C., for a screening. When it came to the sweat lodge scene I had filmed in Matachewan, they literally fell out of their chairs. They spoke in unison, "That ceremony must never be filmed!"

Hey, I'm a shauganash, but I was determined to get it right. They liked the film otherwise.

Then came the client approval screening. After it was over, there were worried looks. The regional clients were generally approving, yet furious at the line, "We must warn the white man before he poisons the whole earth." I was ordered to remove that line with their reasoning, "After all, our jobs in the Ministry of Natural Resources is to prevent this from happening. So how could we say that this is possible?"

I answered that, while on the rock, I had overheard one of the elders say that the outside carvings are a warning for mankind today. The elder was referring to a group of carvings away from the main rock that had not yet been discovered by the dominant society. Fred Wheatley added to the sound track, "Don't contribute to the mess that is being made."

Following that meeting, I immediately asked for a meeting with Deputy Minister Mary Mogford to plead my case.

"Mary," I said, "That warning is one of the most important lines in the entire film." Mary very calmly replied, "If it is true that the elders feel that way, then by all means keep it in." A very intelligent woman, that Mary.

The Mishomis also once commented to me, "The earth will not allow itself be destroyed by fools."

UNEXPECTED CONSEQUENCES

You don't make many friends by going over people's heads in government, but sometimes you have to do what you have to do. I finished the film and the internal screenings began.

The Teaching Rocks was shown in a boardroom in Bancroft District on Staff Day. (Bancroft District was the jurisdiction in which the petroglyphs park lay.) When it got to the point where Fred Wheatley talked about the heron "spearing the small fish that became diseased," the district

manager stood up and shouted, "What a load of horse shit!" Then he stomped out of the room, and slammed the door.

The embarrassed staff, brought in from all over the district, didn't know how to respond.

My clients from Parks' main office admonished me for not giving a perspective from an expert in the field. (That would be a white academic.) They went on to say that I had become "too involved" with the subject. I responded, "With that reasoning, even director Stanley Kubrick could be criticized for being too involved with *2001 A Space Odyssey*."

But the hardest decision to accept was from the Huntsville Regional office that oversaw Petroglyphs Park. There was a manual published by the United States National Parks Service about visitor centre films in parks. It stated that people watching films in museums and visitor centres would not want to sit for more than eleven minutes. My film was twenty-two minutes long. My orders were to cut the film by half.

The people telling me to do this were not bad people. I liked them, mostly, but they had to do everything by the book. I wanted to rewrite the book.

I could not, would not, shorten it, arguing that the reason for that rule was that the American National Park museum films were so boring that people could not sit through them. Mine was not. I pleaded that *The Teaching Rocks* was carefully calculated to enhance understanding and learning. As for length, I said, "I just sat for three hours watching *Lawrence of Arabia,* and I stayed awake the whole time."

Despite my arguments, the region edited it themselves, cutting out eleven minutes. I was heartsick. I then sent the full-length version out to major museums, high-level civil servants in Aboriginal Affairs, the local Curve Lake Band, educational television stations, and the American Indian Film Festival in San Francisco.

Word quickly got back to the Mishomis that his English name appeared in the credits of the film when it was shown on Manitoba's educational channel. I was summoned to meet him in Toronto, when he visited the Native Canadian Centre.

I asked him if he liked the film. He said that it was good, but he again brought up his popcorn analogy. He wanted his name taken off the film. He told me that he was not an Indian, but an aboriginal. And, as such, his people had never signed any treaties, nor had they accepted benefits from our government; therefore, his name was not to appear on any document. It is because of this meeting that I have only referred to him throughout my story as "the Mishomis."

A month or so earlier I also had mailed to him an official government plaque in wood and bronze signed by the Premier, David Peterson, for his service to the people of the province in "revealing the ancient teachings of the Anishinaabe recorded in the Peterborough Petroglyphs." He gave it back to me and said, "You must destroy this," because his English name was on it. He also said to me, "I never revealed any teachings."

I think I know what he meant by this. When we were on the rock for those four days, I stood back out of earshot when the Midewiwin were grouped around him having long discussions about certain images. I knew that I wasn't ready for those teachings. And, as Fred said to me, "Some things are not for me to tell." Others said, "Some words cannot be translated, at least,

not yet." Someone also murmured, "Certain things cannot be discussed, unless there are twelve men present."

I immediately set about recalling and destroying every 16-millimetre print and video copy, and then I went back to the special effects film lab and had his name removed.

And there was one more thing I had to do to seal the deal for myself. The Mishomis did not ask me to, nor did he encourage me to do this; I wanted to prove again my sincerity of purpose by going through the ancient ritual of fasting. I would suffer, to show my gratitude for all that was given to me to make *The Teaching Rocks*. I would go into the forest, under the supervision of the elder himself, and fast for four days and four nights—without food or water.

THE VISION QUEST

It is very significant that you have showed up to do what you are doing.
Your being here is not just by chance.

—Medicine woman

While driving to the same location where we met in the Haliburton Hills a year earlier, I had many conflicting thoughts, *Why was going I through with this?* At one point, a medicine woman told me,

"It is very significant that you have showed up to do what you are doing. Your being here is not just by chance."

So I felt that there had to be a larger purpose to this whole process. I knew fasting would calm my body so that I could hear inner voices, and that's about it. Oddly, it did not occur to me that it would be my vision quest. I had read stories that, while fasting, a ghost would appear in the guise of a bird or animal and reveal information about the future, but I paid that notion no mind.

I was, of course, carrying tobacco; but I wasn't sure why I needed fabric prints of the four colours: red, blue, yellow, and white. I wasn't sure about a lot of things. I arrived off-balance, a bit alienated, unsure if I had prepared correctly, and unsure of what I would get out of it.

The Mishomis greeted me at the camp. I told him I wasn't totally sure of what I was doing. He comforted me by saying that if it was too difficult, I could leave the fast at any time I wanted.

"Don't promise to go for four days. You could become a helper. Even by being a helper you will learn a lot. If you are not sure why you are doing this, you will learn why you are."

I would be fasting with a group of five others, but there were many others there who were helpers. Every moment in the next six days would be part of an elaborate ceremony.

The evening before, a feast of traditional foods—wild rice, venison, corn soup, barley soup, potatoes, and berries—was held in a large teepee. Sweetgrass was burned, the food blessed, and

ceremonial songs sung. Stories were told about the old ways, and that we would understand suffering to understand how lucky we are with our families. More ancient songs were sung, berries were served, followed by a special tea, then sleep.

The next morning, I joined a group of five Anishinaabe who were also taking part in the fast. Helpers cut willow branch sticks, and planted them in the ground, bent over and woven together at the top to provide a curved frame to hold a canvas cover for our individual lodges. Six lodges circled a fire and altar in a medicine wheel pattern. After the lodges were complete, we went back to the main camp to enter the sweat lodge for a moving, intensely hot ceremony. Each of the participants had to state their reasons for taking part in the fast. Mine was simply to show sincere gratitude to all those Anisnawbe men and women who took me aside and encouraged and instructed me on my journey of understanding

Emerging into the light, newly purified by the profundity of the teachings we had just received, we formed a line to walk back into the bush to our lodges. We wore our blankets over our heads to understand humility.

The old man would come once a day to check on us. We would sit in a circle around the communal fire, and the hot coals would ignite sweetgrass to smudge our lodges and ourselves. He taught us how to make tobacco pouches from the four different coloured prints we had each brought. Forty-four bundles of tobacco were enfolded in the coloured cloth and attached to a string to wrap around the door of our lodges for protection. The numbers were significant. Each packet represented one of the forty-four ancient songs that were to be sung during our fasting and ceremonies. There were eleven for each of the four races of mankind: red, yellow, white, and blue. (The original black people were so black, they appeared blue). Liana Wolf Ears' words came to mind:

> "The plants and the animals know what their gifts are and know how to offer them, so they are in unity among themselves and with themselves. But human beings haven't found that unity within themselves or with the four races of mankind coming together."

We could bring no reading or writing material. I began to think what a luxury it would be to have a pencil and sketchbook. The absence of such diversions began to unburden my mind to drift freely into great peace and openness. In my thoughts, I explored the four directions, and thought about the four races of humankind. The hills echoed with the drummers back at the camp, singing songs for our protection.

We were told to stay close to our lodges.

"Don't wander off too far because of the little people, the Maymaygwayshi," he said.

I had heard a few people mention the little people before, and they always talked about them in hushed tones.

"The little people cause you to feel that someone is out there," I was told.

"Sometimes you feel that somebody guides you when you are lost. Close your eyes and put out your hand and the little people will guide you. You see a porcupine mumbling to himself.

People say don't bother him. He's talking to the little people. White people mock Indians, so we don't talk about them."

Maymaygwashi were also said to hang around cliff faces and scenic romantic vistas. So that's who guided me to the best spot to place my camera!

Fasting calms the body so that you can hear inner voices. When the body is still, the mind becomes more active. I'm pretty sure I was awake when I had this powerful dream of flying to Los Angeles and walking up to a stage door. I also saw images of Neil Young's transport trucks. I found the whole thing a bit strange, being awake and having dreams. The frogs and whip-poor-wills sang most of the night, and I lay awake listening to what they were saying. There was a brief lull of night sounds when the frogs stopped singing and the first morning birds started chirping, just before the dawn.

With morning came the sounds of the drumming songs to help us. I couldn't brush my teeth because that took water to wash out my mouth. Oh, for a mouthful of water.

The forest was calling me. Feeling the urge to roam, I took a walk along the bed of a dried-up creek. Reaching a clearing, I put some tobacco on a log and sat down with my back against a tree, adjusting my position with one leg outstretched and one knee near my face. A fog of mosquitos soon began to swirl around my head.

Many years ago, I learned how to not be bothered by mosquitos. Each spring I walk into the bush, sit on a log, and roll up my sleeves. Then I hold out my arms and watch. Five or six mosquitos land on each arm, and I watch them drill, then suck my blood, turning their abdomens red. It would tingle for a bit but after a while the sensation would go away. I was inoculated for my summer's work. It was like getting a flu shot for the winter.

A technique of fly-bite immunization

A dragonfly, master of flight in all directions—backwards, forwards, up, and down—landed on my knee. It was so close to my face that I could look it in the eye. I introduced myself. It tilted its head inquisitively. I tilted mine. It tilted back the other way and so did I. I'm not sure how long this comic dance went on before poof! It took off, caught a mosquito over my head, then landed back on my knee.

I asked it about the little people that I was warned about, the Maymaygwashi. Upon hearing that word, it buzzed up and landed on the far side of my knee so I could see under its nose. The portion between what looked like a nose and the mouth had the pattern of the face of a beautiful woman. Or was it a man? It seemed prince-like, or like some form of royalty.

I moved in close and looked into its face. It was astonishing—a beautiful person wearing a turban and jewels. The dragonfly sat for the longest time, allowing me and the exalted image to look into each other's eyes. There seemed to be a meeting of minds. I was taken away—I don't know where, but I was there. It was a very different part of the world, or otherworld. Suddenly the dragonfly flew up, grabbed another mosquito, and landed back in the same spot. Now the beautiful woman or man had mosquito legs, wings, and appendages sticking out of its mouth as it chewed. Not a flattering look. This pattern continued for another half hour or so, then the dragonfly disappeared. I made my way back through the forest to the medicine wheel of lodges, and fell asleep.

When I awoke the next day, my imagination was fixated on the beauty and power to be found in a simple sip of water. I fantasized about a cool semi-hollowed-out watermelon filled with Perrier water, orange juice, and ice. Surprisingly, I didn't care about food. But water... cool, clear water. The old man continued to visit to see if everyone was OK. Alone with my thoughts, and with my body becoming as pure as a wild animal, the force of gravity was pushing me down. Or was it the Earth's gravity pulling me into it?

We huddled by the fire we shared. It was going to be a cold night. Our heads had to be by the door of our lodges tonight, like the bear who halfway through his hibernation turns in his den. Because of the incline of my lodge, my feet were now more than eight inches higher than my head, meaning they were not getting the blood flow necessary to keep them warm. After drifting off for an hour or two I awoke with my feet close to numb. The drum music to help us started later that evening, but it wasn't helping my feet. I thought, *Well, I'm going to be a rogue bear and turn back around the other way to get some blood into them.* I rubbed them for about an hour and then drifted off.

On the third day I walked back into the forest, found my log, put down my tobacco, sat down, and waited quietly for the turbaned prince. I put my knee again up close to my face and, after twenty minutes, the dragonfly landed on the outstretched leg. It looked up at me. Time stood still. Then it crapped. Then it jumped up to my other knee, close to my face. Here it comes, I thought.

It was looking up over my head for mosquitos. Did it love me only for my mosquitos? With none about, it zoomed away, bounding and weaving in and around the ferns and forest, displaying its mastery of situational awareness. Then it was gone.

I walked to the bottom of a hill and started climbing, but in my weakness, I stopped often to rest. Ants were busy carrying small stones and objects in an assembly line of activity. Occasionally two ants would work together, struggling to drag a tiny stone in this collective undertaking. I wonder what they were saying to each other. Certain ants were used in the past as medicine. The red ants in a potion could help heal wounds very quickly.

At the top of the hill, I came to a bare rock at the foot of an oak tree. I sat down to look out over the valley below. The unity of creation unfolding below gave back the energy I had lost on the climb. I lay in the sun, watching the hawks soar above and below, and I dozed off. When I got back to the camp, the old man was there. He said, "Were you looking for forest fires?" *Curious,* I thought. I thought about that a lot.

On the last day—day four—when the night frogs stopped, we all awoke, desperate for water. The pull of the Earth's gravity was binding us to the ground like a magnet. We eagerly listened for the sound of the chopping of the sweat lodge wood. Early that morning, there were no sounds of children playing. They must have slept in after a late night. Damn. That meant that the parents would be sleeping in. A light rain began to fall.

Around one o'clock, the old man and his helpers arrived. There was a smudging and pipe ceremony before we were led out toward the sweat lodge. We were led to a teepee with blankets over our heads to wait for the sweat lodge to be prepared. Two eagles circled the clearing. Deep thunder claps of an impending storm shook the ground. The lightning flashes were very close. The thunder played a melody as it gradually moved beyond the distant hills.

Inside the sweat lodge a ladle of cold spring water was passed around our circle of excited and newly exalted spirits with parched throats. I felt honoured to be the last to have the swoon of cool liquid on my lips. The taste exploded on my tongue and then danced down my throat. The rush from the source of all life re-awoke my whole being.

The hot rocks from the outside fire were individually brought in by a shovel and carefully placed in a centre pit, greeted as they entered the lodge with "bozho mishomis" (hello, grandfather) Each rock was purified with cedar, which danced on the heated granite surfaces. A medicine woman sprinkled a powder on the rocks, leaving an exotic spicy fragrance. The door was closed and sealed by helpers outside. In deep, dark blackness, the ceremony began.

Ceremony upon ceremony proceded in the sweat lodge, and caught up in its power, I received the answer. I wouldn't say in a flash. It came very, very gently. I came to suffer through this fasting ceremony to find out who I was. That did not happen. I found out who I was not. I knew for sure now that I was not Anishinaabe. Because of the comfort I've always felt in their presence, I'd always wondered.

They say that when you emerge from the sweat lodge, you feel "reborn." I crawled out as a shining shaganash; free, as described in Robert Services's "A Rolling Stone."

> To make my body a temple pure
> Wherein I dwell serene;
> To care for the things that shall endure,
> The simple, sweet and clean
> To oust out envy and hate and rage,
> To breath with no alarm;
> For Nature shall be my anchorage,
> And none shall do me harm.

More ceremonies followed. First, a strong tea to get our digestive systems working again. It goes under the white poison that coats the stomach, and forces it out of your mouth. We put on new clothing because we were "new people." About forty people showed up to celebrate and honour the fasters, Mishomis, and the helpers. Everyone was seated around a large square. In the middle were four kinds of berries in large bowls. The old man said that four sicknesses had come, and the berries signified how the people got together to cure them. The sicknesses were scarlet fever, smallpox, the flu, and alcohol. The bowls represented honesty, kindness, sharing, and strength. The berries were sacraments, and the spirits of the plants were invoked to help prepare our digestive systems for the feast that would follow.

My taste buds sang, danced, and laughed as I ate wild rice, fried duck, barley soup, corn soup, fried breads, bannock, corned venison, salads, berry drinks, and tea. Gifts were exchanged. I received a beautiful blanket and a Navajo sand painting. It felt like Christmas. We sang and danced around the fire. There was a frost that night, but the blanket I received kept me toasty warm in my tent, dreaming free as a rolling stone.

Free as a rolling stone

THE TURNING OF THE TIDE

When I returned to the office, eleven pounds lighter, word was getting out about *The Teaching Rocks*. I was invited to give screenings in museums, libraries, church basements, elders' conferences, colleges, and government boardrooms.

The Curve Lake Band, the closest First Nations reserve to The Teaching Rocks, recommended that "*The Teaching Rocks* be sent to the Peterborough Board of Education and be made a compulsory part of the native studies curriculum in our county."

I had a private screening of the film with a Tibetan lama dressed in long purple robes. He had a powerful presence, and he spoke to me in a very deep voice through an interpreter.

"Rock carvings and paintings at power places in Tibet are largely chosen by their distinctive sound," he said, asking if The Teaching Rocks place had a special sound? I described the hollow echoing sounds coming from the underground streams. He thought about that, and then added, "Some places of power also have the sound of violence in them."

There we were, two of the four races of mankind—from different sides of the planet—alerted again to the power and messages found in ancient wisdom, history, and prophecy.

Again, I heard Liana Wolf Ear's words in my film,

"The scope of this knowledge abounds all of mankind."

I couldn't shake the dream visions from my fast; of the Los Angeles stage door, and of Neil Young's tour trucks. I kept seeing them. Normally, I get all kinds of strange images from my sleep dreams, and I pay them no mind, but these visions stood out boldly. Why a Los Angeles stage door, and why Neil Young?

At a presentation to staff at the Canadian Museum of Civilization in Ottawa, I received an invitation from an American scholar in the audience to present my film and speak at UCLA in Los Angeles. Also in the audience was J.V. Wright, curator of Ontario Archaeology, Archaeological Survey of Canada. He wrote to the Ontario Minister of Natural Resources:

> Mr. Walton has provided the public with a rare, graphic glimpse of the cosmological beliefs of native Algonquian speakers in the province and elsewhere. To be able to obtain direct cooperation and participation of native elders in the production of a film on the subject is a truly exceptional accomplishment. *The Teaching Rocks* undoubtedly contributes to a better understanding of the native people in Ontario in particular, and the country in general.

I think my detractors at work came on board after that letter. Then the film was nominated for an award at the American Indian Film Festival in San Francisco. There I was, jetting to Los Angeles to show the film and speak to the UCLA Archaeological Society, and I was bumped to business class as a bonus from Air Canada, too.

One of the most famous alumni of UCLA anthropological studies was Carlos Casteneda. His writings are about experiences with a Yaqui medicine man from Mexico. His books, including *the Teachings of Don Juan*, helped me understand the protocols of dealing with shamans, medicine men, or "sorcerers," as Casteneda called Don Juan. I was fascinated with Don Juan's teachings about how to gain a hyper-sense of reality, but unlike him I had not used peyote or other psychotrophic plants as allies. Well, I did smoke marijuana. I wondered if Casteneda would be in the audience. Following my speech and screening of the film, when the lights came up, I asked, "Are there any questions?"

A voice shot out of the audience. "What drugs do the Ojibway use?"

My answer, "As far as I know, only reality."

Later that evening, I took a walk down the Sunset Strip and came across an illuminated door behind the Comedy Store. It read, "Stage Door."

There it was, exactly as I saw it in my vision. What a jolt. It was not locked, so I walked in. To my right was a man with his tattooed arm on a curtain that he was slowly pulling back. As he did this, it revealed the faces of an audience lit up by the stage-light glow, laughing and applauding. Then boom, Robin Williams jumped in front of me as the curtain dropped behind. Robin, totally wired from his performance, continued rambling and riffing to me and the Vietnam veteran that managed the curtain. Robin had just finished filming *Good Morning Vietnam*, so he had a lot to say about Nam. But he also listened compassionately to the vet. From the Panavision Canada jacket I was wearing, he was trying to place me from a project he did in Toronto.

Another comedian, David Brenner, came down the backstage staircase, champagne glass in hand. There was an electricity in the air that was very seductive. I felt very welcome in the group, and a long exotic Hollywood night ahead was alluring. Robin's energy was going bam bam bam!

Hollywood, eh? Driving a rented car late at night in a strange city "on something"? A protective instinct for retaining control of my senses took over. Maybe it was the distant sound of drums from the American Indian Film Festival gathering up state in San Francisco. Saved by the drum, the heartbeat from the song that came up through my feet on the rock late that early winter afternoon. And the lesson in the symbols. On one side, the Gitchie Manitou, and the other, the Michie Manitou, one will make you shine, the other scurries in the darkness like dark thoughts. I turned to the stage door, and walked back into the night.

Arriving in San Francisco at noon the next day, the town was abuzz with the news that the rock group U2 would be giving a free afternoon concert downtown, and close to my hotel. I loved their new album, so I unpacked quickly, eager to catch the show, which was being filmed for a new movie, *Rattle and Hum*. Breezing through the hotel lobby, I spotted an elderly First Nations woman sitting alone on a couch. She had a presence about her.

I went over to make some small talk. She invited me to sit down. Her name was Mabel Hill, and she was a Musko Creek from Preston, Oklahoma. As it turned out, she and her family were in town to attend the American Indian Film Festival, which was honouring her recently deceased son, Will Sampson.

Will Sampson was the gentle Indian giant in the film *One Flew Over the Cuckoo's Nest*. He had major roles in many other big Hollywood movies, including *The Outlaw Josey Wales* and *Poltergeist*. Mabel and I talked on the couch for most of the afternoon. I wasn't sorry to have missed the concert.

That evening, *The Teaching Rocks* was chosen to open the American Indian Film Festival at the Palace of Fine Arts. Possibly as a result of getting to know Mabel, my company for the next three days was Apaches, Comanches, Navaho, Cree, Ojibway, and Dakotas—they accepted me in their circles as a "brother." *The Teaching Rocks* won Best Live Action Short Film.

Will Sampson's son Tim gave a speech at the end of the ceremonies, honouring his father. Later, he and I, and a few of his cousins, sat up talking and partying till dawn. At the end, there were just the two of us. He told me how nervous he was at giving a speech while facing a large audience for the first time. He shook his head and said, "I was worried all afternoon and had no idea what to say to the crowd. I got to travel with my dad a lot when he was making movies. We often sat in the back of his limo and talked. I do remember him saying, 'If you are ever in a tight spot and need help, just ask for me and we will do it together.'

"Well, today I was scared shitless, so I went to my hotel room to think, wishing my dad could be there to help. I turned on the TV, and there he was on some lawyer movie. He looked straight into the camera and said, 'We'll do it together.'

"I felt him beside me up on that stage tonight."

Back in Canada, the press was reporting about complaints from certain aboriginal authors; they were criticizing non-native people for appropriating their culture. It signaled me to back away. I was no expert on the subject. I was a shauganash. I did what I set out to do. I went through the wall. I witnessed the magic. I became a new person and, I think, a better person. My wife said that I became a better person after I met Fred. I made a lot of new friends. I learned what a real treaty is. I know my film helped some people confirm their identities. And it helped many in the dominant society understand a richness of culture that had been too long undervalued.

Fred Wheatley continued teaching at Trent University, before retiring to become professor emeritus. He was never one to brag, but he did mention more than once that he taught the "Oxford Ojibway." Four years later, I went to visit him in the hospital in Toronto on the day that the doctors told him that the cancer in his lungs was malignant. He looked sadly into my eyes and said, "It was the asbestos. We used to unload ships in Parry Sound filled with asbestos. It finally caught up with me."

I was honoured to be a pall-bearer at his funeral in 1990 on Parry Island, on his beloved Georgian Bay. He had been a friend, a teacher, a father, a grandfather to me. I had much of his wisdom implanted in me. It was not my role to expound, but I would try to live the teachings. As he often told me, "Once you are seen to live a certain way, then you can be taught more."

Fred came into my life as a result of my quest to unravel the mystery of the Agawa pictographs on that long penninsula jutting west out into Lake Superior. But he took me on a detour to

another of the seven sacred places in Canada that elders talk about in hushed tones. Another young man, Thor Conway, an archaeologist anthropologist was also in the group with me so many years ago viewing the Agawa pictographs, the same evening that the star appeared. That was some star. Seventeen years later he published *Spirits On Stone: The Agawa Pictographs*, and has gone on to write other books on the subject, notably, Painted Dreams.

Horse and rider image painted on the Agawa rock

Thor, with scientific diligence, excavated, discovered, and studied many sacred sites and worked with tribal elders, recording native folklore and oral history. Among them was noted tribal elder Fred Pine from Garden River First Nation, just east of Sault Ste. Marie. Born in 1897, Fred Pine's great grandfather was Shingwauk, the great Lake Superior medicine man and shaman. Conway learned from elders from the area that it was Shingwauk who painted the Messhepezhieu.

Fred Pine's words take the reader back to another world of thinking, out of the layers of time.

"You can burn a bible but you can't burn this rock. The rock guides. One mark on the rocks has a tremendous amount of meaning. It's like shorthand."

Nearly two hundred years ago, by the shores of Gitchi Gumee, this story was told to Henry Schoolcraft, who passed it on to Henry Longfellow who turned it into this poem.

And each figure had its meaning
Each some magic song suggested
For each figure had its meaning
Each its separate song recorded.

(Longfellow, "The Song of Hiawatha")

WERE YOU LOOKING FOR FOREST FIRES?

The air base that I used to bike to, near the St. Mary's River in the Soo, was a division of the Ministry of Natural Resources, my employer. Forest fire management for the province of Ontario was still based in the Sault, and it was a world leader in forest fire suppression techniques.

Ontario Canadair CL215s, a.k.a. 'tankers', the Twin Otter

Because I was close to the fire organization and had produced training videos for them, I was involved in filming situations that were too risky for the press. Great images get good press coverage. Furthermore, over the years, I had retained my "bush legs". Now it was my turn to be the guy flying over classrooms of kids in northern small towns, rattling their desks, drawing their attention away from the teacher. With my beautiful trusty 16-mm Aaton camera, or sometimes a rented Betacam, in hand, I was in and out of water-bombers, float planes, Bell Long Rangers, and Hughie helicopters, chasing three-man fire crews into the bush while flames raged and roared all around. It was like going into battle, except the enemy didn't shoot back. I felt little fear because of the professional practices of the organization from the top down. The MNR had eighty years of history understanding fire behaviour—most of it in my hometown, the Sault. Every person in the organization felt that they had the best job in the world, including me, of course.

Putting out the fire is like scoring the winning goal.

To an outsider, these smoke eaters might seem like a curious bunch. For example, I sometimes called the Nipigon fire office to ask how the fire situation was.

"Pretty bad, Lloyd. As a matter of fact, it's terrible. We have had steady rain for three weeks."

While doing archival film research in Ottawa, a black and white silent comedy about firefighting in Ontario caught my eye. It was filmed in 1926. A story idea came in a flash. I would have two parallel stories going on, one in 1926 and the other today. I was certain that I could make the first government-produced live-action adventure comedy feature for real cinema movie theatres. Hollywood, eh?!

Writer friend David Lickley worked out a story with five different plot lines, including Ojibway "in-jokes." A big part of our audience would be aboriginal fire crews all across Canada. For the story, all of the plots, including a mysterious pictograph image, were like gears that all meshed together in the very last scene.

We filmed at Ranger Lake, northeast of Sault Ste Marie. This was the Ranger Station the Beavers and Otter aircraft were heading to when they roared over our classrooms, driving me crazy, way back when I was daydreaming and looking out the window.

Shooting went well. With most of the film locked in the can, we still needed dramatic on-the-ground action scenes of our actors fighting a real forest fire. Anticipating a hot weather high pressure zone in Northwestern Ontario, we pulled up stakes and moved west. We spent two days huddling in tents in the rain.

Early one morning, the sun was just breaking when I climbed into the co-pilot's seat of a Huey helicopter. Our crew and gear were stuffed into the back. We lifted off, with fingers crossed, hoping for The Big One. Straight ahead, a bald eagle soared at our altitude of one thousand feet. As we pulled up beside it, it turned its head and we made eye contact.

"Looking for forest fires?" it said. It was him, the old man! I thought, "How did he do that?" Then gently, he turned away and glided off to the east. Ahead, due south, four vertical lines of white smoke rose off the distant horizon. The chopper nosed in close to the fire's edge, and set down. We sprang into action. Each member of the crew had a storyboard with numbered scenes. Checking off scripted storyboarded scenes, we needed: slogging through the swamp, hauling hoses, and climbing over dead, fallen trees in bitter heat and smoke. It was the real deal with actors and action, and no special effects needed.

I didn't have enough story to make a feature-length film, but *Gone (Fishing) Forest Fire Fighting* was another award-winning hit, particularly in Spain.

A few years later, during one of the worst fire seasons in twenty years, I was on the front lines shooting and sending back dramatic news images that were telecast on all networks across Canada, and into the United States. In one three week period I was in and out of thirty five different aircraft and helicopters. I was north of Sioux Lookout one evening just before dark, hanging out of a helicopter, hunched over a camera. The pilot did a low, slow circle around a solitary black spruce that was glowing red all around its base. Suddenly the flames shot up the trunk like a sparking fuse, spewing glowing embers that shot in errant patterns outward into the forest. Pow! The pinnacle of the tree exploded like a starburst firecracker in a huge fireball, just like Wayland Drew described in his book *The Wabeno Feast.*

Kevin Bundy as greenhorn Jack Piner

CHASING THE MUSE: CANADA

There was another fireball. This one was seen by over one hundred thousand spectators, live. From the open door of a helicopter, I would film the MNR water-bombing demonstration at the Canadian National Exhibition Airshow in 1989.. The plan was to ignite a firewood-laded barge out in the lake, and our tankers would demonstrate how quickly and effectively they could pick up and drop water on-target.

The pre-show briefing by "Boss Control" was in a hotel ballroom near the airport. As the show planners outlined the orders of the day, I sat among the Snowbird pilots in their glamorous flight suits. I thought of my grade eight teacher, and of not setting my sights too high.

Wearing a life preserver, I climbed into the back of a Bell 206 Long Ranger helicopter with a Betacam camera mounted between my legs on a shock-absorber mount. We made our way to the eastern beaches of Toronto, descending to one hundred feet over the water, at our assigned holding spot. As we hovered, waiting over the water, two CL 215 water-bombers circled us in a holding pattern. We had to stay low because overhead, to open the show, the jets of the aerobatic team, the Snowbirds, would be approaching centre stage from a higher altitude.

The two tankers continued to circle us in Holding Zone B until Boss Control vectored us to Holding Space A, closer to onstage time. This was definitely another of the high points of my life. My boyhood dreams were definitely happening. I would be filming water-bombers whizzing between me and one hundred thousand CNE spectators below. Five more minutes, and we were on. Through the side window of the helicopter, I caught glimpses of the elegant smoke trails following the Snowbirds as they deftly soared their intricately choreographed aerial ballet.

This air-to-air shot was taken moments before the Snowbird collision

In the middle of a turn, over my headphones, I heard the anguished voice of the fire attack officer in the co-pilot's seat, "Oh, fuck! Fireball in the sky!"

Snowbird Team Leader Dan Dempsey's aircraft collided explosively with Captain Shane Antaya's plane, and Dempsey ejected from his flaming cockpit. Eyewitness accounts claim that Shane Antaya used supernatural situational awareness and strength to maneuver his damaged aircraft away from the spectators in the flotilla of boats directly below. He hit the water hard just beyond them. He died a hero.

Immediately, orders came over the headphones from Boss Control: "Show hold!"

The two tankers immediately peeled off to head back to main base. My pilot radioed through my headset to me that I was needed at centre stage on the ground. En route, we had to keep our eyes peeled for an errant American F-16 American fighter jet in the same corridor, alerted that its altitude was 300 metres, the same as ours.

As I pulled my gear out of the helicopter in front of the CNE crowd, I was immediately approached by an RCAF officer.

"We sent our cameraman to HQ to analyze the crash footage, so when the show resumes in an hour or so," he said, "I would like you to film every second of our F-18 demonstration. For some reason F-18s are dropping out of the sky, and we still don't know why."

(Journalists were referring to the F-18 as Lawn Darts. The problem was eventually discovered and fixed, but it wasn't with the aircraft itself. It was a neurological issue in the pilot caused by sudden acceleration without a visual external reference.)

I filmed the F-18 demonstration, which was impressive and without incident. I suppose I can now say that I finally did work for the Royal Canadian Air Force. Our helicopter picked me up and flew me back to airshow HQ at the Airport Hotel. Families of the Snowbirds crew were still on pay phones in the lobby, in shock, and calling loved ones at home with the tragic news. We learned that Dan Dempsey had parachuted from his fiery cockpit, and survived the crash with minor injuries. Film footage showed Captain Shane Antaya staying with his aircraft to steer it away from the spectators in the boats before crashing into the water.

The Snowbird team, a close family, were preparing to fly back to Moose Jaw, their home base. There was sill a post- show cocktail party (minus the Snowbirds of course) I was still in awe of the group of pilots assembled in their colourful flight suits. The tragedy seemed be buried behind everyone's smiles. I found it curious at first, but then it hit me. Oh, the black cloud was there, but there was something else. Perhaps it was the code of being a pilot. In the backs of their minds, they all knew they had to climb into their cockpits tomorrow, take off, and give another show. Grin and bear it, move on, and be a pro. I was still living my youthful dream of the freedom of the open skies, but now I was even more aware of the strict requisites to earn that freedom.

Oh! I have slipped the surly bonds of earth,
And danced the skies on laughter-silvered wings

(John Gillespie Magee, Jr., "High Flight")

THEY CALLED ME BACK

There is a famous line spoken by Anthony Corleone in the *Godfather Part III*, "Just when I thought I was out, they pulled me back in."

From many remote northern communities, aboriginal children are flown to southern schools to continue their high school education. The culture shock, and in some cases, racism that is too harsh to understand and accept, result in a very high dropout rate. Too many kids return home disheartened, with few real job prospects open to them.

I was invited to produce a video to encourage aboriginal children to stay in school and get an education, while retaining their cultural identity. To ease their journey, I also thought it important that non-native children see the film, to help them understand the lifestyles their aboriginal classmates came from, and the struggles they were going through. I hired talented writer/videographer Joe Beardy, a young Ojicree from Bearskin Lake, a reserve in the far northwest of the province, to help. Joe and I filmed many native role models, including NHL and Olympic hockey coach, Ted Nolan, who described his struggles living away from home as a kid and how he overcame them to triumph in white man's society.

Word came that there was a helicopter available in the far northern community of Peawanuk to fly me to Polar Bear Provincial Park on Hudson Bay to shoot scenes for a movie I was making for the centennial of Ontario Parks. Since Joe Beardy and I were about to fly to Moosonee on James Bay to work on the role-model video, we arranged to continue up the James Bay Coast over to Peawanuk afterward. To be back on the coast of Hudson Bay again, in Polar Bear Provincial Park in the heat of summer, with a helicopter at my disposal, was a dream beyond belief.

The shooting went very well in Moosonee. Everywhere we walked in the town, people would say, "There's Joe Beardy." It turned out that Joe had been a TV news commentator in the Ojicree language of the Wa Wa Tay community TV network in the north. He was a star. Walking down the road, I heard my new name. "There's Joe Beardy's Friend" or "Hey, Joe Beardy's Friend."

Just before our Moosonee visit, I had been on holiday, canoeing on the Georgian Bay, so I was wearing a deep tan, and my hair was also a bit long. When I purchased anything in Moosonee or nearby Moose Factory, I was mistaken as a band member, and I was often not asked to pay any taxes. Our flight from Moosonee to Peawanuk arrived three days late, and in the waiting, we had exhausted our cash.

En route to Peawanuk, we stopped for fuel in Attiwapiskat. I wandered into the small building near the tarmac, and asked a group of Cree standing inside if they knew Jackie Hookimaw. Jackie was the lady that took me to visit the trappers in the tipi near Fort Severn.

"Yes, we know Jackie," they all chimed.

"Well, tell her that Lloyd says hi."

I climbed back into the co-pilot's seat to continue chatting with old friend Red Segun, the pilot. Even though it was my birthday, I didn't dare ask him to try out the controls. I thought it might be unprofessional. Red had a worm farm in his garage and was starting a business selling

bait to fishermen. He suggested that I might want to make him a television commercial of an angler being arrested for overfishing. The accused pleads to the Game Warden, "I am sorry officer. I didn't mean to catch so many fish. But I was using Red's Worms!"

Landing at Peawanuk three hours later, we were met at the airport by an old friend, Mike Hunter. Mike handed me a message from Jackie Hookimaw in Attawapiskat. "Sorry I missed you. Wachea, Jackie."

"Moccasin telegraph" is the phrase describing how quickly word spreads in the north.

Mike Hunter drove Joe and me and our considerable gear to a government base station. It was a bunk-house with kitchen, food, and facilities. I had stayed there a number of times before on polar bear, caribou, and park projects. A team of eight technicians from Timmins were staying there as well. They were assembling a radio tower nearby.

As we unloaded our gear, a barbecue was just starting out back. After grabbing our bunks and settling in, I went to the fridge to get some steaks for Joe and I—we would have a birthday dinner. The leader, a guy called Sean, walked up to me and grabbed the food out of my hands. "This food is not for you two," he said.

Stunned, I looked at Joe, who was wearing an identical tee-shirt to the one I was wearing, with Cree symbols on the front. Then it dawned on me, with my tan and longish hair, he thought I was Cree. I was in shock.

Joe looked at me and said, "Welcome to my world."

Having spent the last four days in the presence of the Moosonee and Moose Factory Cree, I had adapted to their ways—not being bombastic. I could not shout back, "Excuse me, do you know who I am? I am from Queen's Park. This food is for us, too!" I wasn't that kind of person.

Joe and I were out of cash. There were no cash machines in Peawanuk. The next flight out was in four days. I knew from fasting that I could survive because the water was free, but I could not shake the shock of the racial affront. I was rattled and buzzed out. The hardest part for me was that I didn't feel like working. Joe would be shooting with video equipment in Peawanuk for the "stay in school" project, and I was to shoot 16-mm film of Polar Bear Provincial Park. It was hard to get to sleep that first night, my birthday night.

The next morning, we dressed and sat on the couch facing the white men seated at the table as they drank coffee, eating eggs, bacon, fried potatoes, and toast. It felt strange to be shunned by my own MNR personnel. I would have given anything for a cup of coffee. The men cleaned up and Sean, knowing I had to hitch a ride to the helicopter with them, said to me, "Let's go."

Joe Beardy and I took to sneaking morsels of food, but we had to be careful because whenever Sean returned, he went directly to the refrigerator and counted items. I had a helicopter at my disposal to film polar bears, but I couldn't feel excited about it. I couldn't look those people in the eye.

The helicopter pilot was new to the Ministry of Natural Resources. On the third day, when he found out that his mentor, famed MNR pilot George Beauchene, was a very good friend of mine, his attitude towards me changed considerably. He went out of his way to execute some beautiful aeronautical maneuvers for those special shots. We even located an inuksuk made by an

Inuit family who travelled to the barren southern Hudson Bay coast many years ago. It was a rare find in Ontario. Returning to base, a fisheries research crew arrived from the back country with a load of sea-run brook trout. I knew the leader of that crew, and we were invited to "Dig in!"

What a feast it was. Word got around. Everyone started to be nice to us.

Joe Beardy and I made three "stay in school" videos in a series we called *Sharing the Vision*. They were translated into French, Cree, Ojibway, and Ojicree. A lot of the aboriginal role models we used talked about how they learned to cope with racial taunts and attacks, not unlike our recent experience. The high dropout rate was easy to understand. Facing hatred day after day had to be so hard on those kids. All I wanted to do that first night in Peawanuk was to go home. In all the years I wondered what it was like to be Anishinaabe, I was totally knocked off-guard when I was treated like one. "Humility is endless". (William Blake)

A year later I heard from Jackie Hookimaw from Attawapiskat. She said that for over a month, wherever she went in Attawapiskat, old people, little kids, everyone, would come up to her and say, "Lloyd says hi."

PLACES OUT OF TIME REVISITED

Over the years, I met many people who, like me, were fans of Wayland Drew's novel *The Wabeno Feast*. Perhaps it was the shared experience of canoeing the pristine unspoiled shore of Superior that made the historical connection seem so prescient. That fiery ceremony and spectacle also had to be a metaphor for something else.

Wayland Drew had had also written a science fiction series, and novelizations of movies for George Lucas, the creator of *Star Wars*. When he was in California one day having lunch with George Lucas, George invited a friend named Steven to join them. Wayland had no idea who Steven was but the three of them hit it off. As it turned out, Steven (Spielberg) was working on the first *Indiana Jones* movie, and he thought that Wayland might be a good fit to join his writing team. Wayland turned him down. He was content to be a high school teacher in Bracebridge, Ontario. His students adored him. Everyone adored him. I wanted to work with him. But why would Wayland Drew want to work with me when he had turned down Steven Spielberg?

Prior to making the film, *Places Out of Time*, Fred Wheatley had retired, bought a boat, and toured my family through his beloved 30,000 islands of Georgian Bay. He showed us its great beauty, and told us stories of its dangers and perils. Knowing that I am wary of rattlesnakes, he told us that the Ojibway people co-exist with them by being aware and alert, especially when picking berries. He said that rattlers hide in berry bushes waiting for a feeding bird to snatch.

"As children we were told, if you are bitten, just lie still if you can, for hours, if need be."

We pulled up to a beach and went ashore to have a swim and make dinner. Just as we were about to run into the water, a very large snake swam up to our feet. My son Jake remembers:

"As I recall it, Fred initially identified it as a fox snake. Too large for a rattler. So I got up to take a very close look as; one, snakes are fascinating, and two, it wasn't venomous. I squatted down and got to about eighteen inches from it. Its wet tail was shaking. Then it dried itself off. At that point "BZZZZZZZZZZZZZZ" went the rattle and I levitated out of there. Fred said, 'Hmmm, I thought it was too big to be a rattler...whoops.' I would have been lying still for a while."

It was on that trip that I remember Fred saying to me, "It would be good if you could someday get together and work with one of my Ojibway students. You would really like him. You must meet him. His name is Wayland Drew."

Fred Wheatley

Wayland (his friends called him "Buster") and I made the multi-award-winning movie, *Places Out of Time* together. It was to celebrate 100 years of Ontario Provincial Parks and the natural, historical and cultural treasures now protected by the park system. The soundtrack was mixed in the recording studios of David Pritchard, the creative audio genius who's all night radio sonic choreography transfixed me as an art student. Filming required revisiting certain sacred sites, bringing new insights. I was still weighing older thoughts I picked up in conversation with elders and apprentices.

The messages in ancient symbols that have been bound to stone walls all over the world for such a long time, messages from another era, might be there to remind humankind that history can repeat itself, perhaps even cataclysmically.

On a wet and chilly Thanksgiving weekend, I made the thousand kilometre drive to revisit, re-film, and re-think the Agawa rock pictographs. I brought my son Jake to help carry the heavy gear to the site, including lighting equipment to help boost the chroma of the figures, which seemed to be fading, perhaps from being touched by forty years of park visitors. Some of those visitors never made it back to the parking lot. Several have been swept off the rock by the swish of a rogue wave.

That knowledge alone was enough warning to me that sacred sites such as this must be approached with the utmost care and respect. Weary from the weight of the heavy load, and wary of my footing on the slippery rock, I barged right past the enigmatic symbols to find a level working platform.

Stacking my load as carefully as I could on the rock ledge I was about to complain about a kink in my neck. Jake stopped me and pointed to the tripod rolling down over the rock's edge. We both lurched towards it only to watch it slip into the cold clear water and drop down, down scraping the cliff face wall, rocking with the current. It settled precariously on a ledge about five metres below the surface, threatening to slide off into the black abyss.

The October sky was slate grey, threatening snow any day. I couldn't do the job properly without the tripod. It was time to pay my dues, and I got out the tobacco pouch.

The dive felt like a perfect ten as I dropped like an arrow. The water was so cold, it shrank my fingers. While reaching for the tripod, my silver rings floated off, spinning and shining against an ink-black background. With one swipe, I grabbed them both, and stuck them in my underwear. With great urgency, I wrestled the heavy tripod to the surface. Filming proceeded with the utmost care and respect.

Places Out of Time was broadcast nationally in Canada at Christmas 1994. It was so well received, including awards in Italy, that a two-night Lloyd Walton Film Festival was organized in Karlsrue, Germany by the Canadian government, and I was invited to speak about Canada, along with acclaimed Canadian author Mordecai Richler. To save Ontario taxpayer money, I was not allowed to attend. But no matter.

It was truly an honour, privilege, and pleasure to visit all of those magnificent landscapes, and to work with David Pritchard and Wayland Drew.

GRINNING DOWN A BEAR

I retired from my extraordinary MNR job, and moved to Muskoka. Since then, I have still tried to maintain the code, going through life with focus, planning, situational awareness, vigilance, attention to detail, and, when necessary, guile.

I really needed that guile when I was hired back by the Ministry of Natural Resources, as a freelancer, to create a thirty-second television spot for the Bear Wise Program. The general message was to be, "Do not use bird feeders, or leave dog food, or food on your picnic table because it attracts bears."

I was asked to film smashed garbage pails, bird feeders, and the messes left by bears in urban areas. It was June, and the city of Sudbury was having bear problems, so it was easy for me to find spots to film the debris left by unruly bears.

But, in my mind, to make the TV spot interesting, I needed to do the job better—to show bears actually doing the damage. Although I did not have the time to sit and wait for one or more bears to perform all of the scenes I required, the urge to do the job better than they asked was biting me. During a visit to the Sudbury MNR office, a Conservation Officer acquaintance called me aside.

"You didn't hear this from me," he said, "But if you want bears, I know where you'll get lots of bears."

He directed me to a green house about sixty kilometres from Sudbury, off the highway, at the end of a gravel road. The next morning, I located the house, stopped my van, and opened the window. A man was sitting on the steps of his front porch talking to a bear.

"Good morning," I said.

"Morning," he replied.

He stood up and started walking towards me. The bear walked by his side. I got out of my truck.

"Are you scared?" he asked.

"Not if you're not."

I also said "Good morning" to the bear.

We shook hands (me and the man).

"How can I help you?"

I explained my need to film bears in the act of smashing bird feeders, dog bowls, and camping coolers. He invited me in to meet his wife.

Over coffee, she told me the story of once waiting in a doctor's office for the results of some tests. The waiting room walls were covered with wallpaper decorated with bears. She was diagnosed with cancer that day, and given six months to live. On the drive home, bear after bear appeared along the road over the last mile to their house. An especially friendly black bear, one she called Ben, was waiting in the yard.

She said, "When I got cancer, my daughter had a white bear appear to her in a dream. The white bear came to her from a carving on a medicine woman's shaman stick. It told her that it would help her mother heal."

She said, "Shortly thereafter we had a white bear come out of the woods. Ben came up to me, patted my knee, and said to me three times, "mukwa, mukwa, mukwa." The white bear appeared two years in a row. The first time, it was about a year old."

Feeding Ben

Her husband worked in the mines in Sudbury and, every day on the way home, he stopped at a bakery to pick up leftovers to feed the bear. What started with one bear grew to up to a dozen bears joining Ben in the yard. On a hot summer day, they lined up, each taking its turn to use a child's plastic swimming pool. Strangely, during the spring bear-hunt, American hunters camped nearby, but they did not see any bears.

She felt that the bears brought her healing power.

"I was sick, and Ben sat under my window every night. I'd get up in the middle of the night and say, 'Are you there, Ben?' and he'd snort."

It had been eight years since her first diagnosis with terminal cancer. I've been told that, among our First Nations people, bears are respected for their knowledge of the power of healing.

She went on to say, "I was on the phone with my daughter with the window open, and I felt something hot on my face. I turned my head, and there was Ben. I swatted him and said,

'Don't do that, Ben.' Another time, I was licking lemon cream off my finger when he bit me. The bear backed up to apologize."

I passed the audition with the couple, but they had one rule. I had to keep their names and whereabouts secret. The plan was to allow me to film what I needed when they got back from town at about four o'clock that afternoon. Back in town, I loaded up on dozens of lemon and jelly doughnuts, and other mixed flavours at Tim Horton's. When I paid, the cashier said, "You goin' to a party?"

"You wouldn't believe this party," I laughed.

Next, at a pet supply store, I bought dog food, bowls, a bird feeder, and bird feed to add to my arsenal of lures and props, and I headed back to their haven, deep in the bush.

My hosts hadn't arrived back yet, but a lone bear was waiting by the house as I pulled into the driveway. Although I was early, I wanted to get started. I got out and opened the wide back door of my Honda Element. I hastily grabbed a dog bowl and food. The bear was moving towards me quickly. I put the full bowl down beside the vehicle and hopped back into my seat. With the camera lens hanging out of the open window, I filmed him devouring the dog food. When he finished, he came over to my door and stood up, his paws against my quickly closed window. Our eyes met. Then it hit me—not the bear, but the realization that I had left the back door of my vehicle open! A cornucopia of jelly food delights were laid out there—a perfect setup for creating a feeding frenzy in the back of my car!

My mind harkened back to Davy Crockett. Davy, my hero, could "grin a bear." Mustering all of the teachings given to me by so many men and women of wisdom, my body became calm, and my mind free of fear. As I opened the door, the bear backed away. I slowly got out, summoned my guile, forced a grin, and introduced myself.

"Hi, I'm Lloyd. You look so good there, and I would like to film you and your friends later. We're going to have a busy time, but there is something I have to do first."

I could smell his dog food breath—he followed me as I walked backwards towards the open rear door.

"I'm just going to close this, and walk around to the other side and get in. I will catch you later." I closed the rear door a second before he spotted the treasure. He was sniffing me. My heart was pounding. As I opened the passenger door, the bear's ears went up, and he jerked its head. My host's car pulled into the driveway behind us.

With the sound of their voices emerging from the car, five other bears came out of the woods, from every direction. Calmly, he and his wife greeted them, and talked to each one by name.

I was able to record rare real-live cinema action with bears swatting down bird feeders, emptying dog food dishes, and popping open coolers on a picnic table.

INTO THE STONE

After I had all the footage I needed, we sat on the steps sipping tea, watching our actors go about their black bear games: snorting, sniffing, rolling, biting, swatting, and chasing each other up trees.

I drove off, again with that old cowboy feeling, plus a tinge of Davy Crockett, "King of the Wild Frontier".

THE LAST TIME

The last time I saw Archie Cheechoo was on the Nippissing Reserve west of North Bay. He was staying with his mother as he convalesced from a second heart surgery. As I got out of my car, his mother, who had been standing outside on the porch, went into the house to get him. He came out to greet me, and said, "My mother told me that an old man was coming to see me."

I replied, "I guess her eyesight must be going."

He said, "No, her eyesight is perfect."

We laughed.

His life on the road, travelling with other medicine men and women performing healing ceremonies, combined with a bad diet, cigarettes, and the absorption of people's pain, had resulted in his first quadruple heart bypass.

Over the years, I had witnessed some of those healing sessions in hotel rooms and in the back rooms of friends' homes. It had taken a toll on him. In his healing ceremonies, the pain he absorbed from his patients—mental and physical—had to come out of his body and it did, sometimes violently.

Archie told me that during his recent heart operation, he walked up to a line. It overlooked mountains, forests, and streams. Eagles soared above. Down below to the left, buffalo were grazing. On the other side of the line was a group of teepees. A beautiful woman in traditional dress came out of the teepee, walked towards him, and beckoned him to step over the line.

He said, "Suddenly I had the urge to eat a nice big steak. I decided to come back to this world."

We laughed again. He had a great laugh. I told him that I, too, came back from the edge of death one night in a freezing teepee, because I needed to take a piss.

Lloyd & Archie sharing a joke

The last time I saw the Mishomis was at a horse ceremony near Penetanguishene on southern Georgian Bay. Tall poles with billowing colourful fabrics encircled a large fire pit. A larger ring of teepees surrounded the circle. It looked like there were more than a hundred people there. As I approached, the old man greeted me warmly, and asked me to sit with him in front of his lodge. He looked so happy to see me.

I reminded him of the story he told me that took place back in the 1920s, when the Mounties came to his Anishinaabe community in Alberta to purchase horses. The Mountie superintendent

insisted on purchasing one spotted horse, but the old owner refused to sell it to him because, he said in his best English, "That horse no look good."

"Well, he looks fine to me," insisted the Mountie superintendent, who would not leave without that horse. He would not take no for an answer, and he left with the steed.

A week later the Mountie returned the horse, indignant that the old man would sell him a blind horse.

"I tell you that that horse no look good," insisted the owner.

It was a crazy joke, but the old man and I giggled like kids. He loved to laugh.

Logs were placed on the fire, and people began gathering inside the sacred ring of poles. The Mishomis asked me to sit by his side in the large circle of guests during the feast and ceremony under his command. I was surprised to hold such a place of honour. His gracious acceptance of me made me swell inside. He glowed in his handling of the ceremony, but never in a showy way.

I was not specifically invited to this event; I just showed up, unprepared. Looking around, I began to feel uncomfortable—there was something I couldn't quite put my finger on. It had nothing to do with what he did or said, of course. I felt that some people might be offended or jealous of me basking in his glow. Everyone there had paid their dues to be there. I just dropped in to fulfill a treaty made many years back. He was treating me again with kindness, honesty, sharing, and strength. During a break in the ceremony, I said farewell, and prepared to take my leave.

As I walked past the food preparation area, a woman's sharp glance caught my eye. It was the woman who, many years ago told me that it hurt her to know I was making the film about the teaching rocks. Something felt undone. I kept walking, but now, my self-doubt was resurfacing. Was it a money thing? No. The movie was offered to the public at cost. Nobody got rich off it. I slowly made my way to the parking area, with the burning feeling that I had still let her down.

Through the smoked glass rear window of my truck, in the distance I saw the old man for the last time. As he sat there shining, the coloured streamers overhead were catching light as they slowly zig-zagged in the breeze. I looked down at my 300-mm telephoto lens sitting on the seat. What a shot it would make. But he did not allow himself to be photographed, and there must be no camera when the spirit appears. There was a lot of spirit in that scene. I had a knot in my stomach and my hands were shaking.

I slowly pulled away, reconsidering again whether I had done the right thing, making the movie. Had I coerced Fred Wheatley into expounding on that which was reserved to only a select few? No, we drew attention to symbols such as the medicine wheel. It takes years to learn of the medicine wheel teachings, but it was more like I had shone a light on a complex book, and hinted at the contents.

For each shot I recorded for the film, before the camera was turned on, I placed tobacco in ceremony. I was guided by the star, my heart, and by so many kind Anishinaabe who appeared, guiding me slowly through a tangle of unknowing, closer and closer to the mystery. After so many years, I still learn something every time I watch *The Teaching Rocks*.

Fred Wheatley best summed up our intentions: "If you can just look at it and think—think that there were people who lived at one time with great wisdom."

I still try to remain conscious of having to walk in a good way. Doing so has brought unexpected rewards. I remember the old man, soaring beside me as an eagle three years later turning his head, looking me straight in the eye and saying. "Were you looking for forest fires?" Was that real? What is reality? It was both a super, and a natural experience.

Thirteen years after the curious and powerful Neil Young tour truck vision, I was wearing a backstage pass, given by a friend, wandering down below the Air Canada Centre in Toronto and there they were, the Neil Young tour trucks. Neil Young was there as part of the super-group, Crosby, Stills, Nash, and Young. A rumble of expectation was building from the huge crowd. All of the sound, rigging, and lighting personnel had gone to man their show stations. The roadies were in their makeshift dining area, finishing a hearty meal, planning to catch a bit of sleep before the hectic load-out in three hours.

Stephen Stills walked up, introduced himself to me, and said he was lost. I put my arm around his shoulder and guided him towards the mounting crowd roar. We talked about the show he had given the night before, and how their music over the years had nurtured my artistic muse. At the end of a long dark hallway, we approached three men grouped in a huddle. Then there I was, locked shoulder to shoulder in the pre-show pep talk with David Crosby, Stephen Stills, Graham Nash, and Neil Young. I felt the brotherhood.

Neil Young, the obvious leader of the group, was conjuring the spirits to help them put on an exceptional show. He was using his hypnotic powers to motivate himself and his mates, just before they were to walk out to an excited crowd of twenty thousand people. This was their preparation ceremony to summon their strength, power and energy

His words were so inspiring that I was emotionally charged—I was prepared to walk out on stage with them. "What the hell?" I thought. "I know all of the words and harmonies." That was some trance!

I felt a tap on my shoulder. It was Elliott Roberts, their manager. He said very politely, "You don't need to be here." I humbly backed away.

I watched the show from the work space of Neil's guitar tech, Larry Craig, one of the co-creators of the signature Neil Young guitar sound. Larry never stopped working the whole evening to make sure his boss sounded great. Watching Larry, I reflected on the loyalty of so many friends, fellow workers, and technicians over the years who have stood behind me and my work.

DEEP INSIDE THE TEEPEE

I was back in Timmins at a Grand Council Treaty Nine conference giving a presentation about how, so many years ago, this hired hand helped hold off the giant foreign conglomerate from decimating their land through clear-cut logging. A re-screening of *She Go Bee* went over very well.

Later that evening, I made my way to a large teepee set up in a field. The sun was slowly pulling down the colours of the big, deep-blue Timmins sky. A first star appeared. I took a deep breath of the fragrant summer night air, and then crawled into the east-facing door of the large, bone-white-skinned wigwam. Alone, sitting cross-legged on the balsam-bough floor, I felt a sense of tranquility. A lot of care had gone into creating this place of reverence. The crackling fire, ringed by stones, sent a ribbon of smoke upward.

Voices approached. One by one, various old and new acquaintances crawled through the door of the wigwam, paid their respect to the fire by sprinkling tobacco over the flame, then joined me in the lodge circle. As a shauganash, a white man, it felt good to be so comfortable in this company of Cree, Ojibway, Ojicree, Lakotas, and Stoneys. I felt humbled to be included in their presence.

Among them was Rick Lightning, son of the late revered Alberta medicine man, Albert Lightning. I mentioned to Rick that, many years before, I had experienced a remarkable ceremony held by his father in a similar-sized teepee. Rick Lightning replied by telling a story about a buffalo hunt back in Alberta with his dad. The hunters were about to begin the skinning ceremony of a recently killed female when its mate showed up and started bellowing. Albert told everyone to stay put. He got up and walked toward the angry bull with outstretched arms. Albert stopped very close to it and began to speak. He told the bison that from the beginning, animals were given many gifts at creation. One gift was to offer their bodies to sustain us humans.

"Your mate is fulfilling the function given to it by the Great Spirit, "he said.

He assured the massive snorting bull that the cow had not died in vain, and that none of her body would be wasted.

The placated bull turned, and slowly walked away. Albert came back to the group and asked someone to run back to the camp to get a pail to collect blood from the severed jugular vein of the deceased female bison.

He said that now someone must drink it.

Everyone pulled back. Albert pointed to his son Rick Lightning.

"Aww, Dad," said Rick.

"Did you drink it?" I asked.

Rick grinned and said, "I drank it, and it surprised me. It felt rather pure."

Rick told me years later that when Albert Lightning died, an eagle circled the funeral ceremony. A shaft of light came out of the clouds, the eagle flew up into the shaft, and then the clouds closed over.

Clayton Cheechoo, a James Bay Cree, also had stories for me, but before he began, he prepared me by cleansing me with smoke from burning sage. Holding an eagle feather, Clayton offered tobacco and cedar to the fire, and then spoke in hushed tones of the work that my friend and brother Archie Cheechoo had done, healing his people. What is sacred and what is secret are closely related. I was out of the country when Archie died, so I missed attending his funeral. Clayton told me that Archie died in a fit of laughing. That would be Archie. Humour was his gift. He was also a trickster, in my books.

Everyone had a story to tell about the Mishomis, the grandfather. Living into his hundreds, he still had immense powers of teaching, being, and shining. His presence commanded respect, but that respect was fully returned. He had a direct pipeline to another world.

My enchanted journey started from hearing my dad's stories of his trip west at a very young age. I suppose I heard them so many times that they became imprinted on my destiny. (I, too, love my motorcycle.) When my father passed away, among the papers he left me was a clipping from the *Sault Daily Star*. The story described an event in 1898. A local resident ethnographer, L.O. Armstrong, made a trip downriver, east of the Sault, and stopped one evening near an Indian camp. Through an interpreter, he invited the inhabitants to hear a recounting of Longfellow's "The Song of Hiawatha." About twenty Ojibways turned up to listen.

The name Hiawatha meant nothing to them, but as Mr. Armstrong proceeded with the stories, when interpreted, they exclaimed, "Why, we know those stories! We tell them to our children."

Mr. Armstrong continued, "Whenever the legends were faulty, they boisterously demanded their correction, and upon doing so they grunted approval and satisfaction." After the Song of Hiawatha was fully retold, the Ojibway audience mentioned that all the names used were Ojibway except for Hiawatha and Iwa Yea, a Sioux word meaning "my little owlet".

In 1900, two years after that fireside recital, an invitation was sent to Henry Longfellow's daughters to "stay in our royal wigwams in Hiawatha's playgrounds in the land of the Ojibways." Some members of the Longfellow family did arrive to stay at Longfellow's Island, downriver from the Sault. In honour of their visit, a party of Ojibways camped on the island. Thirty wigwams were set up in three circles about the cottage—the inner circle consisted of the chief's wigwam; the second circle, the warriors; and the outer circle, those who were neither chief nor fighting man.

I see this event as another tribute to the power of oral history. I remember again, Fred recounting to me a story of reciting a story back to his grandparents. They would say "No, no. You must use these words when speaking of it. Otherwise you are making it sound more exciting than it is."

I still think about that night when the old man drew the map of North America for me, and then tore it up, and took it with him. The lesson was about paying attention. Yes, he did slip the puck behind me, but I think he then flipped it up so that it was balanced on the horseshoe coming out of my ass. The Mishomis died at the age of 108. He still visits me regularly in my thoughts.

ACROSS THE SKY

October was warm in Muskoka this year. All of the cottagers, up from the city for Thanksgiving and to close up their cottages, had departed. I live here year-round now, doing what I originally set out to do, paint. You can say things in a painting that you cannot say in words or movies. I am still chasing that mystery in a work of art—where something arrests the viewer, and demands a second or third look.

I had a small job to do. It was an easy job, photographing a palatial island cottage for a real estate agent. I loaded my camera gear into my old boat named "Blue Alert," and I set off down the cove. On this warm autumn day, the last dragonflies of the year were zigging and zagging, upping and downing. It was Indian Summer at its best. Turning due south out onto the big glassy Lake Muskoka, edging past island after island, the red maples were in full blush. That's where Muskoka gets its name, from the Ojibway word describing the red of the leaves. I arrived at my destination, filled the camera with shots of the cottage; then I got back into the boat and headed home.

For the long journey back, I set the engine speed at idle, and then I stood up, leaned on the top of the windshield with my elbows, and steered with my knee. Pods of loons singing and diving for dinner accepted me as no threat. They were gorging on their last meals before they flocked together to head south. Slowly put-putting across the glassy surface, both the boat and my mind were on autopilot.

I drifted into daydreams of old friends, acquaintances and heroes of mine—some still alive, some long gone. Teachers who taught me, not only to look, but to see. Anishinaabe companions ever so patient with my questions, and so giving in their answers and teachings, often with gentle humour, calling me, "brother," teaching me how to truly engage in my surroundings without fear. I've lived a charmed life, and met my heroes. Bob Dylan once thanked me for coming to a concert and said to me, "Nice to see you again." (Was he referring to the time I didn't stop him when he was skate boarding with his kids?)

I once entered a cage with lions and tigers. When things seemed to get a little tense—the tiger stopped his act and started staring at me—I asked the trainer if he had a gun. He replied, "No, but I have a stick with a piece of meat on it."

Alone, snowshoeing across a frozen lake in northern Alberta, a large, dark, woolly bison appeared nearby on the shore. It stood motionless, checking me out with those dark eyes. Those eyes, penetrating like Rosie's eyes, studying the paperboy standing in the doorway.

A ripple on the water triggered a flashback of another ripple when I was up on Georgian Bay driving a rented boat. I was looking for a place called Honeymoon Bay to film a scene with an actress with beautiful eyes. Threading our way through many islands, the landscape looked familiar. Fred Wheatley had taken me to that very location a few years before. When I hit a big stretch of open water, I cranked open the throttle, feeling the freedom of the big Georgian Bay

sky and the wind. Fred was always adamant about water safety. It was out on the open water of Georgian Bay, he once said to me. "Never take the Georgian Bay for granted." Thinking of my precious film gear and actress I cut the power, and the boat rocked to a stop. Just ahead, ripples were breaking over a sharp rocky shoal looming slightly below the surface. Slamming into it at speed would have sliced open the bottom of the boat and ripped off the motor. A certain disaster was averted.

In the ripple of that memory, Fred was giving me a heads-up today and right now. "Never take Lake Muskoka for granted."

It was time to stop dreaming and focus on navigating.

The sun was on my back as I entered the narrow channel leading upriver to my home. Suddenly, up ahead against a blazing autumn backdrop, a big bald eagle swooped horizontally across the sky, and then glided down, soaring straight towards me at eye level. The setting sun lit up its white head, yellow beak, and fierce oncoming glare. Zooming closer and closer, intense dark slit pupils burned into me.

Sensing the photo opportunity of a lifetime, I instinctively grabbed the camera, turned on the motor drive, held it up, and squeezed the shutter. A warning came on in the viewfinder, saying that my memory card was full. I lowered it to my chest, fumbled through the menu to screen, and deleted about four shots.

Suddenly, with a bang, whump, and a loud whirr from behind, the boat jumped up out of the water, and breached on a neighbour's floating diving raft. The engine revved and the propeller whined loudly, spinning in air. I cut the power.

The eagle whooshed past my ear, head turned back towards me, throwing a quick shadow on my eyes. A brilliant gleam from the sun reflected through its eye and shot into mine. In a flash, I saw him laughing at me. Then, into the light, he was gone.

Over the years, instinct, perseverance, and lighting were my guides for filming. That sudden moment of magic reminded me again that Mishomis and I still had a treaty to honour. When the spirit appears, "There will be no cameras!" He had just reminded me again with a pretty good joke.

Feeling like an idiot, I sheepishly looked around to see if any neighbours had witnessed my folly. A simple rocking motion caused the boat to gently slide sideways off the raft, and back into the water. In sublime humility, I continued on up the narrow cove. I cut the engine. The sound of laughing water tumbling over a beaver dam broke the evening stillness. Blue Alert slowly and silently drifted sideways to a perfect stop against the dock, at the northernmost tip of the lake.

BIBLIOGRAPHY

Copway, George. *The Traditional History and Characteristic Sketches of the Ojibway Nation.* Toronto: Prospero Books, 2001.

Dempsey, Hugh A. *Indians Tribes of Alberta.* Calgary: The Glenbow Institute, 1986. (p. 87)

Drew, Wayland. *The Wabeno Feast.* Toronto: House of Anansi Press, 1973.

Erdoes, Richard, and Alfonso Ortiz (ed). *American Indian Myths and Legends*, New York: Pantheon Books, 1984.

Schoolcraft, Henry. *The Myth of Hiawatha, and Other Oral Legends, Mythologic and Allegoric of the North American Indians.* Philadelphia: J.B. Lippincott & Co., 1856.

Smith, Donald B. *From the Land of Shadows: The Making of Grey Wolf.* Saskatoon: Western Producer Prairie Books, 1990.

Smith, Donald B. *Mississauga Portraits: Ojibwe Voices from Nineteenth-Century Canada.* Toronto: University of Toronto Press, 2013.

CPSIA information can be obtained
at www.ICGtesting.com
Printed in the USA
LVHW011616090819
627135LV00006B/156/P